Masterpieces of
AMERICAN PAINTING

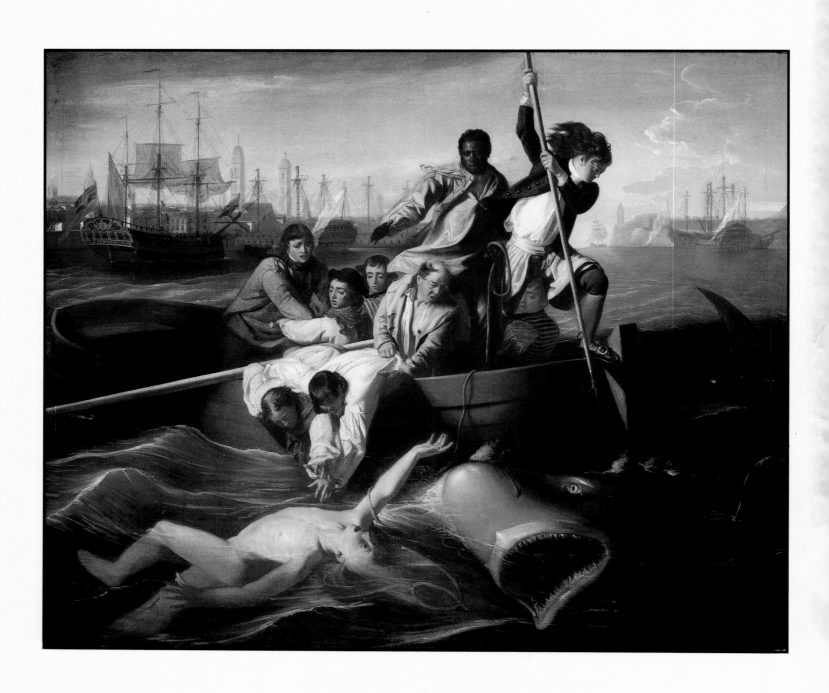

Masterpieces of
AMERICAN PAINTING

Leonard Everett Fisher

Exeter Books

NEW YORK

A Bison Book

The author and publisher would like to thank the
following people who have helped in the
preparation of this book: Adrian Hodgkins, who
designed it; Thomas G Aylesworth, who edited it;
Mary R Raho, who did the picture research;
Ron Watson, who prepared the index.

First published in USA 1985
by Exeter Books
Distributed by Bookthrift
Exeter is a trademark of Simon & Schuster, Inc.
Bookthrift is a registered trademark of
Simon & Schuster, Inc.
New York, New York

ISBN 0-671-06989-6

Printed in Hong Kong

CONTENTS

ABOUT THE AUTHOR

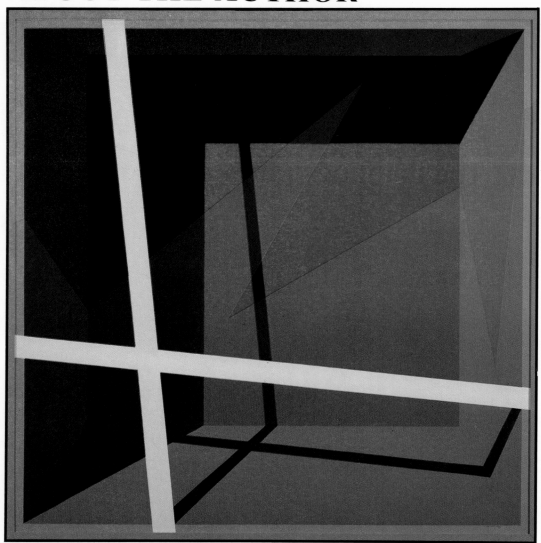

Shadow of a Ribbon (1970) *Leonard Everett Fisher (1924–)*
New Britain Museum of American Art, Connecticut

In 1973, Leonard Everett Fisher's major one-man exhibition, *Twenty Four Years in Retrospect* opened at the New Britain Museum. It consisted of 69 works created between 1949, when the artist was twenty-five, and 1972. Egg tempera, gelatine size, acrylic, gouache and scratchboard works showed his versatility.

Fisher's *Shadow of a Ribbon*, included in the exhibition, is a prime example of a facet of the artist's ouvre. Like the best of creative artists, he has his own personal, easily identifiable style that is clearly a mirror of its time.

Fool the Eye or *trompe l'oeil* painting dates back to the Romans. The 17th-century Dutch artists were magic realists extraordinaire. And in the 19th century, American William Harnett and the great John Haberle of New Haven, Connecticut, continued the tradition in their own inimitable ways.

Fisher uses the same devices as his predecessors: sharp focus precision, linear perspective, realistic scale of the objects, tight control of hues, values and intensities in order to create fantastic deceptions of space. He carries the *trompe l'oeil* style even further by extending the paintings of the box-like space to include the framing as seen in *Shadow of a Ribbon.*

Ever striving to perfect his statements, Leonard Everett Fisher relishes the accumulated skills that he has developed and produces works of great beauty and simplicity, filled with color harmonies. His paintings are to be contemplated, and *Shadow of a Ribbon* is a work both provocative and visually stimulating.

Charles B Ferguson, *Director,*
The New Britain Museum of American Art

AUTHOR'S NOTE

There are some aspects related to the artistic choices of this book that deserve to be noted at the outset. These views deal with the craft of painting—the act of applying pigment to a surface, to use a broad definition. Also, these views deal with the art of painting—that mysterious something which attracts our attention, excites our senses, invades our spirit and extends our vision. Obviously, opinion, with or without a sound knowledge base, however conditioned in this the Age of Information, is a constant companion. Nevertheless, *art in painting* is inextricably linked to application of pigment to a surface, to the *craft of painting*, for essential visibility. Without even the most rudimentary craft, there can be no visual art. There would be no visible expressive nature. Michel Angelo's Art, wrote William Blake (1757–1827) depends on Michel Angelo's execution altogether.

Given our time of reference—the final quarter of the 20th century—there exists a profusion of artistic purposes expressively offered by a variety of media trying the very outer limits of our sensual capacities. Within this bustling zone of cultural energy is the craft of painting, which in itself bombards receptive audiences with a variety of useful applications. And in all of these there is a certain leveling of importance if not value, as each vies for our attention in a frenzied and more widely educated society. In terms of the American experience, I speak of easel and mural painting, editorial and book illustration, institutional illustration, painted graphic design and the like. In each of these genres have been seeded masterpieces of painting with artistic impact and continuity making them worthy of apotheosis.

This book, however, concerns itself with easel paintings. These are largely unattached works rather than integral parts of architectural structures (*eg*, murals), texts (*eg*, book illustrations) or products (*eg*, advertising illustrations). These easel paintings are works that were often self-started by an artist's response to instinct, need and environment, not to mention a timely commission or two. Here, the artist expressed ideas and personalized his or her vision while extending our own—making what does not exist appear to exist—or fixed on canvas, as it were, an interpretation of people, places and things for whatever the historical, spiritual or memorable intent.

A final word. I am an artist—painter, illustrator, designer. I bring to these selections a craftsman's sense of labor and purpose, and an artist's perception of painted masterpieces.

LEF
Westport, Connecticut, 1984

INTRODUCTION

Masterpieces Defined

'There is no such thing as English Art,' said James Abbott McNeill Whistler (1834–1903), an expatriate American painter working in England. 'You might as well talk of English Mathematics,' he continued. 'Art is Art, and Mathematics is Mathematics.'

Whistler's remarks may not have had too sympathetic an audience, given the climate of 19th-century nationalism that was moving Europe—and in the end, America—inexorably toward the massive wars, devastations and calamities of the 20th century. Moreover, and in hindsight, Whistler was justifying his thorny presence amid an English art establishment that thought his innovations were eccentric and impudent. Nevertheless, Whistler's observation about the fundamental nature of art, made in Paris in 1886, was prophetic in the light of the broad image of internationalism that characterizes the sweep of modern painting a hundred years later. All this as America and the world moves inexorably toward the uncertainties of the 21st century.

What then is American painting as practiced over a roughly 300-year period, *c* 1680–1980? What is a masterpiece of American painting? One would have to reach, first, for an explanation of 'masterpiece' before attempting to answer the questions posed above and which are so central to the theme of this book.

'Masterpiece' as a descriptive term has an instant meaning for most people, whether lexicographers, art historians, critics, artists or the general public. Simply stated, a 'masterpiece' usually signifies a flawless production. It matters little whether it be a baseball game having extrinsic and measurable statistics or a painting with intrinsic and immeasurable energies. A perfect game is a perfect game. A perfect painting is something else again.

Not all practicing painters or students of painting (*eg*, non-painting public, historians, critics etc) view the essential nature of a painting in the same way; nor do they view the methods employed to create painted images with the same understanding. Many artists, for example, in assessing works not their own, often cannot escape their personal experience with the labor of creativity in making esthetic judgments. The pain of creativity, as it were, conceptual as well as technical, is ingrained and never far from the artist's consciousness. The non-artist is never quite so encumbered. Also, there are levels of education and comprehension, of intellect and sensitivity that make each and every one of us respond to paintings in varying ways. Suffice it to say, a single painting can be good, bad or boring to an individual on three different days. While that very same painting can be good, bad or boring to three individuals on the same day.

Yet despite this varying scale of response, certain paintings emerge—albeit for different reasons—and establish their presence, bending us to their will. We call these works 'masterpieces' more or less. I say 'more or less' because older, familiar works—*eg, Paul Revere* by John Singleton Copley (1738–1815)—achieve a greater degree of acceptability for their historical implications, let alone their artistic skill—not-to-be-tampered-with national treasures—than newer, less familiar works—eg *Beach Blankets* by Milton Avery (1893–1965)—which however acceptable among the cognoscenti have not yet been firmly fixed as national treasures.

Whatever one's preference in painting styles, periods, movements, media and purposes; whatever one's visual and emotional expectations—from naturalism to non-objectivity—from the narrative to the sensual—from *Eight Bells* by Winslow Homer (1836–1910) to *Number 1, 1950* by Jackson Pollock (1912–1956)—from the conservative to the radical—there are characteristics common to this variety that are the essence of masterpieces.

These traits encompass, for the most part, the painter's passion for the tools of his trade and a preoccupation with concept and its communication. Obviously, the artist's use of manual skill in the service of the concept, final image and its meaning or effect is a fundamental element in this. All together, these characteristics must produce a painting that commands the viewer's attention and fascination if it is to be a 'masterpiece.' Such a painting usually establishes visual credibility that sets its own reason for being. Added to this is a vitality in the art as a whole and a sense of universality that reaches out beyond the edge of the canvas. While such paintings as James Abbott McNeill Whistler's portrait of his mother, *Arrangement in Grey and Black*, become enormously popular, the popularity may be only a byproduct of the painting's stature as a masterwork of art. Popularity does not in itself cause masterpieces either to exist or to flower. There are masterpieces in the pantheon of art to which the general public does not respond.

In any event, underpinning these seemingly elusive qualities—the magic of a masterpiece, so to speak—there is a certain logic that a master artist—and that is where a masterpiece originates, from the soul, mind, eyes and hands of the master artist—pursues in the creation of a painting, sometimes calculated, sometimes not. Here the artist is concerned with purpose and how to communicate that purpose. For example, if the artist wishes to record an apple exactly as that apple exists under a given light—as it is in nature and not an interpretation—it would be illogical to use an abstract mode and create a painted invention which has nothing to do with the objective appearance of that apple. The intent would be denied. However, if the artist intended to use the apple as an idea or symbol (*eg*, original sin) then he or she has the option of painting such a form as naturalistically or as abstractly as the mode of expression dictates. Masterpieces of painting, generally speaking, and whatever their physical appearances or manner of expression, usually have pursued a logic of application appropriate to their intent. In other words, all is clear in the mind and vision of the artist as the work begins. And there is no hesitation with regard to the use and application of the medium. If all the parts of the painting (*eg*, its organization, originality, color, value, lineal structure, forms, shapes etc) remain interlocked and interdependent; if the concept remains clear, the technique unwavering and the balance between the two unyielding, then the expressive nature of the painting can impose itself upon a willing viewer. Such painted clout is a ready candidate for elevation as a 'masterpiece.'

Given all the qualities discussed and the perfection of their artistic natures, what then truly elevates paintings to the exalted status of 'masterpiece' is both predictable and unexpected. One would expect well-crafted and expressive paintings of antiquity (*eg*, at least 100 years old) that have survived to fill in the gaps of art and social history, thus ensuring our continuity, to be called 'masterpieces.' There are other works recognized by knowledgeable persons as having the influence to move art directions this way or that. These, too, are masterpieces. Then again, there are paintings of such charisma that they establish themselves as constant esthetic forces regardless of their style, period of origin or technical handling—masterpieces too. Sometimes it takes several lifetimes for a painting of intelligence and inventiveness to be seen as a masterpiece.

In the end, a single painting must echo its own era and a point of view of its own historical time, made visible—saved from obscurity—by patrons with the ability to establish the work as being important—a masterpiece.

As all this relates to masterpieces of American painting, works produced by American artists in America or abroad and having inherent in them those special qualities being reviewed on these pages, certainly merit citations as masterworks. And there are many more than those that appear in this book.

However, the works chosen have significance in addition to being extraordinary examples of their genres. There are, for example, 18th-century paintings of immortal Americans painted with English excellence and American frankness. The wizardry of their execution and the energy that flows from the canvasses, combined with the deified personalities of George Washington or Paul Revere, establish the paintings as masterpieces. They are the icons of the American nation.

Among the 19th-century paintings are those whose elements of technique are marvels of controlled and exquisite harmonies. Here the solidness of drawing and the flicks of masterful brushes produced haunting schemes of light and motion to depict a romantic America for us to recollect.

As the 20th century hurtles on to its conclusion, its artworks have not yet been as thoroughly sifted as in more stable times. Still there are paintings already established as masterworks. These are as noteworthy for their visionary breakthroughs as they are for their inventiveness, personality and influence. These are all new and different languages of seeing that defy simplistic definitions and expected ideas of the nature of a 'masterpiece.'

Painting in Colonial America

When the London Company planted the British Flag in Jamestown, Virginia, in 1607, establishing the Crown's first permanent colony on American soil, Flemish painter Peter Paul Rubens (1577–1640) had just completed his canvas *Adoration of the Shepherds* for the Duke of Mantua. In 1620, the year the Pilgrims landed at Plymouth, Massachusetts, Diego Velazquez (1599–1660) of Spain painted his *Water Carrier*, as Anthony Van Dyck (1599–1641) arrived in London from Antwerp to establish the portrait at the heart of English painting. Ten years later, in 1630, the Puritans founded Boston, while in Leyden, Holland, Rembrandt Van Rijn (1606–1669) was already experimenting with the drama of light and dark in a profusion of self portraits. While Britain was gaining a foothold in the American wilderness of New England

between 1620–1630, French painters like Le Valentin (1594–1632) and Simon Vouet (1590–1649) were in Italy studying the incredible realism of Michelangelo Merisi (1573–1610) called Caravaggio. Another Michelangelo—Michelangelo Buonarroti (1457–1564), perhaps the most venerated artist of his time—was not dead 50 years when Peter Minuet (1580–1638), a Dutch colonial governor, bought the Island of Manhattan from the Indians in 1626 for $24.

The first painters in America were hardly the extraordinarily gifted and sophisticated artists of Europe. Seventeenth-century painters did not thrive in the forest. Their milieu was the courts of Europe and their formula for success was the European continent. America's earliest painters, on the other hand, were sign painters unmotivated by esthetic freedom, self-expression or visionary insights. They simply lettered the signs of taverns and those of the shops of local wigmakers, hatters, chemists and the like. More often than not these artful craftsmen pictorialized the signs of their clients.

The Green Apple Tavern sign would be adorned with a reasonably large picture of an apple rendered in flat tone and line with green oil paint. The sign painter himself had made the paint. Sign painting, however, was not a full-time craft. There was not enough work to earn a man a living. The sign painter had to resort to other means of survival.

By the mid 1600s the British colonies had grown, and by the 1670s they were beginning to show signs of prosperity. Now the sign painter found employment as a house painter or 'painter-stainer,' coach painter, and more often than not a designer and painter of grave-markers. Those sign painters who were more skillful than others, and who were encouraged by their own ambitions and the urgings of their friends, began to paint portraits. Known as 'limners' or 'face painters,' and remaining historically anonymous for the most part, these artisans filled the need of the colonists to be remembered—to have likenesses of themselves to hand down to future generations or to ship back to relatives in England.

Unlike the trained artists of Europe, whose understanding of the oil medium produced atmospheric illusions and whose knowledge of light and shade enabled them to paint three-dimensionally—to paint form—giving their portraits superb qualities of life and art, the untrained colonial face painters painted their sitters as they did their signs: flat, simple and lifeless. While the painted bodies were stiff and poorly drawn and the faces clumsy and crudely painted, the subjects of these portraits seem to stare at us with a stubborness that matched their great adventure in New England. While the limners often boasted about what great artists they were—sales pitches were as necessary then as they are today, and there were few around to say otherwise—the limners did not purposefully express their feelings about the people they painted or even express the nature of their New World environment. If the starkness and clumsiness of the portraits seem to us, today, to express their time, place and character, then they do so innately and not by artistic design.

The only thing that interested the face painters was to render the persons who sat before them as faithfully and as naturally as they could. And the only thing that interested the sitters was self-recognition and to be represented with nobility and affluence whatever their social condition. It happened that many a limner believed his finished work to be quite lifelike, if not absolutely naturalistic. So did the sitter. The

11

fact of the matter is that most of them—painters and subjects—had no perception of painted naturalism or how to achieve it. The flat, two-dimensional, ungraceful look of the paintings was unplanned.

By the beginning of the 18th century, while the limners struggled to improve and continued to satisfy a healthy demand for painted likenesses, a number of trained artists began to trickle into the British colonies. One of the earliest of these artists was Gustavus Hesselius (1682–1755) who came to Maryland from Stockholm, Sweden, in 1712. Hesselius was not the best that Europe had to offer. Nevertheless, he was the first professionally schooled painter who used his training to produce more competent portraits in the colonies. Moreover, he was the first painter in America to create pictures outside the portrait realm, producing historical, religious and mythological compositions. One of these was a *Last Supper* commissioned by St Barnabas Church, Prince George's County, Maryland, in 1721.

Another professional painter who braved the uncertain esthetics of the New World was John Smibert (1688–1751). Smibert, an Edinburgh Scotsman, painted in London before coming to America in 1729 via Florence, Italy, where he had spent time studying Italian painting schools. Once in Boston, his first commission was a portrait of Bishop George Berkeley and his family (*The Bermuda Group* (1729) collection: Yale University Art Gallery). Smibert had met Berkeley in Italy and interested himself in one of the Bishop's projects—a college for American Indians in Bermuda.

In any case, a year later, in 1730, Smibert exhibited a number of his paintings in Boston in what was at once an advertising scheme to acquire portrait commissions and possibly America's first one-man show. Smibert's portraits and later landscapes (produced after 1749) were more luminous and better-crafted than the works of Hesselius. In toto, they presented an elegance, however still provincial, not yet seen in the American colonies. Greatly influenced by the English portrait painter Sir Geoffrey Kneller (1646–1723), Smibert became a link between the stylized sophistication of British portrait painting and the uncompromising realism that emerged in the portraiture of the gifted John Singleton Copley (1738–1815) of Boston and later London.

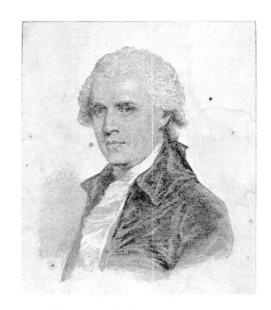

John Singleton Copley.

American-born Copley, in going the other way—back to England—left behind his artistic powers and a considerable reputation developed over a period of 30 years between 1743–1773. In London, Copley met Benjamin West (1738–1820), another American-born expatriate painter, now court painter to George III whose politics would soon cost him his American colonies. Copley had corresponded with West for years. He had even sent paintings abroad to be shown at the Royal Academy with West's encouragement. Both West and art dealer John Greenwood urged Copley to give up America for Britain and the Continent, an act which Copley was forced to perform when his apolitical stance amid seething Boston was compromised. Married to the daughter of Richard Clarke, the Tory merchant who imported the tea that was dumped into Boston Harbor, Copley, with friends on both sides of the colonial dispute, failed to negotiate a truce between the Sons of Liberty and the Tory merchants. Now seen as a Tory sympathizer, Copley had no choice but to seek his fortune elsewhere. After traveling in Europe, he returned to England, where his abilities and fortune steadily declined, leaving his American portraits as the basis of his reputation.

Benjamin West, on the other hand, was not as gifted an artist as Copley. Yet his influence as a neoclassic painter of contemporary historical

events—approved by the King of England, no less—reached into the realm of French art all through the 19th century from Jacques Louis David (1748–1825) to Ernest Meissonier (1815–1891). Moreover, West's power within the English art establishment—he was a founding member of the Royal Academy and its second president after Sir Joshua Reynolds, in addition to being friendly with the King—made him a much-sought-after personage by every American artist who visited London following Independence and as long as West lived. And West was very generous with his time as both host and teacher, spreading his influence back to America, an influence that dominated American art for half a century.

Among those Americans who traveled to London to study with West were Charles Willson Peale (1741–1827) and his son Rembrandt Peale (1778–1860); Ralph Earl (1751–1801); Gilbert Stuart (1755–1828); John Trumbull (1756–1843); Thomas Sully (1783–1872) and Samuel Finley Breese Morse (1791–1872).

These gentlemen were portrait and/or historical painters, for the most part, anxious to pin their economic salvation and artistic immortality to the celebrated and to the momentous occasions of their day. Charles

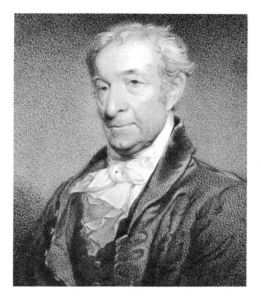

Above: Gilbert Stuart.
Right: Charles Wilson Peale.

13

Willson Peale was the most restless of the group. His interests waxed and waned between painting the famous and experimenting with sky-lighted studios, galleries, museums, politics, pageants, dentistry, public health, machinery, chemistry and natural history. One of his elaborate schemes involved a combined art and science society—Peale had become interested in prehistoric bones. The scheme dissolved. What emerged, however, was America's first school of art—the Pennsylvania Academy of Fine Arts (1806)—and the first natural history museum in the Western world—the Academy of Natural Sciences of Philadelphia (1812). Peale's supercharged and inventive existence was due, in part, to necessity. His constant indebtedness caused him to seek oppor-tunities other than the painting of portraits. Also, the arrival in Phila-delphia of success-strewn Gilbert Stuart put too competitive a dent in Peale's sagging portrait business.

Gilbert Stuart was, at the time, perhaps America's best portrait painter. Born in Rhode Island, and having recently returned from West's studio in London, he became the rage in New York, Philadelphia, Washington and Boston, where he painted only the rich and famous. He was an irresponsible, difficult person whose lively temperament and

John Trumbull.

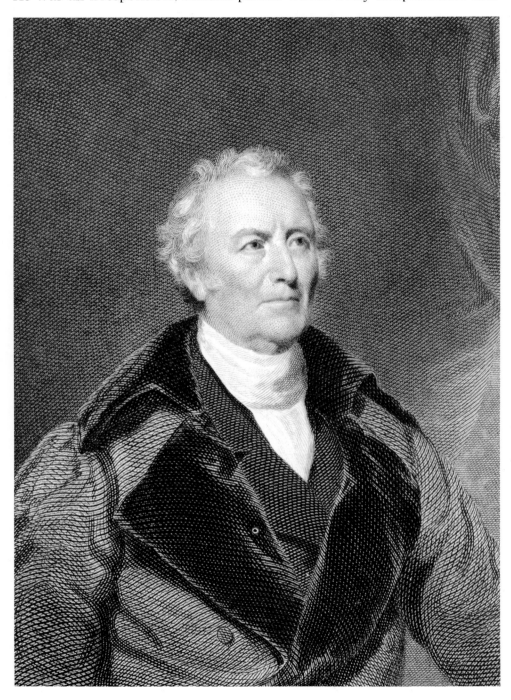

Grandma Moses.

drinking capacities were well known but tolerated: his gifts far outweighed his unreliable character. Everyone of note insisted on being painted by him, including the stern president, George Washington. In fact, Stuart made a handsome living painting the first American president. He painted several portraits of the great man. One of these made Stuart immortal and burned *his* image of Washington upon every succeeding generation of Americans. Stuart made at least 90 to 100 copies of his own painting of Washington on demand, charging $100 each.

Ralph Earl of Connecticut was something of an anachronism in this group, while John Trumbull, also of Connecticut and the son of a Connecticut governor, cut a tragic figure of promise unfullfilled.

Earl was a studio-trained rural Yankee familiar with Benjamin West's London. But unlike his contemporaries and fellow apprentices from America, Earl retained in his paintings a stiff provinciality and tenseness that set them apart from the fluid technical control that characterized Copley, Peale and Stuart. Earl placed his painted subjects in an atmosphere, the illusion of which is aided by the artist's knowledgeable manipulation of light, shade, perspective and an oil medium whose qualities lend themselves to atmospheric illusions. Earl's knowledge of linear perspective and his first-hand observations of European masters removed him from the ranks of 'primitive' painters. Yet there is a naiveté about his portraits, which seem to express the flat, lifeless images of the unschooled limner. Interestingly enough, the untrained limner acting as a professional portrait artist in America would disappear from the scene about midway through the 19th century. Nevertheless, that flat and naive tradition of the limner would persist throughout the history of American art. It appears again and again, increasing in importance as an acceptable style—the 'primitive style.' Chief among those practitioners of the style are Edward Hicks (1780–1849), John Kane (1860–1934), Morris Hirschfield (1872–1946), Horace Pippin (1888–1946) and Grandma Moses (1860–1961).

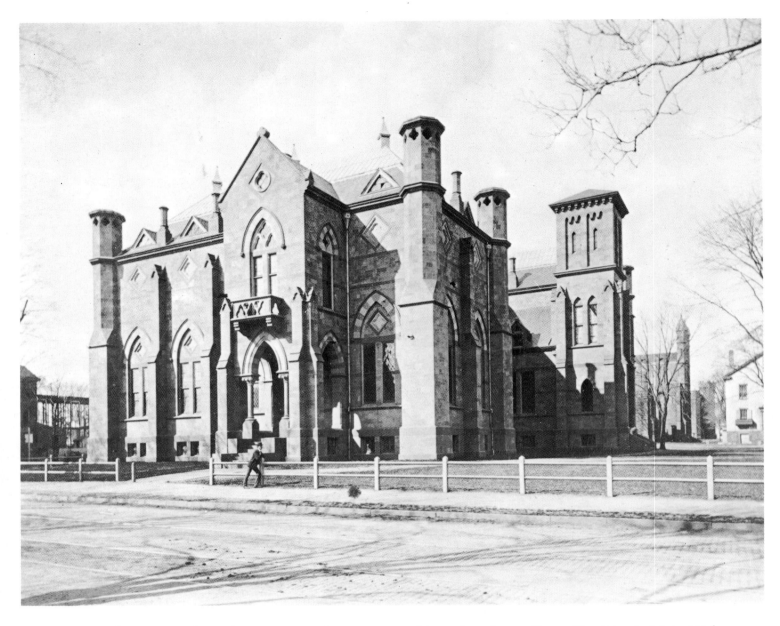

John Trumbull was anything but naive with respect to his painterly skills. He was wealthy, arrogant, aloof and well educated too. But he confused his sense of self with America's destiny, miscalculating both and producing a failed career. John Trumbull seemed to represent the passage of a now-obsolete 18th-century patrician point of view to a 19th-century plebian future being wrought by the coming of the Industrial Revolution. Trumbull was an aristocratic revolutionary who preferred to create only an appearance of change, a change whereby the royal prerogatives of George III would simply be transferred to a new American royalty, John Trumbull's own class. In Trumbull's mind, the American Revolution was being fought by the common man to preserve and reserve the power of rule for American upper classes. Appointed a colonel in the Continental Army of George Washington, he became more of a witness to events than a participant. He mismanaged his rank and traveled to London, the enemy war camp, to study art with Benjamin West. He was soon arrested in reprisal for the American execution of British Major Andre in the Benedict Arnold affair. Trumbull was later freed to pursue his life of career disappointment: paintings to which few responded and commissions that did not fully materialize. His talents floundered in rejections, bitterness and discouragement. Even when he was able to secure the Capitol Rotunda commission involving eight large wall decorations, he was denied the completion of the final four because the first group was so negatively received. Trumbull died a dispirited man, having managed to live on a pension tendered near the end of his life by Yale University in return for

his life's work. Yale also agreed to build a gallery to house Trumbull's art—the first such university-connected art gallery in America. Not satisfied with his institutionalized immortality, Trumbull managed to have his mortal remains entombed like a monarch in a sarcophagus housed in a vault beneath the gallery with the epitaph:

Patriot and Artist
to his country he gave
his Sword and his Pencil.

A quarter century after Trumbull's death in 1843, Yale opened the doors to the first university school of art in the United States, with the spirit and art of the late Colonel Trumbull everywhere. For the next 120 years or more, many a Yale student of painting—including this author—found their way to the Trumbull tomb to varnish paintings in the nearly dust-free condition of the vault. Trumbull was the last witness of the War for Independence to hold a high military rank. With his death died the last vestige of that event. His star rose, however, with those unacceptable decorations he painted for the Capitol Rotunda, which are still in place today. These large wall paintings combined with the British-West influences began a tradition of American murals in public places. And, interestingly enough, that tradition was seeded and nurtured for many instructional generations at the Yale School of Art where John Trumbull lay in his tomb, influencing in death, as he could not in life, a direction in American art.

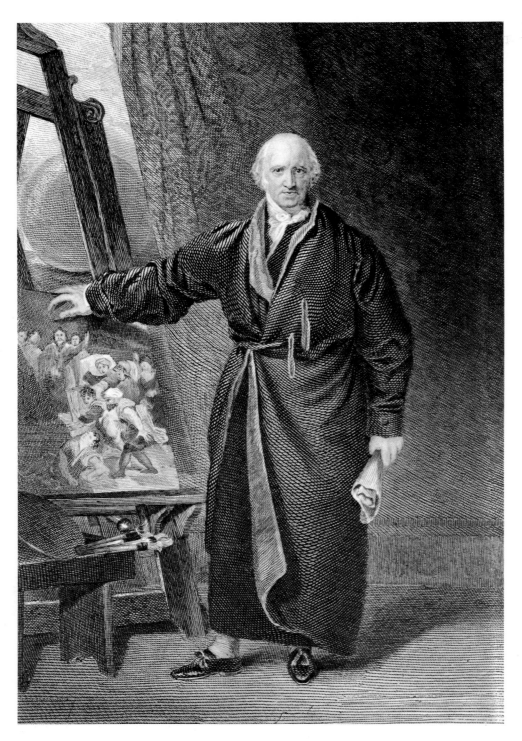

The Nineteenth Century

As the last generation of 18th-century colonial-born Americans eased their advancing years into the 19th century—the new United States was not yet 25 years old on New Year's Day, 1800—John Singleton Copley and Benjamin West, both of whom became, in effect, Englishmen, subscribed to cultural values that were in the twilight of their essentialities while tentatively testing new artistic roads. And they forged a link—especially West—with young American artists and with America itself. The path to West's studio in 19th-century London was crowded with hopeful painters. Those who remained to study with him carried home his artistic preferences and a hint of Copley's romanticism.

West had become an innovative painter who insisted, much to the annoyance of the art establishment, that historical scenes be accurate right down to the buttons on the uniforms rather than, as the English and French schools would have it, idealized settings with figures dressed in Greek togas. Accuracy in the interest of realism was the American strain in West's erstwhile British affectations.

Copley, on the other hand, had intrigued a number of young Americans with his *Watson and the Shark* (1778), an imaginative composition of an incident in the Caribbean that Copley had heard secondhand. With West painting accurate settings and accessories and Copley indulging his imagination, the seed was cast for a widening of artistic ideas in America that would lead straight to Winslow Homer (1836–1910), James Abbott MacNeill Whistler (1834–1903), Thomas Eakins (1844–1916) and John Singer Sargent (1856–1925), among others, via the first quarter century romantics who studied with West and had met Copley in London.

Gilbert Stuart and John Trumbull, students of West's, were 18th-century thinkers in a 19th-century world. Stuart was his own man, painting idealized portraits with more warmth and plasticity than Copley. Trumbull tried too hard to be *the* American Benjamin West. None of these sensed the bite of change that would soon engulf every aspect of American life. Peale alone seemed to herald that change. He had turned his remarkable energies and inventiveness in every direction at once, challenged by all that was new and different, interesting and

Above: John Singer Sargent.
Right: Thomas Eakins.

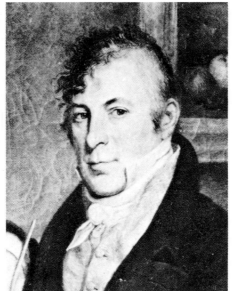

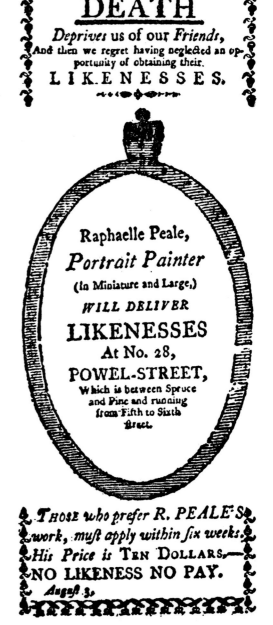

useful, as his contemporaries faded into their declining world. The Industrial Revolution, seeded in Britain circa 1750, had begun to supercede the American Revolution as a force for change. Peale, dead at eighty-six in 1827, was born too early.

By 1830 the hum of factories and the clank of machinery had entered the stream of American awareness. The values of 18th-century agricultural, rural America were beginning their slow sufferance of the aggressive pragmatism of 19th-century industrial, urban America. By mid-century, the railroad—not yet transcontinental—was effectively binding the country in a network of economic, political and cultural rivalries whose very contentiousness and distress in a rapidly developing civilization exploded in Civil War (1860–1865).

Into this vortex of change came the brothers Peale (Of 11 Peale children, three became painters: Raphaelle (1774–1825), Rembrandt, and Titian (1779–1885). A brother of Charles's, James Peale (1749–1831), painted portraits and landscapes, chiefly miniatures.) Other new artists were Washington Allston (1779–1843) and Samuel Finley Breese Morse, students of Benjamin West. In 1826 Morse was named the first president of the National Academy of Design and went on to invent the telegraph. Allston and Romanticism were synonomous, however. Romanticism, the flights of imagination, mood and sensuality as opposed to those of intellect, logic and reason, had a lifetime grasp of Allston—body and soul. His irrepressible bent toward imaginative, visionary and unpredictable imagery began in the black slave quarters of his family's South Carolina properties. It was nurtured away from home at Harvard University, a place not easily given over to the unrealities of black ghost stories as retold by Washington Allston, whatever the tradition of witchcraft in Massachusetts. Allston's flights of fancy were heightened if not altogether reassured when he set eyes on Benjamin West's small canvas *Death on a Pale Horse* (1802), upon his arrival at the master's London studio.

Allston seemed to be in the right place at the right time. England and France were already in the throes of Romanticism, a movement of spirit over intellect—of imagination over reason—that had burst upon the art and literary circles of Europe as the smoke of industry began a century-long effort to close an iron fist upon Western civilization.

Top left: Titian Ramsay Peale.
Top center: Raphaelle Peale.
Above: An advertisement by Raphaelle Peale which appeared in a daily paper in 1801.

In England, literary Romanticism was represented by Samuel Taylor Coleridge (1772–1834) whose haunting, rhythmical poetry (*eg, The Rime of the Ancient Mariner* 1798), soared beyond mundane experiences to spiritual realms never before visited in literature.

Across the English Channel, in France, painters Theodore Gericault (1791–1824) and Eugene Delacroix (1798–1863), broke with tradition and set France on a more Romantic artistic course. This direction would emerge at the end of the century as the seedlings of modern art, despite the futile interruptions of the academicians. Gericault made his mark with the huge *Raft of Medusa* (1819), a canvas with political overtones dealing with a sea tragedy. It seemed to have a visual link with Copley's *Watson and the Shark*, painted 41 years earlier. Delacroix made his point with *The Bark of Dante* (1822) and later with exotic subject matter and color rooted in the flavor of North Africa.

In any event, Washington Allston, back home with his reveries, became another tie between the West–Copley tradition and magnetism anchored in Britain and the sweep of American painting. This time the link was between the romantic thrust of European art forms and the direction of American landscape and figure painting—Romantic Naturalism and Romantic Realism.

Among the former—the Romantic Naturalists—were Thomas Cole (1801–1848), Asher Brown Durand (1796–1886), Frederick Edwin Church (1826–1900), Albert Bierstadt (1830–1902) and George Inness (1825–1894). Together, with a number of others, these painters comprised the Hudson River School. What they all had in common was a reverential awe for the wild beauty of the American landscape, chiefly east of the Mississippi River. Their great and spacious vistas owed as much to European masters of the landscape with respect to the technical formulation of the paintings—their scale, color, perspectives, points of interest etc—as they did to their emotional, romantic view of their America. This was especially true of George Inness, who spent some time studying among the Barbizon painters of France.

Below: George Inness.
Below right: A 'trick' double exposure photograph of Albert Bierstadt, taken by Charles Bierstadt at the age of 31.

Among the latter—the Romantic Realists—were an assortment of painters who did not comprise a fixed school focusing on a given subject, concept or set of principles. These painters, for example, included such artists as Winslow Homer, whose seascapes, figurative seascapes and historical compositions dealing with the Civil War were painted with such outward accuracy that it masked the compelling drama and emotion of Homer's art, to which he would never admit. Homer typified and represented the artistic lineage of Benjamin West traveling through Washington Allston, albeit with his own crisp New England stamp upon it all.

Beyond Winslow Homer were those romantic painters whose expression of mood underwrote the very nature of their artistic being. As different as Thomas Eakins was in his uncompromising but atmospheric realism from the visionary works of Albert Pinkham Ryder (1847–1917), they were both bent on involving the viewer in the sheer subjectivity of their art. What made them both Romantics was the fact that the viewer of their art could no longer be a casual observer of a pictorialized event. The viewer was drawn into the painting by the very pull of its mood or mystery.

Scattered everywhere were the romantic genre painters like George Caleb Bingham (1811–1879), whose brilliant and expressive quietness of life on and off the Missouri River set the imagination of any viewer at the water's edge and moved him or her with profound feeling. Other genre painters like William Sidney Mount (1807–1868) and Eastman Johnson (1824–1906) proferred a populist point of artistic view. Painters of every day matters, theirs was essentially a plateau of story-telling, sentimental canvasses, immediately comprehended by an unsophisticated audience. Many of these works produced toward the end of the century prefigured the early schools of American magazine illustration.

Allied to these genre painters during the last quarter of the 19th century were the *trompe l'oeil* (fool the eye) artists: John F Peto (1854–1907), John Haberle (1856–1933) and William Michael Harnett (1848–1892). These three took everyday still-life materials, set them in interesting arrangements and transferred their absolute appearance onto a canvas. In some instances the painted duplications were so marvelously rendered that the painting heightened our awareness of the objects, lifting them out of the ordinary forever. These were nearly the last word in painted illusions of the physical world, of physical reality.

The two painters most independent of any school, group or collective ideal were Albert Pinkham Ryder and James Abbott McNeill Whistler. Ryder was the loneliest figure, preferring to deal with his visions over long periods of time and in utter seclusion. Whistler, on the other hand, lived abroad and challenged the establishment with his ideas that art was produced for the sake of art and that subject matter was incidental to the intrinsic nature of a painting. John Ruskin (1819–1900), the English critic, accused Whistler of 'flinging a pot of paint in the public's face.' Whistler sued him for libel and won. In commenting on the trial, Whistler wrote 'A life passed among pictures makes not a painter. . .'

In any event, both Whistler and Ryder pursued their inner feelings and ideals, visions and images. They were very original painters who were precursors of the modern art movement which would probe new levels of esthetic and visual experience.

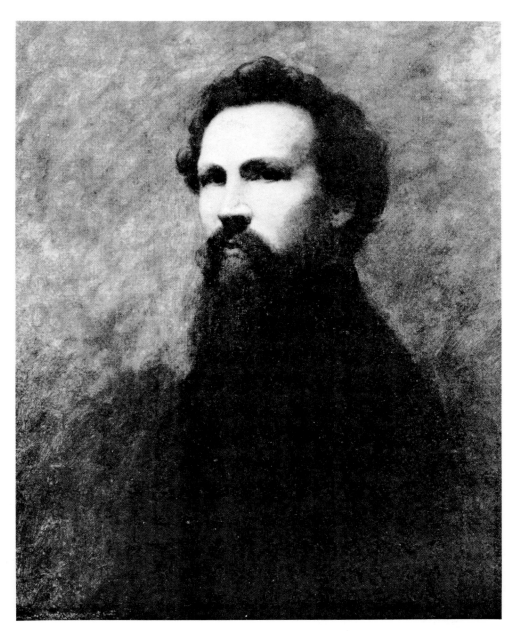

Right: Eastman P Johnson.
Below: Winslow Homer.
Below right: James McNeill Whistler.

While Ryder and Whistler were breaking with tradition, one in England and the other in a Manhattan tenement, French artists were once again breaking with tradition as well. Camille Pisarro (1830–1903), Edouard Manet (1832–1883), Claude Monet (1840–1926) and Paul Cezanne (1839–1906), among others, were setting the stage for all the new directions that painting would take in the new 20th century. Both Albert Pinkham Ryder and James Abbott McNeill Whistler were among those great individualists of the late 19th century including Paul Gauguin (1848–1903) and Vincent Van Gogh (1853–1890) who reordered the artistic principles of their day and sent their notions hurtling into the 20th century in search of untapped realms of painted experience.

The Twentieth Century
No summary of the art of the 20th century can adequately describe the diversity of esthetic approaches. Nor can it reasonably describe the proliferation of individuality in the world of painting. As the 20th century moves toward its conclusion it seems safe to assume that no moment in history ever ran its course with such rapid-fire change affecting at once every corner of the earth.

The main thrust of 20th century painting, as in other art forms, has been subjective and intuitive, dealing as it has, for the most part, with intangible matters and emotional responses rather than with the appearance of the physical world. Objectivity, as seen in the paintings of the 18th and 19th century American painters, had waned some-what. The depiction of historical events and portraiture no longer satisfied the artist. The need to stretch one's vision or mind was as evident in America as it was in France, however unsure American Realists were of the Impressionists and Post-Impressionists—of Monet and Cezanne. American romantic landscape painters came the closest to drawing us into their awesome vistas.

Subjectivity in painting was hardly an invention of the moderns. Sienese painters of the Trecento and Quatracento periods in Italian art—the Duccios and Sassettas—were intensely subjective in their mysticism and symbolism involved as they were with the spiritual world of the 'hereafter.' The very nature of their medium, water-based egg-tempera, denied them the possibility of creating vibrant earthly atmospheres or objects seen under a light. The medium was too high keyed, its value range too limited and its application too linear. Form, for example, was created by crosshatching rather than by smooth-running gradations. And nature is not a series of lightless crosshatches waiting to be rendered. In effect, the subjective art of these painters produced airless abstractions. Nothing on earth had the physical appearance of the images in these paintings, however much one recognized the figure or a building. There was only a resemblance to actuality.

Oil paint, a relatively new medium, came into use at the end of the 15th century for a very fundamental reason. The philosophical point of view of society had changed. No longer were people interested solely in the spiritual world, in the 'hereafter.' Now they took a greater interest in the secular world, in the 'here and now.' They awoke to their own physical world, leaving a pace or two behind that mystifying 'hereafter,' a place to which everyone went sooner or later, but, nevertheless, a place from which no one had ever returned to describe. Oil paint provided painters the opportunity of describing the real world with a profound sense of the space occupied by humankind and with the same richness of light (and dark) found in nature. For the next 500 years or so, oil paint became the

chief medium of painted expression—the medium with which painters tried to describe and explain the human experience. And while this purpose and this medium remained constant, the expressions did not.

The change of medium from egg tempera to oil during the Renaissance was one of the most significant occurrences in the history of painting. It was a technological adjustment to a philosophical switch in society's outlook. The next significant event in the history of Western painting took place during the 19th century, as the Industrial Revolution gathered momentum. That change was a philosophical adjustment to a technological switch in society's outlook. This time the medium did not change: it remained constant. Oil. What changed was the way people thought about themselves in a world losing its familiarity. Society was moving from an age-old agriculturally oriented system to an industrial one. Nothing would ever be quite the same again.

Subjectivity in modern art, or modern subjectivity in art, to all intents and purposes, began with the emergence of the Industrial Revolution. The individual, once rooted to the land in seemingly perpetual servitude, now had an option—the city factory. Cornered by the option wrought by the change, people wrestled with their identities, political freedom, intellectual freedom—any freedom that would save mind and soul, if not body, from the stale air and uncertainties of economic industrial servitude. And as the social history of the Western World moved ever westward from classical Greece, whatever affected European art would eventually come to roost in America.

At the turn of the century, well-schooled American painters were ignored at home. Americans of wealth had a taste only for European painting, chiefly unexperimental traditional paintings. Unable to impress their own countrymen with their artistic gifts, many American artists turned to newspaper cartooning and illustrating. A number of these banded together to mount protest exhibitions of their paintings. In 1908 eight painters organized themselves into a group called *The Eight*, protesting the presence of the traditional European art establishment in the United States and their own lack of recognition. The Eight were led by Cincinnati-born Robert Henri (1865–1929). They included Maurice B Prendergast (1859–1924), Arthur B Davies (1862–1928), George B Luks (1867–1933), William J Glackens (1870–1938), Ernest Lawson (1873–1939), John Sloan (1871–1952) and George W Bellows (1882–1925). All but Davies were committed to interpreting American city life and the human condition therein. Their subject matter—backyards, alley cats, professional fighters, saloons and the like—was rejected with scorn by critics, public and traditional painters alike. Soon they were nicknamed *The Ashcan School* and despite the heckling, established a serious American genre movement.

It is interesting to note that, while similar artistic rebellions were going on in France at the same time, a short-lived but significant movement burst upon the Italian scene running parallel with *The Eight*. Between 1910–1914, a group of painters and sculptors led by Filippo Marinetti (1876–1944), a poet, joined together to extol the glory of the Machine Age—its energy, its motion, its power, its speed, its total efficiency in war. War, they insisted, was the ultimate rationalization of industry. When Italy went to war in 1914, the Futurists saw their *Manifesto* absolutely justified. They disbanded and marched off to the front in obeisance to the great god, Machinery. Their art, however, lived on—an art that searched for the new dynamics inherent in a new industrial society.

Far left: Robert Henri.
Left: John Sloan.
Right: Portrait of George B Luks by
Robert Henri.

Far left: Maurice B Prendergast.
Above left: Ernest Lawson.
Left: William Glackens and his
daughter.
Above: Arthur B Davies.

In any case, *The Eight* performed two acts of courage that in the end opened the doors wide to the advent of modern painting in the United States. In 1913 they brought to the United States the International Exhibition of Modern Art, now referred to as the Armory Show. And in 1917 they formed the Society of Independent Artists.

The Armory Show was comprised of 1600 paintings and sculptures, chiefly from France and the studios of *The Eight*. They included some acceptable works in the academic tradition. But they also included Picasso's new *Cubism* and such works as Marcel Duchamp's *Nude Descending a Staircase*, which was quickly dubbed *Cyclone in a Shingle Factory*. From the moment the exhibition opened on the night of 17 February 1913, it was visited by huge crowds of every level of New York society, from millionaires who treated the moderns with scorn to the school children who laughed from beginning to end. American artists themselves howled with derision. Cezanne's efforts, which were not wholly acceptable, were, nevertheless, derided less than Matisse, whose work was looked upon as 'the scrawls of a boy.' Former President Theodore Roosevelt commented that his Navajo Indian blankets were better than the new Cubism. And so it went. The nation's newspapers and magazines were filled with rejection and derision, supported by America's conservative tastes in art as seen in the collections of the wealthy, and by American artists themselves, shocked by the French adventures into color, line, shape, form and spatial relations. The furor never ceased as war fell upon Europe (1914–1918), and continued on through the Great Depression of the 1930s; it finally ran out of breath when World War II (1939–1945) overwhelmed much of the planet.

Surprisingly, several American painters were already working in Paris, being profoundly affected by the energy of French modernism, before the Armory Show was sprung upon an unsuspecting America. One of these, Virginia-born Stanton MacDonald-Wright (1890–1973), a student of Henri Matisse (1869–1954), was experimenting with the abstraction of color, insisting that color was to painting as sound was to music. He called it *Synchromism*. Among those American artists who found their way to Synchromism and whose paintings glowed with the shape and form of intense color—and no recognizable object—before *The Eight* introduced Modernism in painting to America was Morgan Russell (1886–1953). Russell had met MacDonald-Wright in Paris in 1911. The latter had been there since 1907. The experiment was carried on further in the United States by James Henry Daugherty (1887–1974), whose fascination with color and the totality of abstraction led him to Synchromism in 1916.

By the 1920s American painters who were not put off by what the Armory Show had represented—subjective art—abstraction—flocked to Paris to confirm or legitimize their interest. Some, like Grant Wood (1892–1942), came home and pursued other more realistic avenues. Others sacrificed themselves on the altar of the Paris Art Establishment by following without personal or further contribution the Frenchmen and their styles. Still others returned home with a freer view of painting.

Also, by the 1920s other artistic movements emerged that would influence American artists half a century later. These movements, principally Dadaism and Surrealism, were spawned by the indifference to human life and values and the restructuring of European society brought on by the Age of Industry and total war. The Dadaists attempted to communicate unplanned, unlikely or non-harmonious visual effects—a fur teacup in a fur saucer, for example. It was an

Grant Wood signs an original while American artists Arnold Blanch and Doris Lee look on.

Ben Shahn.

28

29

Left: Milton P Avery.
Below: Mark Rothko.

attempt visually to rationalize the irrational. Its immediate effect was to shock. Surrealism had more precedence in the history of Western Art. Modern surrealism, however, was an attempt to extract the stream of seemingly disconnected images from the subconscious and render them with total reality. It was to bring one's dreams, as it were, onto the plane of reality with permanent visibility.

'Whatever exists in the universe,' wrote Leonardo da Vinci (1452–1519) in his *Treatise on Painting*, 'whether in essence, in act, or in the imagination, the painter has first in his mind and then in his hands. . . . A good painter is to paint man and the workings of man's mind.'

Following the utter devastation of World War II (1939–1945), there was a brief period of adjustment, reorganization and relative stillness. The world seemed to sag, exhausted from its trials, but, nevertheless, girding for the next round of the unexpected. In that four-year lull (1946–1950) there was little challenge to the already established esthetic natures of visual art. The Realists (symbolic, social or literal),

Right: Willem De Kooning.

Above: Jackson Pollock.
Right: Clyfford Still.

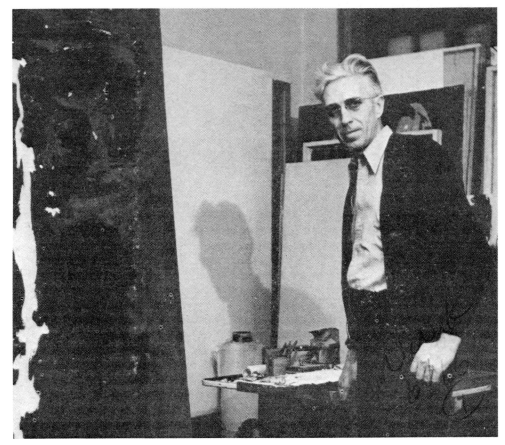

Surrealists, Abstractionists, Non-Objectivists, latter-day Impressionists etc, all had their audiences working in what seemed to be an accommodating world of art. The Age of the Atom had come and gone. Now entered the Ages of Space, Technology, Information, High Technology and whatever else one wishes to call the 20-year period from 1950 to 1970.

Between 1950–1970 and into the 1980s, the world once again erupted with marching men, unrest, discontent, the psychosis of fear and doom as never before. Against this background—a tattoo of power nationalism, economic challenges, creative science, the simultaneous rise of hedonism and religious fundamentalism and disruptions of every dimension to accustomed life styles and systems of society—came a new kind of American painter. Fed by a half century of esthetic and visual diversities and the institutionalization (*eg*, museum acceptance) of modern art as wrought by the rebellious French painters and the iconoclastic Dadaists, marched a new breed of American painters: the Abstract Expressionists, sometimes called Action Painters.

Led by Jackson Pollock (1912–1956), Clyfford Still (1904–1980), Mark Rothko (1903–1970), Willem De Kooning (1904–), and others, the Abstract Expressionists, and to a lesser degree the Pop Artists who came later (*eg*, Andy Warhol, 1929–), epitomized the quintessence of creativity—the freedom of the painter to allow his or her creation to happen without any contrivance or preplanning. In a sense it represented the penultimate cry of the human being for the ultimate freedom in a world closing in on one's ability to control one's own destiny.

With art and life now traveling hand in hand, each representing similar appeals while challenging authority and rules at every level, there came still another group of painters—Hard Edge—who seemed to be responding to a need for rules and authority. The reaction was setting in. More and more, younger painters looked for a handle on life and reality. Social, Photo and Magic Realists each sought avenues of personal expression more closely connected to the physical world rather than the world of the mind and/or soul. Sprinkled everywhere were and are individualists creatively independent of these groupings but who owe their visual statements to all that had gone on before them and to all that continues to go on around them. Their analysis is somewhere in the future, when their more current artistic energy is sifted for significance and evaluated for excellence. These American independents, seemingly isolated from the various schools—Andrew Wyeth, to name one—but nevertheless major contributors to and members of the generic American School, have both historical roots and contemporary foundations. They owe their esthetic and visual options not only to the master painters of tradition, as nearly every painter must, but to those moderns from the beginning of the 19th century on who defied established orders, broke into heretofore unknown realms of vision and gave art an international language.

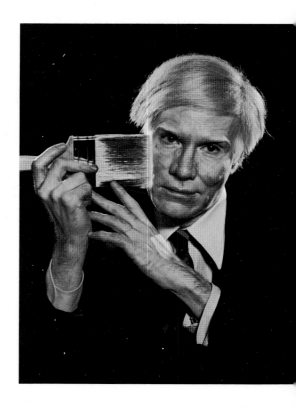

Andy Warhol, photographed by Karsh in 1979.

Andrew Wyeth.

32

THE PAINTINGS

Paul Revere (1770)
John Singleton Copley (1738–1815)

Museum of Fine Arts, Boston, Massachusetts

Five years before Paul Revere made his dramatic but incomplete ride across the Boston Neck to warn of the British menace, Copley painted this singular portrait of him. Revere was then thirty-five years old; Copley, thirty-two.

The Boston Tea Party—'Boston Harbor a teapot tonight'—was yet three years before them. Copley's father-in-law, Richard Clarke, had a proprietary interest in the taxable tea that Revere and others would dump into the harbor one wintry December night. For his part, Copley was neutral in revolutionary matters, preferring to mind his own art rather than someone else's politics. Paul Revere, master silversmith, would soon represent what Copley's half brother, engraver Henry Pelham, described as 'undisciplined rabble.' Pelham had already accused Revere of plagiarizing his engraving of the Boston Massacre (1770) and selling prints from a copied plate at huge profits. By Spring, 1774, Copley had had enough of the American trauma and sailed for England via Italy and the Continent.

One wonders what these two—Revere and Copley—said to each other across the canvas, as Revere posed thoughtfully with the trappings of his trade while Copley leaned on his maul stick flicking his brush in ever-increasing patterns of polished perfection. Whatever was said, Copley caught a vague hint of Revere's energy and volatility, however pensive the figure's position, and however neatly arranged all the parts. Here was Revere. But more than that, here was America—thinking— on the edge—ready to challenge. Copley's response to the momentary chemistry, subliminal or not, plus his remarkable skill produced an unforgettable portrait of immense dimension.

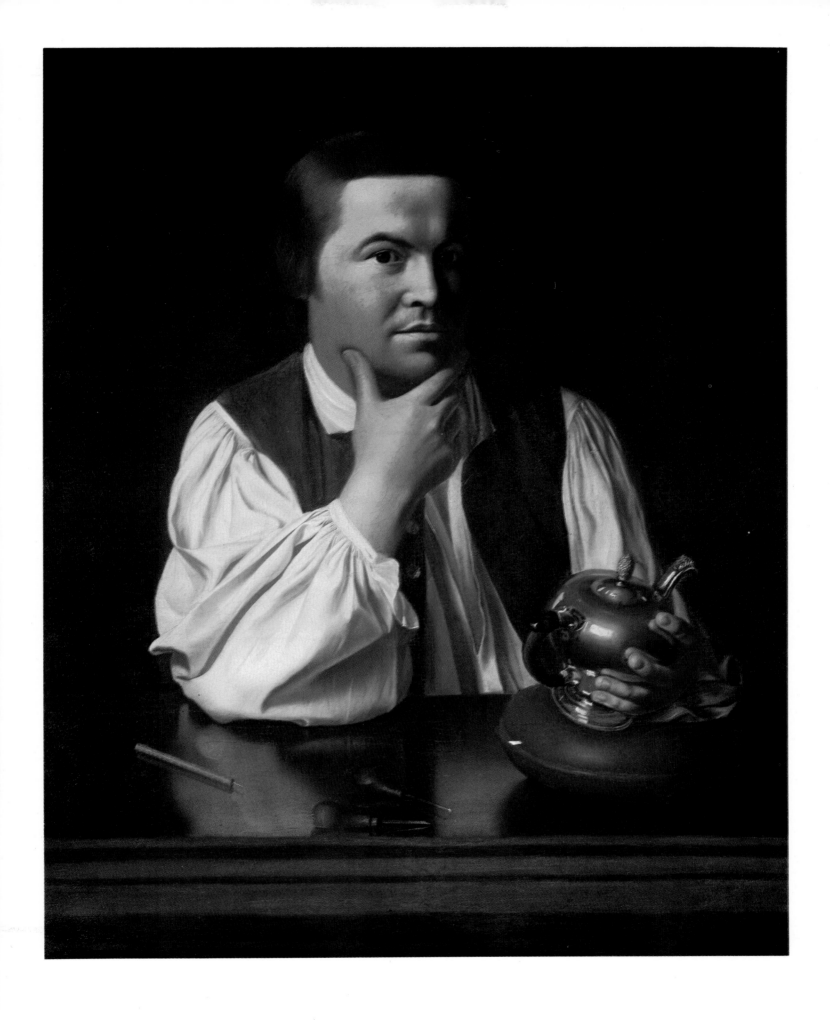

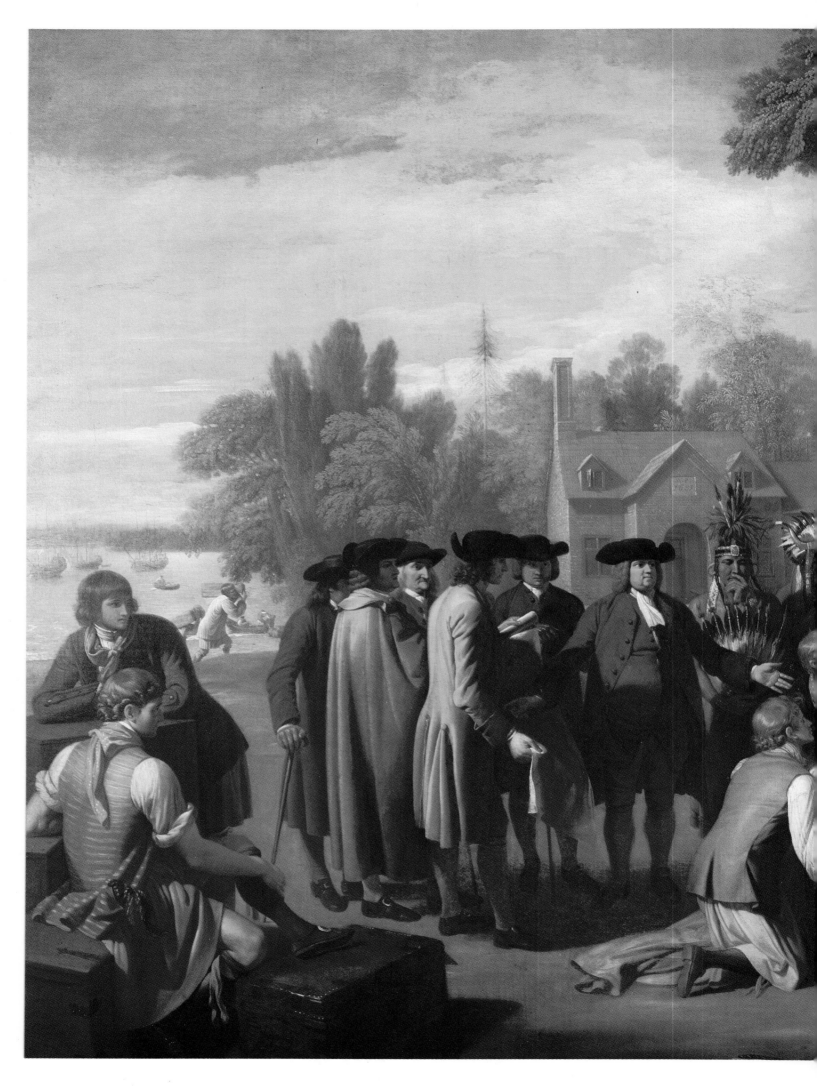

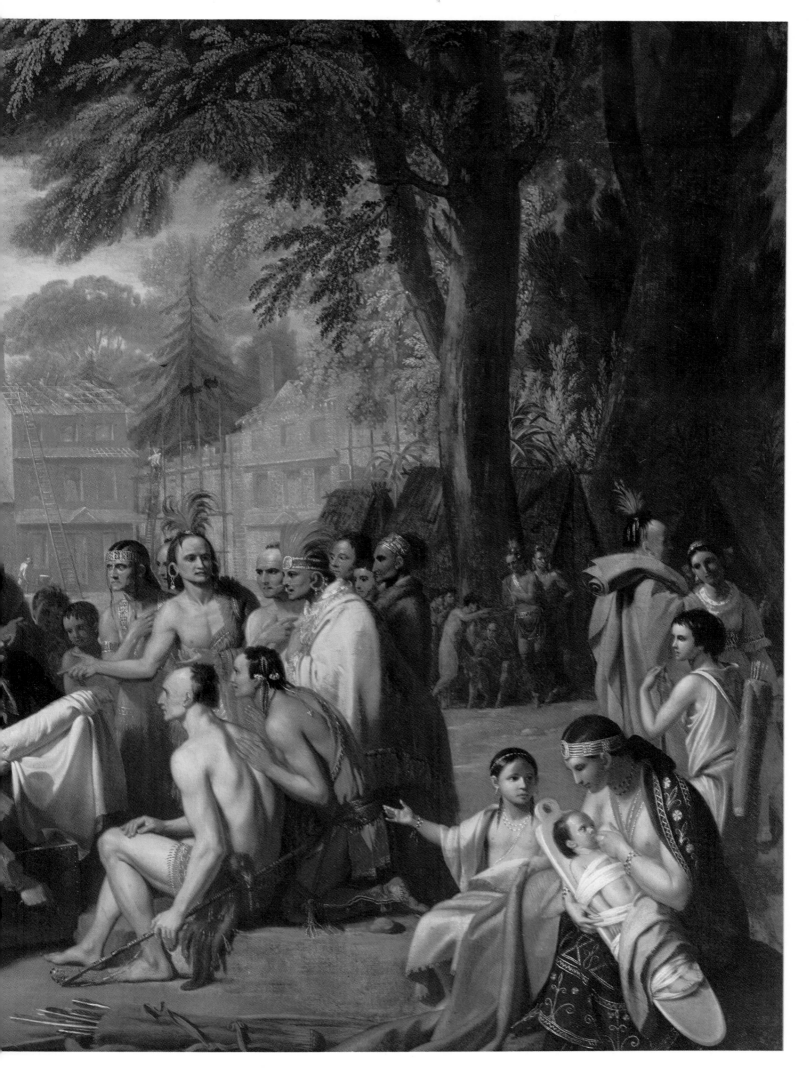

Penn's Treaty with the Indians (1771)
Benjamin West (1738–1820)

The Pennsylvania Academy of Fine Arts, Philadelphia, Pennsylvania

For 11 years, 1769–1780, Sir Joshua Reynolds, President of the Royal Academy, delivered lectures setting down rules of artistic excellence. On his agenda was the painting of history. Reynolds cautioned his audiences, which included the American émigré from Philadelphia, Benjamin West, that they would be less than genius and far from grandeur if they painted petty details. He cited Michelangelo, the 'Homer of Painting,' as the most profound example of a painter of grandeur whose works contained no 'drudgery'—no detail.

West had other ideas. Arriving in England in 1763, a painter of portraits, he soon began to devote himself to the wider field of historical events. His first excursion into detailed historical visualizations was his *Death of General Wolfe* (1770). An ordinary composition, it incorporated expected traditional passive groupings with parenthetical mourning figures seen time and again in Western art. Copley would use the same devices to paint his *The Collapse of the Earl of Chatham in the House of Lords* (1780) ten years later. Unusual, however, was the fact that West had ignored Reynolds' caution. Instead of dressing his figures in the usual classic drapery, he clothed them in appropriate contemporary dress with vivid accuracy. West followed this work with *Penn's Treaty*. Although the event was freely depicted, the attention to detail was not. The overall impact was no loss of grandeur, given the sweep of the 7′ × 10′ oil, but rather a startling visual truth and a convincing first look at America and its history by Europeans. West's fame was instant. The painting became an immediate cornerstone for the future of European and American historical painting and illustration.

Roger Sherman (1775) *Ralph Earl (1751–1801)*

Yale University Art Gallery, New Haven, Connecticut

Until Ralph Earl went to England in 1778 to study with Benjamin West—he did not return until 1785—he was a self-taught painter. That in itself does not sound too singular. However, given the near wilderness of western Massachusetts where Earl was born and raised, there was hardly an example to follow other than an occasional itinerant limner. There were few paintings, if any, for young Earl to look at; no museums; no one knowledgeable in the painter's craft to quiz; no profound painting activity. Ralph Earl carried his interest by himself with the immensity of his ambition and natural ability.

His portrait of Roger Sherman, painted prior to Earl's European sojourn, was a keenly felt image that was underwritten, as it were, by three subjective ingredients: the uneasiness of the American experience on the edge of revolution, the wilderness-seeded simplicity of the painter, and the toughness of the man being painted. Roger Sherman, also born in Massachusetts, was a severe and powerful American patriot who came to Connecticut in 1743, at age twenty-two. There he prospered and became the only American to sign the four most significant national documents: the Articles of Association, the Declaration of Independence, the Articles of Confederation, and the Constitution. He represented Connecticut in Congress as Representative and Senator. But in this portrait Ralph Earl appeared to catch the American character and spirit as it seemed to be embodied in the steely, tough, tense and plain visage of Roger Sherman sitting in an unadorned space on a simple chair. In this painting, man, New England and nationhood were one and the same thing.

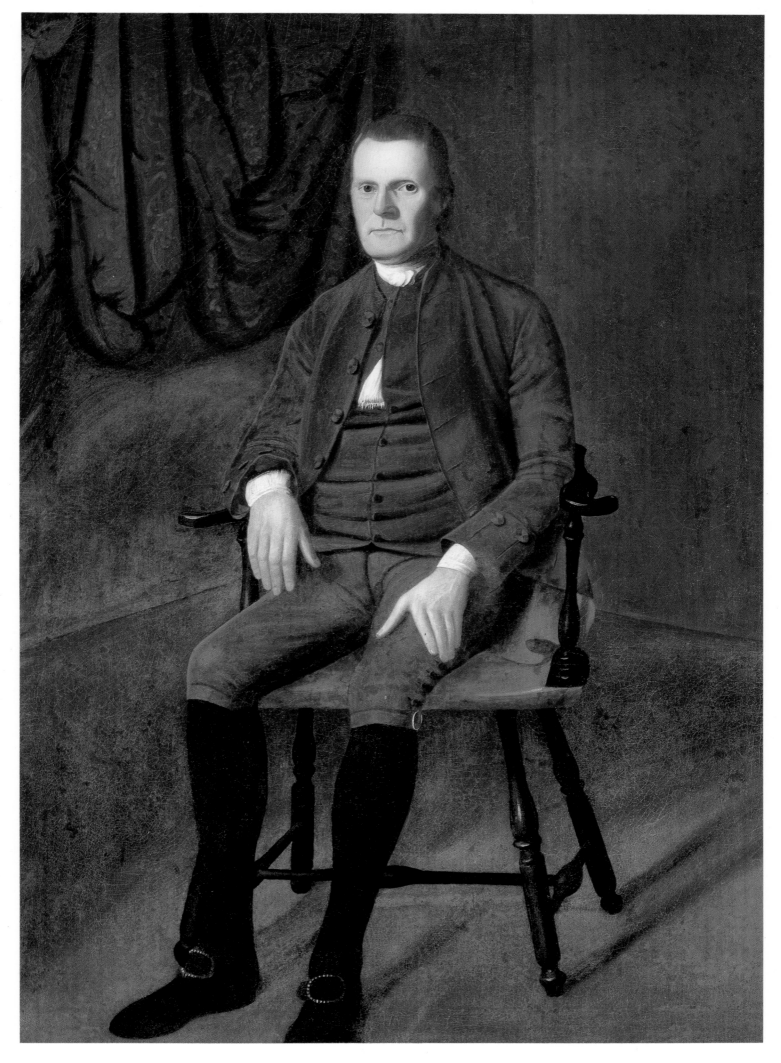

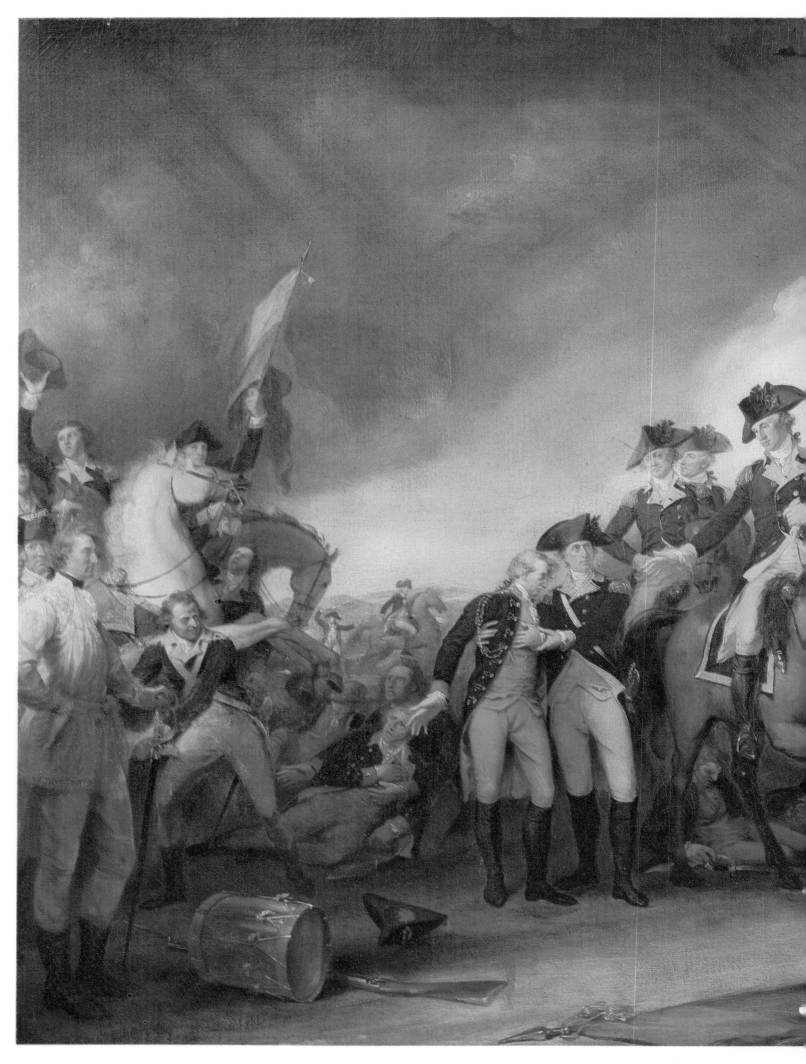

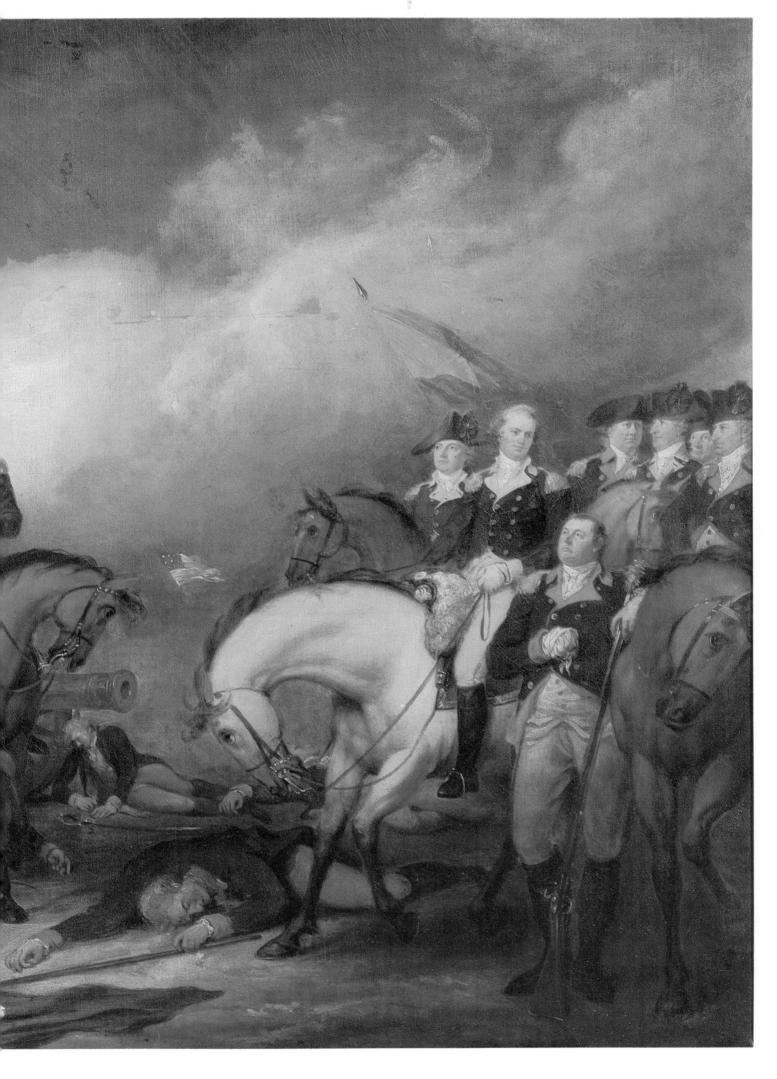

The Capture of the Hessians at Trenton
(1787–1794) *John Trumbull (1756–1843)*

Yale University Art Gallery, New Haven, Connecticut

For five years, 1784–1789, while in London under the spell of Benjamin West, John Trumbull began his labors of recreating on canvas some of the more momentous battle scenes of the War for Independence just concluded. Over a 12-year period, 1786–1798, he completed a dozen of these paintings. Among them was *The Capture of the Hessians at Trenton.* The actual battle had taken place the day after Christmas, 1776. Washington, encamped in Pennsylvania, took his ragtag army across the Delaware River into New Jersey and there surprised and defeated a Hessian force of some 1500.

The Capture of the Hessians at Trenton is a small canvas measuring approximately 20″ × 30″. It conveys an heroic and monumental aspect of a battle not actually seen on the canvas. The battle is finished. The living, the dead, the victors, the losers, the wounded, a toppled drum, a snorting horse and the repetition of uniforms are all frozen together on a horizontal foreground plane. All this seemingly framed by three nearly still flags that 'read' in a clockwise direction from the central fallen flag up the left side across the dynamic diagonal of the fast-scudding clouds to the right side flag and group, and back again. Despite the formality of the groupings, it remains for the diagonal line formed by those background clouds to give the painting its sweep and the event its restlessness.

Staircase Group (1795)
Charles Willson Peale (1741–1827)

The Philadelphia Museum of Art, Pennsylvania

As America, England and France moved from the Age of Enlightenment and Revolution into the Age of Industry and Empire, American painters at home and abroad sensed that the subject areas of art were about to widen. Historical painting had already taken on a more convincing look with less idealized artificiality. Portraiture remained still the best avenue for livelihood and the major effort of the Anglo-American painting 'alliance.' Yet, other than Copley's *Watson and the Shark* (1778), an imaginative approach to a contemporary incident, few painters were willing to break ground and exercise their imaginations. American portraits were, for the most part, skillfully managed and straightforward, rarely appealing to the senses. The best of them offered characterization in handsome technique within the realist tradition to satisfy the no-nonsense demand of their more pragmatic and conservative clientele, most especially the New England establishment.

But that inventive and exuberant spirit, Charles Willson Peale, a consummate portrait painter among other things, broke the mold. With his *Staircase Group*—two of his young sons—he invited the viewer into a capricious space of seemingly measurable dimensions: the painted winding staircase framed by an actual wood step and a doorway. The viewer is instantly trapped and taken into the painting and up the stairs along with the boys. Willson sharpened his 'eye-fooler' with marvelous drawing, details, textures, color, value and the play of light. In so doing he toyed with the senses of the viewer, exchanging the painting's reality for that of the viewer. This was no mere amusement in the guise of a double portrait. It was and is a work of art significantly crafted to unsettle our ideas of reality, illusion and truth.

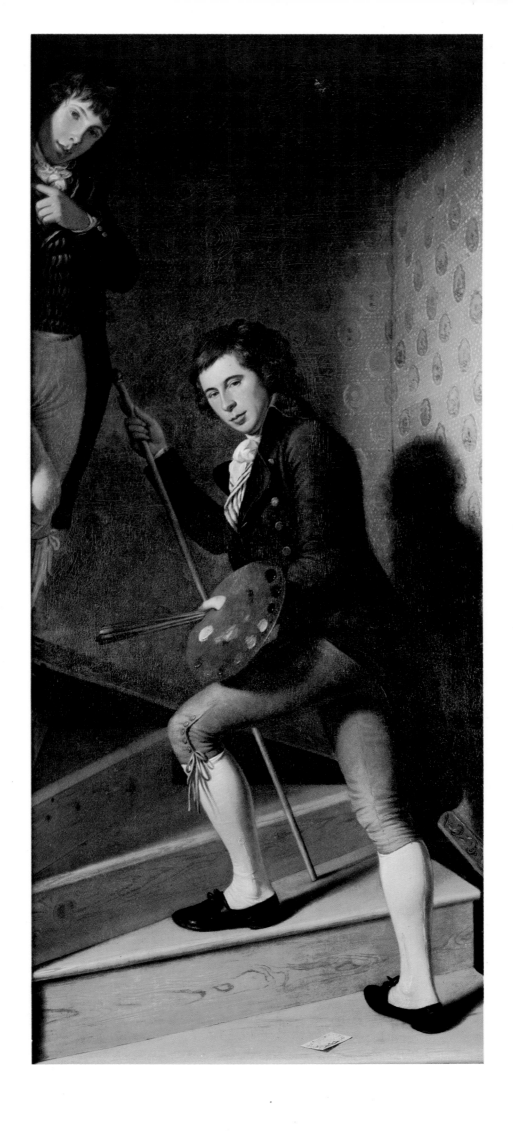

George Washington (1796)
Gilbert Stuart (1755–1828)

The Pennsylvania Academy of Fine Arts, Philadelphia, Pennsylvania

No face is more familiar in all of American history than that of George Washington. His presence on the American scene from Independence in 1776 to his death in 1799 was formidable and overwhelming. History recalls the larger-than-life figures of the men from Massachusetts: the Adamses, Hancock, Warren and others; and those from Virginia and elsewhere: Jefferson, Madison, Henry. But none have been thrust so visually upon the consciousness of Americans as the quiet, unsmiling faces of George Washington painted by Gilbert Stuart.

Both Charles Willson Peale and John Trumbull painted Washington. None of these had the grace, style and fleshiness of a Stuart. There was a softness to Stuart's work that did not exist in the polished drama of a Copley, for example. Yet, that softness yielded both a warmth and spark of life with masterful draftsmanship. The freshness of a Stuart, whether in his portraits of Washington or others, stems from his working method. He literally drew with his brush, blocking in the whole painting with great blurs of color without benefit of a charcoal drawing underneath. Little by little, and with great speed, he kept refining the features until he caught what he wanted. Stuart knew when a painting was finished even if he had not covered the entire canvas with color. His stylish but solid portraits were the rage once he returned from 17 years abroad and set up his studios in Philadelphia and New York in 1792.

But in this portrait of Washington, Stuart elevates a great man to unreachable loftiness with a majesty of bearing that leaves one with a memorable painting, a sense of immortality and history—and a sacred image—an icon for Americans.

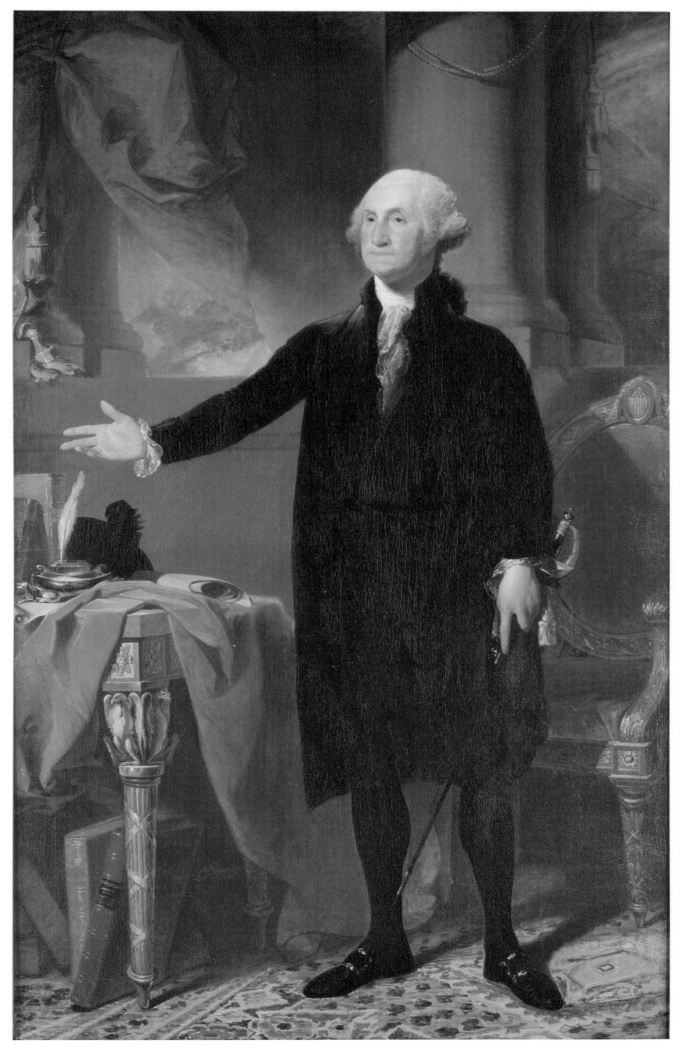

Moonlit Landscape (1819)
Washington Allston (1779–1843)
Museum of Fine Arts, Boston, Massachusetts

Harvard-educated Washington Allston was America's first major romantic painter. He referred to his own works as 'visionary' pictures—paintings that sprang from imagination rather than from people, places and events, and that appealed to viewers with imagination.

Allston gives us a clue to his own thinking when in his *Lectures on Art* he writes:

> They [Tintoretto and Veronese] addressed themselves, not to the senses merely, . . . but . . . to that region of the imagination which is supposed to be under the exclusive dominion of music, to which, by similar excitement they caused to teem with visions that "lap the soul in Elysium." In other words they leave the subject to be made by the spectator, provided he possesses the imaginative faculty; otherwise they will have little more meaning to him than a calico counterpane.

Allston was not interested in outward realities, in duplicating with paint the landscape of America, however majestic. He was a precursor of 20th-century concepts of painting that proclaimed that reality was the painting itself, not something one mirrored on canvas. Benjamin West, whom he knew in London, turned in this direction with his *Death on a Pale Horse* (1817). He was a friend of the great English expressionist Joseph Mallord William Turner (1775–1851) and others who were breaking new ground in the interest of imagination, Samuel Taylor Coleridge, the poet, and Washington Irving, the novelist. Using nature as a springboard, Allston resorted to his own inner visions to create such superb dreamlike paintings as the *Moonlit Landscape*, a disquieting vision that exists nowhere but in Allston's mind.

(Page 48)

The Old House of Representatives (1822)
Samuel Finley Breese Morse (1791–1872)
The Corcoran Gallery of Art, Washington, DC

Most of the civilized world remembers Samuel F B Morse as the inventor of the telegraph and the code that bears his name. Fewer link him with the world of art to which he first aspired. Educated at Yale, Morse yearned to create monumental historical paintings in the service of America. Toward this end he went to England in 1811—to Benjamin West—to learn how. After a number of rejections, he was finally admitted to the Royal Academy to study. He promptly won several prizes and returned home in 1815 to pursue, unenthusiastically, the career of a portrait painter, in which he prospered. In 1826 he founded the National Academy of Design and became its first president. Six years later, however, he gave up painting when he was refused a commission to decorate the Rotunda of the US Capitol. In 1832, at age 41, he turned to telegraphy.

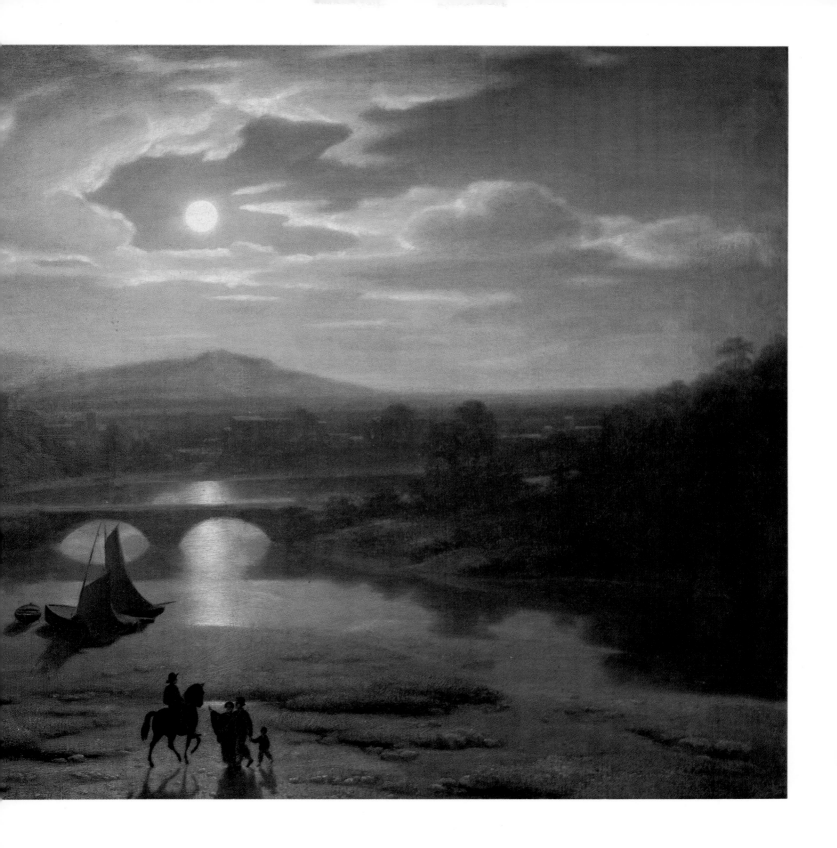

Two of his paintings are of considerable significance. One is his portrait of the aging *Marquis de Lafayette* (1826), as graceful, symbolic and monumental a portrait as ever painted by an American. The other, seen here, is *The Old House of Representatives*. In the latter, Morse fixes an historic scene and place in the warm glow of candlelight with brilliant accuracy, including the portraits of 86 Congressmen in attendance. Juxtaposing the large dimension of the building against the small scale of the figures, Morse created a soaring architectural interior of immense dimensions (the canvas itself measures about 7′×12′). Here, on a limited flat surface, Morse not only immortalized an historic American site but filled its huge space with the imagined murmur of voices that seem to move along the great horizontal and vertical curves of the painting.

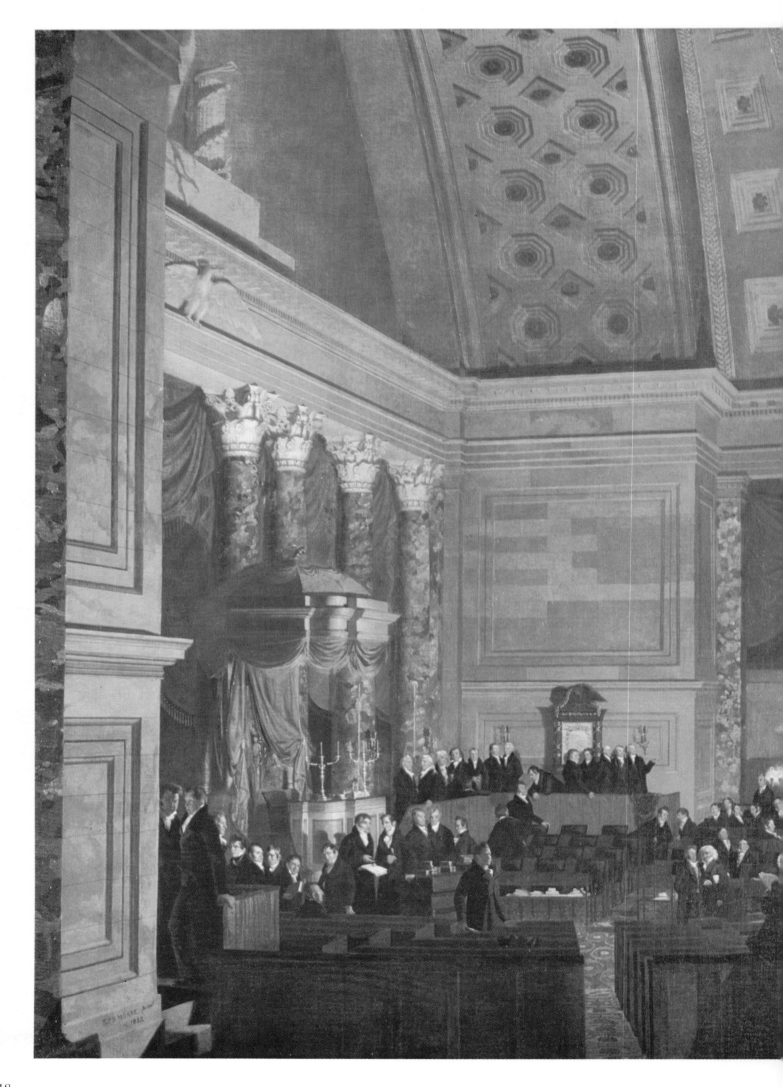

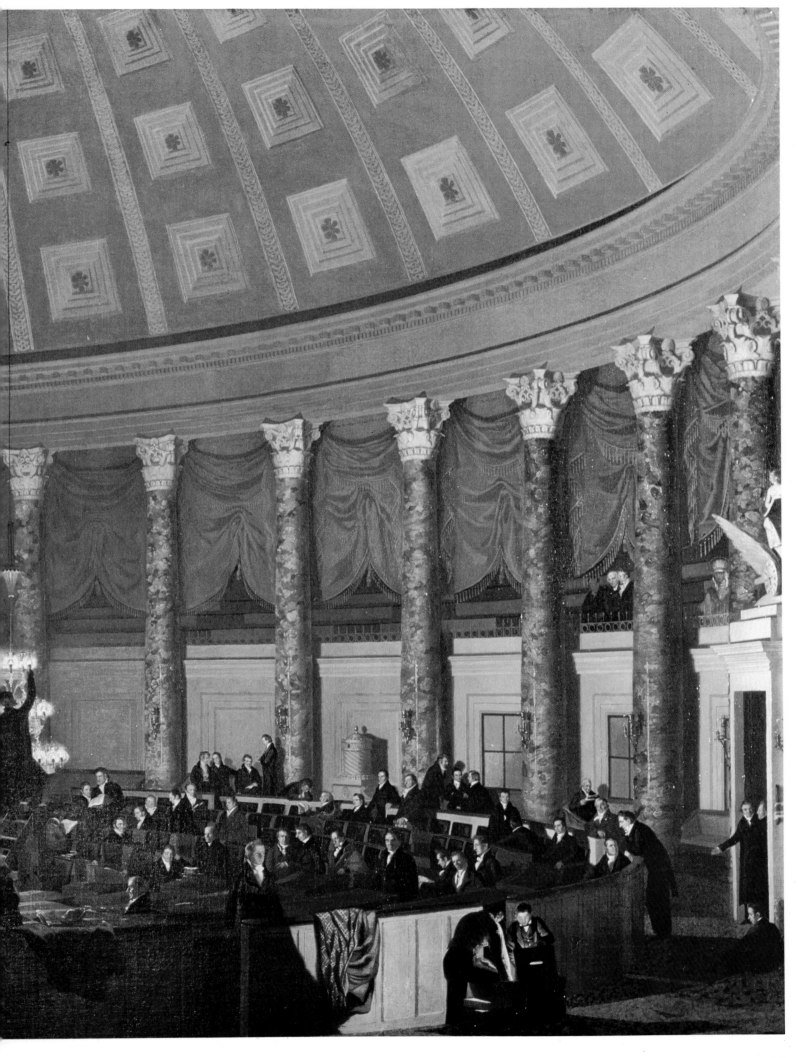

49

After the Bath (1823) *Raphaelle Peale (1774–1825)*

The Nelson-Atkins Museum of Art, Kansas City, Missouri

Raphaelle Peale, an accomplished painter of portraits and still lifes, was a younger son of Charles Willson Peale. Like most of his contemporaries —that is to say, painters—he toyed with the idea of painted nudity but rarely faced up to it. John Vanderlyn (1776–1852), a painter of considerable ability who spent a great deal of time in Europe, also toyed with the idea as he reached for realms beyond mundane portraiture. Vanderlyn had painted a number of subjects for which he received little patronage, recognition or even encouragement. In fact, his reach for uncertain esthetic regions led him straight to abject poverty. Among his works was *Ariadne Asleep on the Island of Naxos* (1812), a female reclining nude precisely drafted and exquisitely painted in the European manner in Europe. When seen two years later in Philadelphia, 'Ariadne' caused an uproar—'painted indecency!' cried the Town Fathers and Mothers.

Nine years later Raphaelle Peale purposefully outwitted society's moral policemen with his painted joke *After the Bath*. With hypnotic skill he painted a sheet behind which could be seen only the unadorned arms and feet of a girl. By implication, Peale firmly planted a completely nude female figure in the minds of everyone who looked at the painting and tried futilely to look through or beyond the sheet. Peale's rendering of the sheet was the equal of anything offered by the acknowledged masters of still life realism, the 17th-century Dutch. But in the end, it is the simplicity of the concept, its profound craftsmanship and sense of humor, that combine to place it among the more memorable American images.

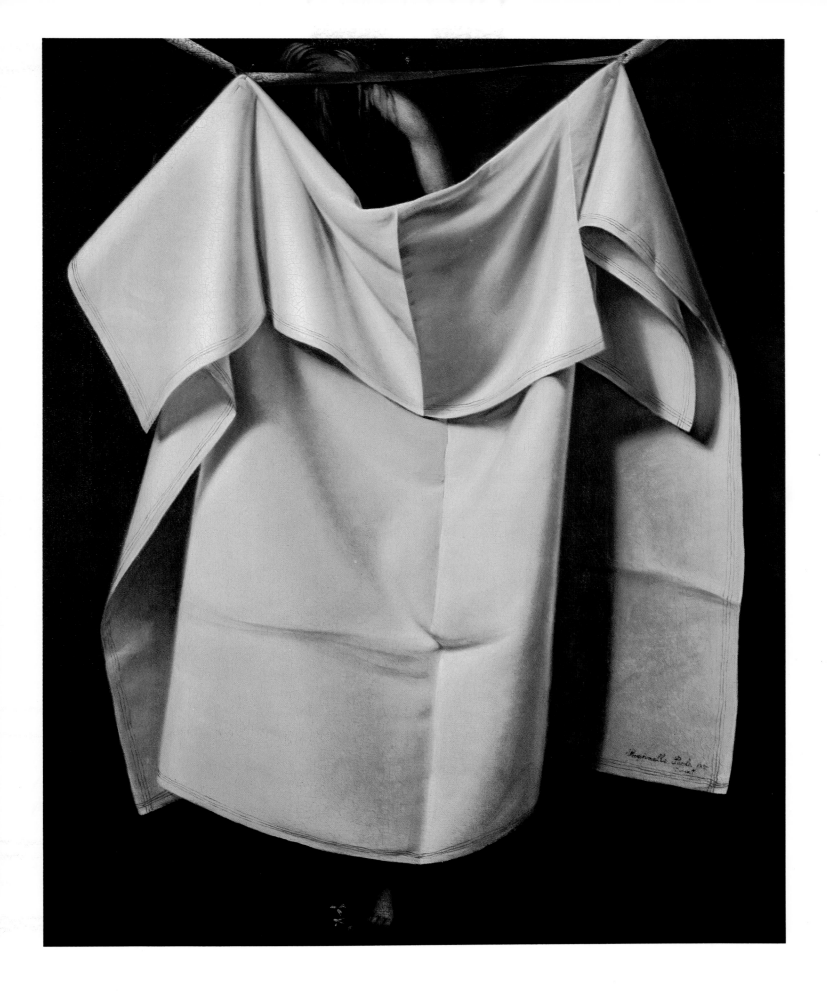

Bird's Eye View of the Mandan Village, 1800 Miles Above St Louis (1837) *George Catlin (1796–1872)*

National Museum of American Art, The Smithsonian Institution, Washington, DC

Pennsylvania-born George Catlin was 33 years old in 1829 when he saw his first American Indians. And these he saw in Philadelphia, not in the Western wilderness. A one-time lawyer, now a self-taught portrait painter, Catlin was moved by the sight of so native and yet so alien a culture that in his mind was doomed as a civilization on the American continent. He decided to devote the rest of his life to painting the life and times of the Indians before they became extinct. Catlin set out for the West in 1832, where he remained for eight years, painting more than 500 oils: Indian portraits, ceremonies, activities, villages, and in short, everything that mattered in recording the 'manners, customs, and conditions of the North American Indians.' Catlin established an 'Indian Gallery' which consisted of his art collection, a troupe of Indians and a wigwam or two. These he took to Europe on a Grand Tour. Catlin later traveled in Central and South America. He offered all of his art to the Smithsonian Institution, where it was housed seven years after his death.

Catlin succeeded—as in his *Mandan Village*—in recording with flavor and accuracy a way of life that did indeed disappear. Without his strong project commitment, we would know little of the life of the American Indians of the Great Plains circa 1832–1840. Catlin's sharply mannered approach offered a great sense of the Indians' natural environment and the very atmosphere of their existence. More than that, Catlin's fastidious craft and stylization was entirely appropriate in expressively communicating the look and life of the American Indian.

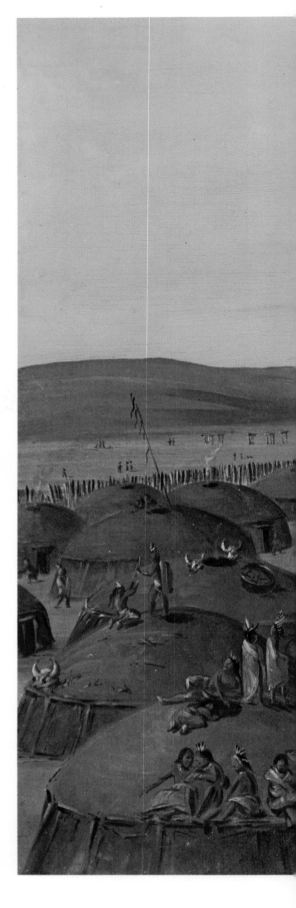

(Page 54)

The Oxbow (1836) *Thomas Cole (1801–1848)*

The Metropolitan Museum of Art, New York, New York

'If the imagination is shackled, and nothing is described but what we see, seldom will anything truly great be produced in painting. . . . But a departure from nature is not a necessary consequence in the painting of compositions,' so said Thomas Cole in a letter to Robert Gilmor on 25 December 1825.

Thomas Cole, who emigrated from England to the United States as a teenager, and who later helped found the Hudson River School of Landscape Painting, states clearly and simply his entire artistic premise. Along with Thomas Doughty (1793–1856) and Asher B Durand, Cole was among those early painters so transfixed by the grandeur of the Hudson River Valley from Albany to New York City, and so inspired by the literature of the region (for example, Washington Irving), that he devoted his short life to pure landscape and allegories that leaned on landscape.

While settling in the Catskills, Cole had traveled to Europe to see the Old Masters, including such Romantic landscapists as France's Nicolas Poussin (1594–1665). He was unimpressed, although influenced by the likes of a Poussin. For Cole and other pioneer landscapists, figure compositions and portraits merely reflected the varying corruptness of

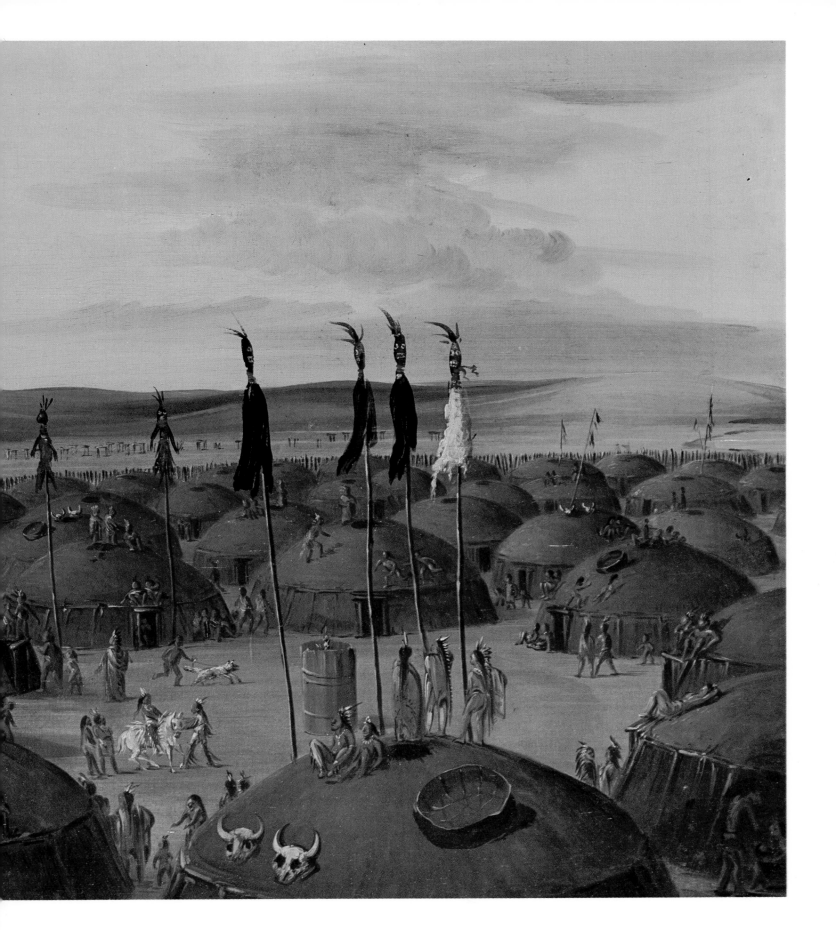

changing civilizations. They insisted that the future belonged to those who put clear and beautiful thoughts into their pictures. To Cole, landscape had symbolic significance since it represented unspoiled, pure and truthful nature, from which could only rise uncorrupted expression. Cole implied all this in his majestic painting of *The Oxbow*, a meander in the Connecticut River Valley near Northampton, Massachusetts.

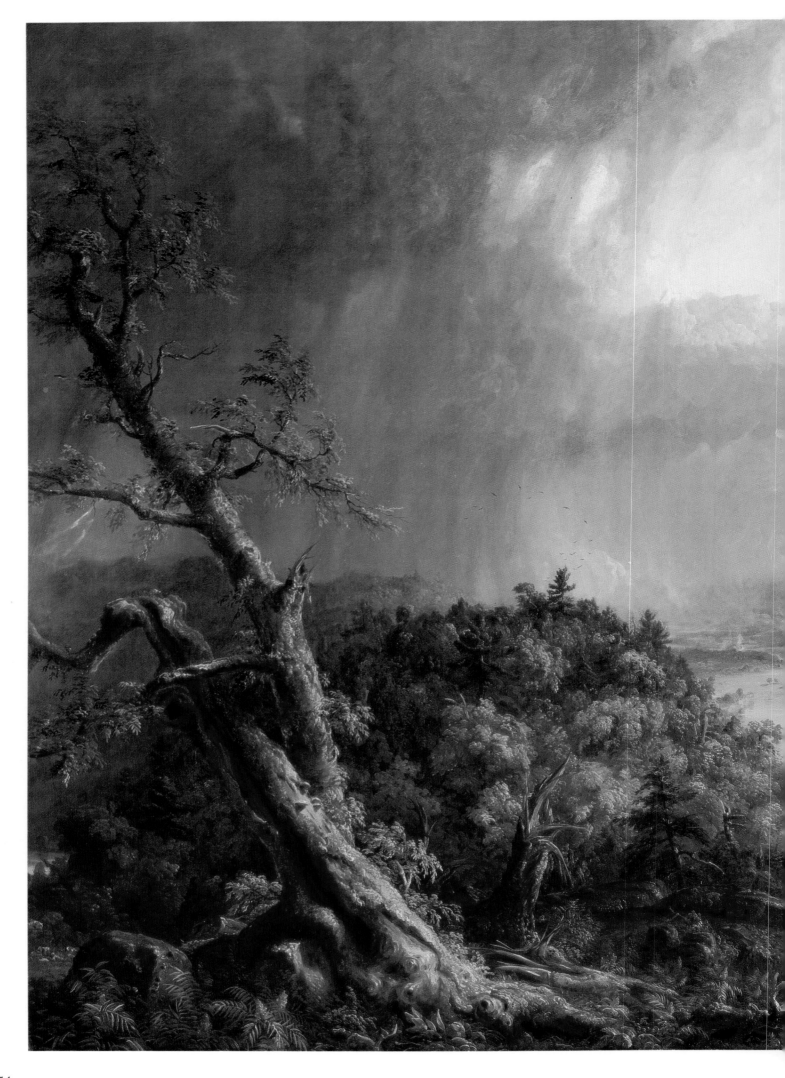

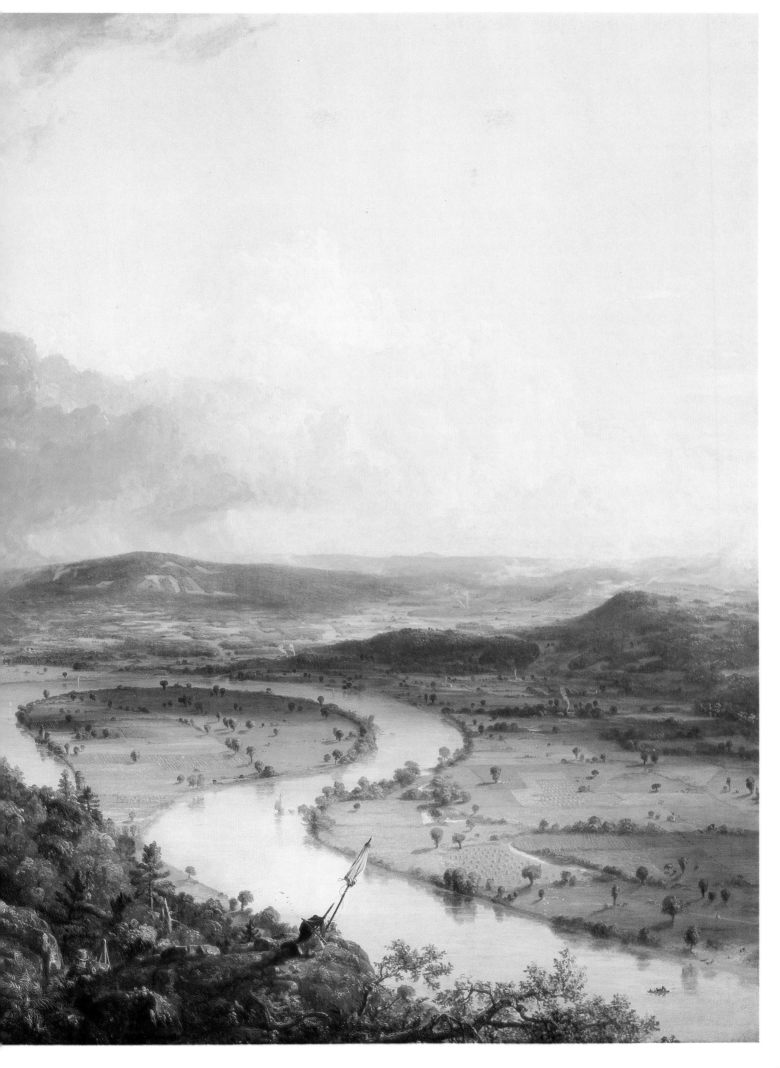

Fur Traders Descending the Missouri (1845)
George Caleb Bingham (1808–1879)

The Metropolitan Museum of Art, New York, New York

To George Caleb Bingham, Art was an imitation of Life. 'The ideal in art,' he would lecture, 'is but the impressions made upon the mind of the artist by the beautiful . . . in external nature, and that our Art power is the ability to receive and retain these impressions so clearly as to be able to duplicate them upon our canvas.'

Whether Bingham was nearer the truth of art than other painters is moot. Too many artists of his own time and throughout history would have difficulty with that thesis. What matters is that Bingham pursued his ideal on canvas and succeeded in expressing a natural environment so vast that it spilled beyond the limits of his canvas in the mind of the viewer.

Bingham was a highly trained (Pennsylvania Academy), well-traveled and educated painter. He served in the Union Army during the Civil War and dabbled in Missouri politics all his life. He was a genre painter who committed his brush to everyday life on the Missouri River. And he offered his ideas on art as Professor of Art at the University of Missouri. In his 'Fur Traders' he presents a brilliant example of an artist's absolute control over his ideals, subject and tools—an example where Bingham's art served his intellect without reservation. In this everyday scene, he not only managed to express the slow flow of the river, men and boat by the obvious horizontality and simplicity of subject, he actually slows it all up even further by the vertical counter-pointings (as in the cat and paddle) and their watery reflections; and by moving the subject in a right to left direction while we view the art from left to right, our natural reading habit—especially of horizontal matter such as letters and words. In such a fixed geometry, Bingham envelops his canvas in an atmosphere of tonal laziness and communicates eternal drift.

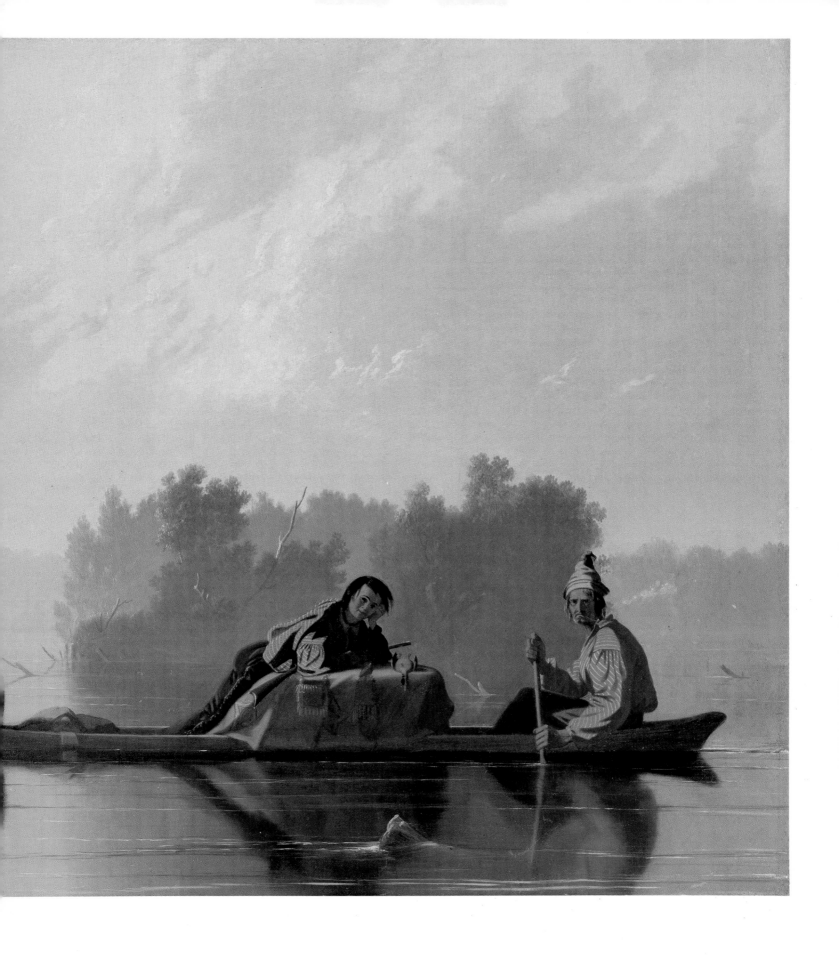

War News from Mexico (1848)
Richard Caton Woodville (1825–1856)

National Academy of Design, New York, New York

American genre painting during the mid-nineteenth century and beyond was not merely the re-creation on canvas of every day, matter-of-fact activities with which most ordinary people could identify. Such paintings were usually injected with a sense of well-being, humor and a sunny disposition, hardly offensive to anyone.

Richard Caton Woodville belonged to those who had an eye for the ordinary. His too few paintings were remarkable expressions of the commonplace, wonderfully executed, near-faultless in their arrangements. They overflowed with American characters and details that in toto infused his art with a memorable personality of the matter-of-fact. Among these paintings are *The Sailor's Wedding* (1852), and *War News from Mexico* seen here.

Woodville's mastery of light, space and the forms within it, together with his control of clearly painted minutiae—an echo of the 17th-century 'Little Dutchmen'—all in the interest of scene and design; his ability to centralize his idea by the patterns of his figure arrangements put him far beyond the mediocrity of his subject matter.

Unfortunately, Woodville's body of work was slim. He had spent little time in America painting. Instead, he left as a newlywed in 1845—aged 20—and never returned, preferring to study and paint in Düsseldorf, Paris and London, shipping his canvasses home. The scion of a wealthy Baltimore family, Woodville had few financial problems. Yet all was not serene and sunny. He died in London of a drug overdose in 1856—at age 31.

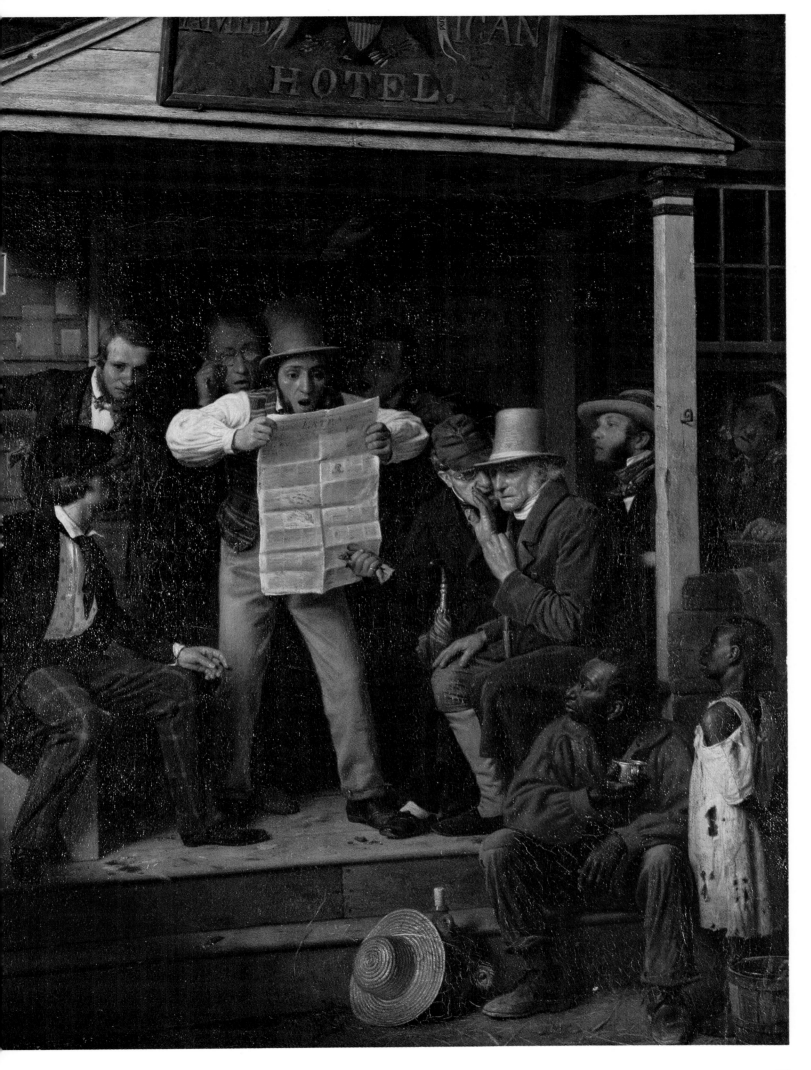

Kindred Spirits (1849)
Asher Brown Durand (1796–1886)

The New York Public Library, New York

Asher B Durand, another founder of the Hudson River School of Landscape Painting, began his professional life as an engraver. He gave it up to paint portraits. Eventually, he gave up portraiture for the landscape, this after copying Old Masters in Europe. But Durand never softened his fastidious attention to detail and the careful rendering that marked him early on as a successful engraver.

Awe-struck by the magnificence of the Hudson Valley environment, Durand sought out scenes there and rendered them relentlessly without changing so much as a blade of grass. Unlike Cole and other romantics who rearranged nature to suit their own fancies, Durand believed that the very existence of nature was all the truth necessary. No one need tamper with that. Yet, however much Durand thought he duplicated nature as it existed, he did adjust his values and modulate his color—if not the anatomy of the flora and fauna—to create infinities of vistas that seemingly moved back into the picture plane forever. In *Kindred Spirits*, Durand carefully selected an area in the Catskill Mountains of New York that expressed the American wilderness at mid-century as he conceived it to be, and he painted it with the same expressive monumentality that did indeed exist in that environment.

Interesting, too, was the fact that Durand was the first of his breed to paint outdoors, on-the-spot, as it were. How else, he insisted, could one ever paint nature's truth? In that respect, Durand offered an idea that would bear fruit with French landscapists—the later Pleinairistes—Jules Bastien-LePage (1848–1884) and Edouard Manet (1832–1883).

The Banjo Player (*c* 1855)
William Sidney Mount (1807–1868)

The Detroit Institute of Fine Arts, Michigan

If a parallel could be drawn between a cheerfully disposed author and a cheerfully disposed painter, the genial Messrs Washington Irving and William Sidney Mount would emerge. Mount did not believe in pandering to the artistic whims of the few. Instead, he aimed his art at the multitude. 'Paint pictures that will take with the public,' he exclaimed. He followed his own advice and take with the public they did—sunny genre paintings of life on Long Island where he was born and lived. Mount was a consummate craftsman whose expert and lively drawing belied the frozen pleasantries of his paintings of storytelling around a wood-burning stove, people dancing or strumming musical instruments as in *The Banjo Player*.

There seemed to be a double edge to Mount's art, however: the portrayal of people pursuing some ordinary rural activity and the conscious principled construction of a painted composition. In the painting of people, Mount seemed to have kept his distance—an onlooker rather than a warm friend. Mount enjoyed the clinical study of every subtle aspect of people engaged in some activity—how they stood, sat or reclined to do whatever it was they did: drink, sleep, fish, fiddle etc. Still, there was something objective in Mount's intent, as if he were bent on leaving a record of appearances of his Long Island neighbors rather than their significance. Nevertheless, Mount's unmoving scenes were crafted with great clarity and skill. Where it concerned the latter, Mount was an able designer whose interest in the pure constructional system of his composition was uppermost in his mind. So meticulous a craftsman was he that every part of the painting was interrelated. No small part could be altered, moved or removed without the process affecting the rest of the composition. Moreover, as in *The Banjo Player*, Mount understood form and volume and never stereotyped his subject to conform to a general public attitude.

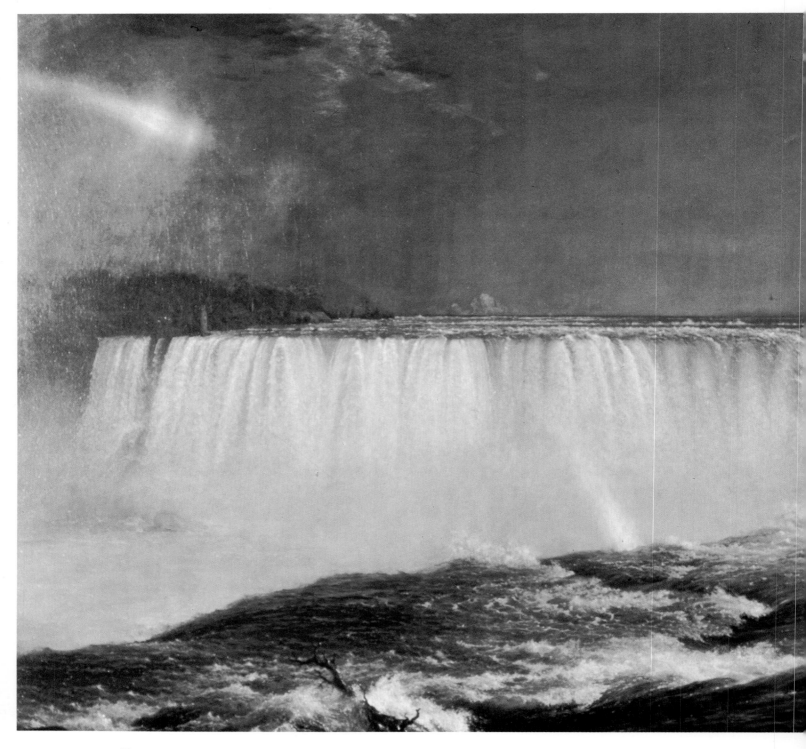

Niagara Falls (1857)
Frederick Edwin Church (1826–1900)

The Corcoran Gallery of Art, Washington, DC

At mid-19th century Frederick Edwin Church was hailed as America's best painter. His canvases of spectacular panoramas on four continents appealed to both a reach for the colossal and the uncompromising realism of 19th-century American taste. Underlying this, too, was the American yen for the wilderness.

Born in Hartford, Connecticut, Church spent his student years with Thomas Cole, painting the Catskill Mountains. But restless Church soon found the Catskills not wide enough for either his vision or his canvas. At age 27, in 1853, Church began to wander the globe painting the Andes Mountains in South America, icebergs in Labrador, and various vistas in Europe and the Near East. In between trips he painted great natural geologic sites like Niagara Falls. All this he did with such

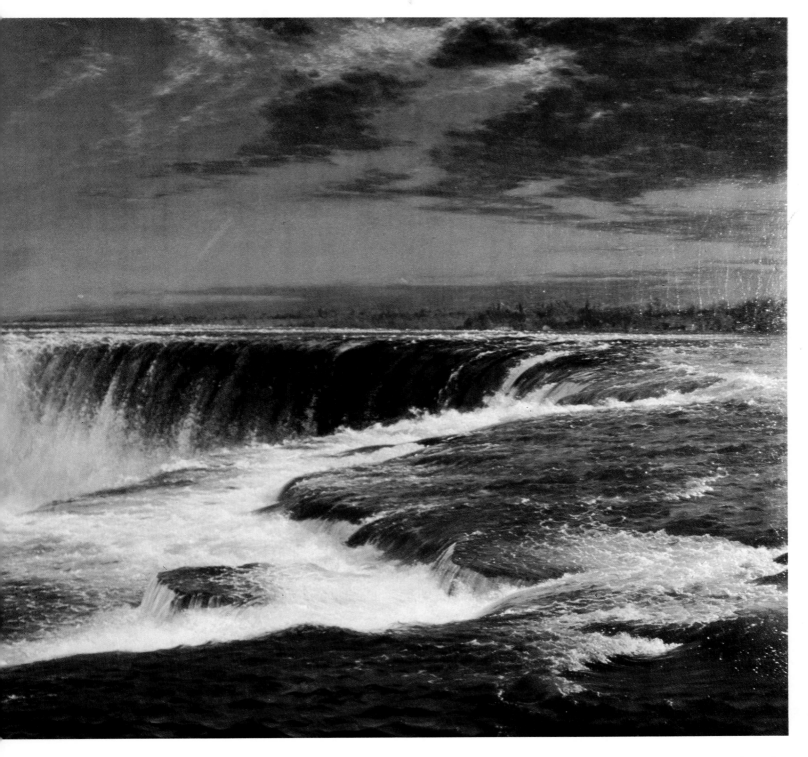

remarkable luminosity, atmosphere, form and detailed realism that the viewer was almost immediately delivered inside the realm of the painting's grandeur and experience. Moreover, Church was a master of the communication of massive scale, regardless of the physical size of his canvas. The credibility of the splendor of Church's depictions was never in doubt.

Niagara Falls was typical of Church canvases that showed little regard for civilization. Usually, Church refrained from depicting any sign of Man in his art. To him, Man's appearance spoiled the natural untamed magnificence of the world's topography. In *Niagara Falls* the water serves to envelop the onlooker in nature's scale which looms colossal on the canvas. The scene becomes a symbol of the unconquerable power of nature over Man. With this Church achieves the painted presence of monumentality.

Owl's Head, Penobscot Bay, Maine (1862)
Fitz Hugh Lane (1804–1865)

Museum of Fine Arts, Boston, Massachusetts

Until the mid-19th century, American landscape painters were content to create sun-splashed scenic warmth. It was as if the country, not yet 100 years independent, were bathed in perpetual summer: such was the optimism that permeated the land. But along came the naturalists and the more scientific realists—like Church and others—who offered oils for every season. By the 1860s some of the 'sunshine' canvases had yielded to the frozen horror of icebergs, cool autumnal tones and ice-bound ships frozen in New England ports. A coolness had entered the palettes of American landscapists that seemed to parallel the shiver that ran through the country over the issue of slavery and the trauma of the Civil War.

Fitz Hugh Lane was Gloucester (Massachusetts) born and a New England man to the depths of his soul. There was a sense of thrift and dryness to his art that reflected a New Englander's penchant for essentialities. Lane's interests, true to 'down east' form, were the sea, the shoreline and ships properly rigged. There was nothing sophisticated in his view of New England water and the immensity of the sky that enveloped it. Yet, in 'Owl's Head,' there is an elegance to the canvas brought on by Lane's sharp simplicity. Here, Lane's quiet vision is evoked by a cool palette, by a low horizontality accentuated by the lapping water that softly rolls inland from one end of the painting to the other, and by the silhouetted foreground that serves to anchor the painting solidly to its low base. Occasionally, Lane pierces his calm with a small-scale figure, some ships and a red marker. But it is the luminous, changing sky that so prominently fixes all of the painting's parts in a glow of light that sets a memorable mood.

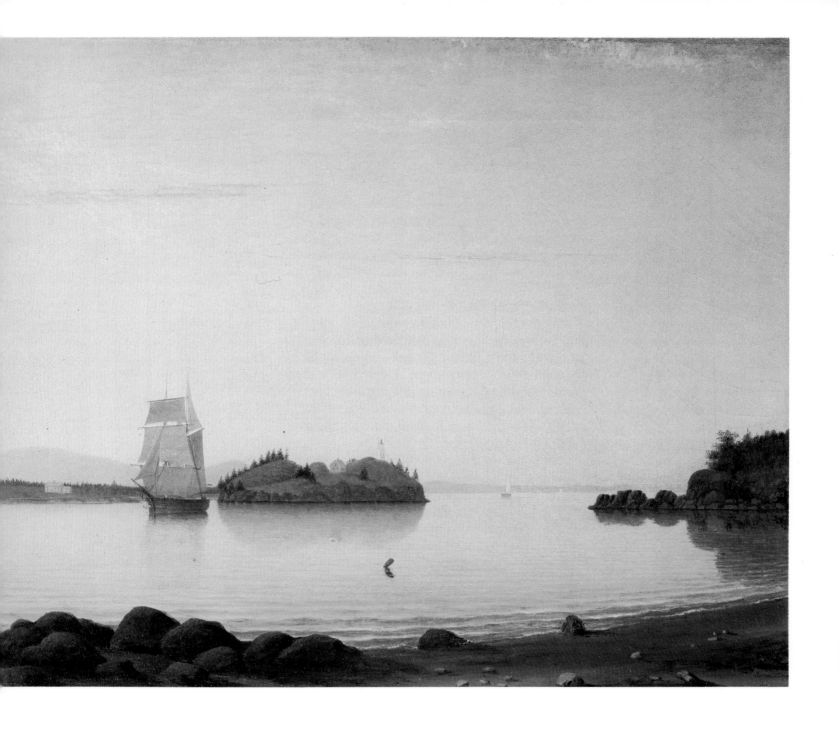

Old Battersea Bridge (1865)
James Abbott McNeill Whistler (1834–1903)

The Tate Gallery, London

In the same decade that Frederick Edwin Church was painting the realities of geology with the grandeur of creation, and others were perfecting their publicly approved story-telling canvases, James A M Whistler was startling the cognoscenti with his unacceptable ideas about painting and art.

'A picture [is] a picture apart from any story which it may be supposed to tell,' he wrote. 'As music is the poetry of sound, so is painting the poetry of sight and the subject matter has nothing to do with harmony of sound or of color.'

A native of Lowell, Massachusetts, Whistler had fired the first salvo on behalf of a new perception of art. Whistler's nonconformity or 'eccentricity' was not new for him. It was seeded by his military origins, a heritage that had placed him in the United States Military Academy at West Point in 1851. His poor academic performance earned him a dismissal three years later. Whistler promptly expatriated himself first to Paris and later to London where he crossed swords with the art establishment including the formidable critic John Ruskin who accused Whistler of 'flinging a pot of paint in the public's face.'

Old Battersea Bridge, also called *Nocturne in Blue and Gold*, is an especially strong example of Whistler's use of subject matter to communicate a visual experience removed from the subject, an experience related to the color and its connection to the general silhouette of the design. The painting is among the very early works in Western art to fall under the spell of Oriental art. This is most evident in the compositional nature of the work, in the patterns created by the bridge and its environs. Whistler had become interested in Oriental graphics. It was the beginning of modern art and its internationalization.

Prisoners from the Front (1866)
Winslow Homer (1836–1910)

The Metropolitan Museum of Art, New York, New York

Winslow Homer, Boston born and New York trained (National Academy of Design), was the master artist of three distinctly different areas of visual expression: illustration—he worked for *Harper's Weekly* and other magazines between 1858–1876, a period of eighteen years; genre—of ordinary life as it was lived out of doors; marinescapes—the sea in all its aspects.

When *Harper's Weekly* sent Homer to join the Army of the Potomac in 1861, then under the command of General George McClellan, it was expected that he would send back visual reports (drawings and sketches) of life among the troops as they went about their business of fighting a Civil War. Whatever the expectations, most of the 'war' art—and there was not that much of it—dealt with the more peaceful pursuits of camp life rather than with death, the agony of battle and the general trauma of war and its dislocations. Rarely did an artist-correspondent provide any insight into the character of the men under arms. Homer sent back his drawings and to a great extent elevated the war genre above the mundane, above the vacuities of army life.

Prisoners from the Front, an oil which was executed from such sketches after the war had ended, is one of the most quietly penetrating looks at dishevelment, humiliation, defiance and indifference on a battlefield. Homer not only distinguishes vanquished and victor by character and degrees of shabbiness, he accentuates the prisoners' misfortune in the gray browns of a drab palette and heightens the indifference of Union Colonel Francis C M Barlow with the sharpness of his neat blue uniform seen against the lighter blue of the sky.

Thunderstorm Over Narragansett Bay (1868)
Martin Johnson Heade (1819–1904)

Amon Carter Museum, Fort Worth, Texas

Like most painters of his era, Pennsylvanian Martin Johnson Heade began his professional life as a portrait painter. Later he studied in Italy for several years before embarking on a South American adventure to paint Brazilian hummingbirds for a projected book about those animals.

Heade was one of those daring painters—a romantic—who allowed the accuracy of his rendered shapes and forms to be caught up in the atmosphere indigenous to the life he was painting. For example, Heade was not content to paint hummingbirds fluttering around a specific species of orchid. He went beyond the more pedestrian rendition and evoked the heat and dampness of the rain forest or the cool, dry air of the mountainside. And this he did with brilliant definition of space and air and distance without losing the bright clarity of the prime subject, whether hummingbird or orchid.

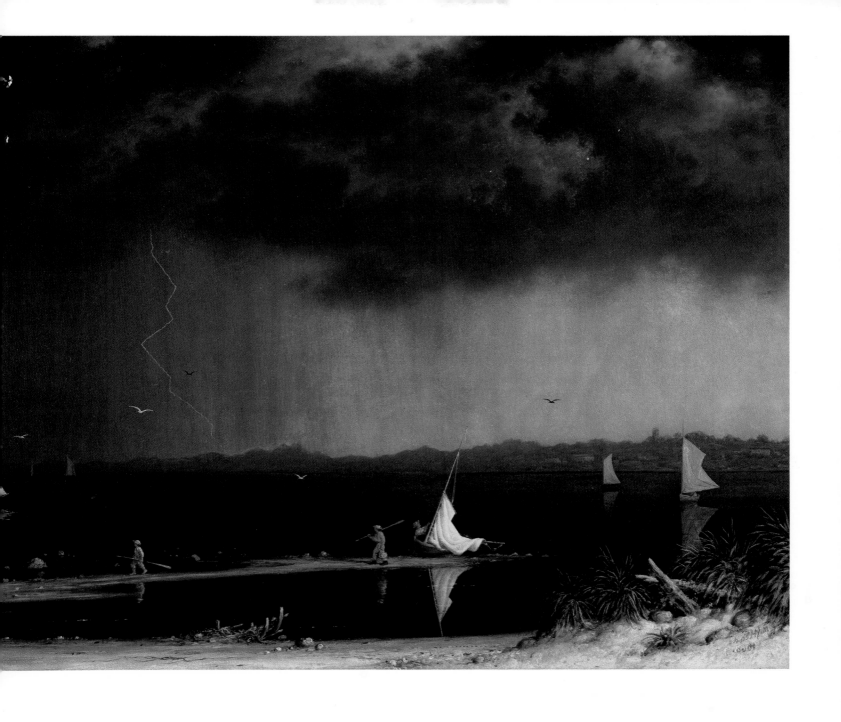

Heade's feeling for atmosphere achieves a spectacular image in his *Thunderstorm Over Narragansett Bay*. Strangely enough, the painting, which measures about $2\frac{1}{2}' \times 4\frac{1}{2}'$, was once titled *Storm Approaching Larchmont Bay*. Whatever, it made little difference over which bay the event was happening. What leaps out at the viewer is a work of great dramatic impact. The white sails contrasted against the dark and ominous greens of the background are startling. Interesting, too, is the sharp focus of the foreground and middleground below the painting's horizontal center and the not so sharp focus of the same picture planes in the sky—above that center line. The contrast of the two causes an earthbound stillness and an awesome movement in the sky, the very storm itself.

The Sierra Nevada in California (1868)
Albert Bierstadt (1830–1902)

National Museum of American Art, The Smithsonian Institution, Washington, DC

Among the able landscapists who were thunderstruck by the huge and endless scenery of the American West was Albert Bierstadt. Responding to the immensity of the scale, the spectacular vistas of the Sierra and Rocky Mountains, Bierstadt created huge canvases.

Bierstadt, a German immigrant, came to New Bedford, Massachusetts, as an infant. He returned to Düsseldorf, Germany in his 20s to study painting. Eventually, he moved around Europe before returning to the United States in 1857. A year later he became a member of an expedition exploring vast tracts of unknown territory in the American West. The Gold Rush had come and gone, but America's fascination with its untamed West was just beginning. Soon the Transcontinental Railroad would open the western reaches of the continent to the onrush of civilization. On this and subsequent trips, Bierstadt photographed and sketched the region. These sketches he used as reference to create his huge canvases in a New York studio. There, in New York, in the East, Bierstadt's art was greeted with admiration and wide popularity. In Europe, he was decorated by royalty for his efforts.

Bierstadt's response to large-scale landscape with large-scale canvases seemed esthetically logical enough. In such works as 'The Sierra,' seen here, he was able to increase the illusion of enormity by small-scale rendering of every subject on the canvas, however large or detailed. The contrast between sharply rendered detail and a huge canvas heightened the illusion of large scale. More than any other painter, Albert Bierstadt brought the West back East with style and grandeur satisfying a reach for 'bigness' that touched the nerve center of American ambition.

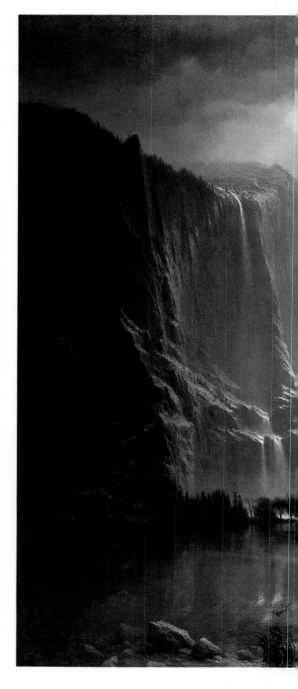

(Page 77)

Max Schmitt in a Single Scull (1871)
Thomas Eakins (1844–1916)

The Metropolitan Museum of Art, New York, New York

Few American painters of the late nineteenth century were as artistically educated, esthetically perceptive and analytical—or as stubbornly committed to a definition of high art—as the well-trained Philadelphian, Thomas Eakins. A student of everything pertinent to art—chiefly human anatomy—Eakins used his brilliant intellect and skill in the interest of thoughtful expression. If he studied the anatomy of a rope down to the last strand, it was not to duplicate the rope in a painted mirror vision to demonstrate the visual mechanics of painted realism. It was to express, in some way, the nature of the rope—or, as it were, the character of a human being. Synthesis and selectivity was the process that moved Eakins beyond the crowd and made life difficult for him. In his lifetime, he received little recognition, much criticism and unfeeling indifference from the middle class patronage that marked the American art establishment. That patronage, whatever the degree of wealth, rewarded only those painters whose intellect and middle class values were akin to their own. And usually, these values when fixed on a canvas, required little thinking to transport the viewer.

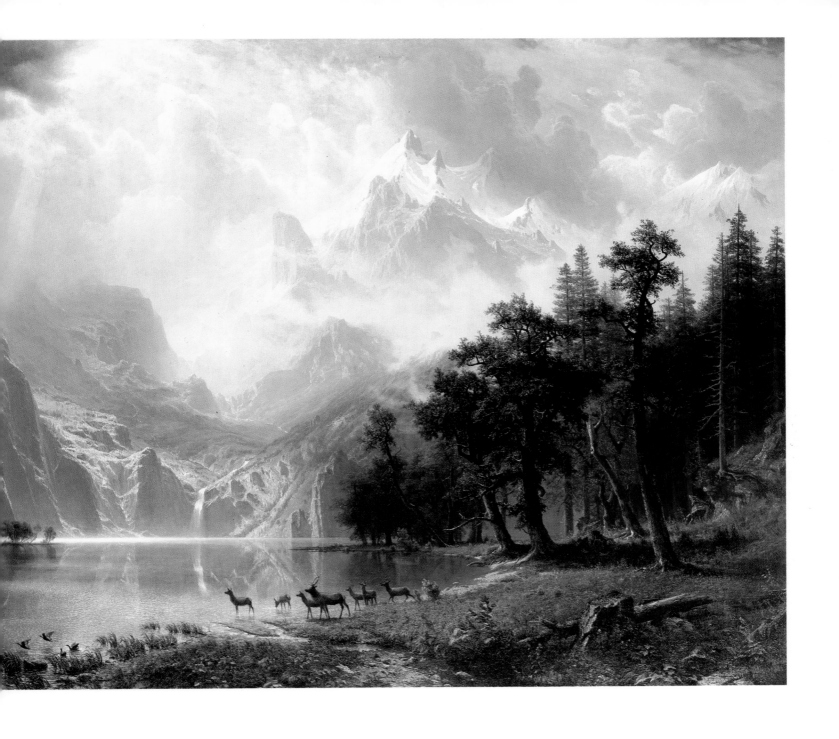

Eakins spent considerable time developing strong genre works dealing with sports. Among these is his *Max Schmitt in a Single Scull*. Here, a lone figure peers quietly from his boat as it glides on a glassy river. Notable in the painting's serenity, a condition brought on by its horizontality, middle distance rhythmical arches, flat and reflecting water, is the image, not of Max Schmitt at leisure, but rather the presence and spirit of Eakins himself, whose own thoughtfulness is expressed everywhere in the painting.

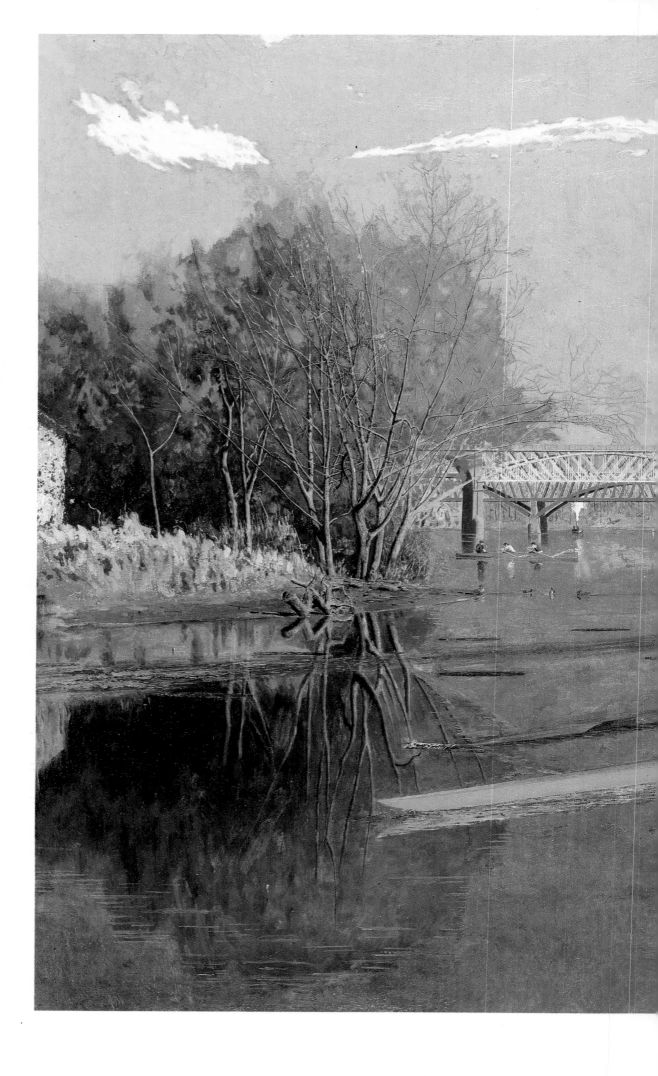

Arrangement in Grey and Black: Portrait of the Artist's Mother (1871)
James Abbott McNeill Whistler (1834–1903)
The Louvre, Paris

There is a six year difference between Whistler's *Old Battersea Bridge* and this portrait of his mother. Whistler is now well into his 'Symphonies,' 'Arrangements,' 'Nocturnes' and 'Harmonies.' His artistic interest has quickened with regard to pointing up the nature of his painting rather than the subject matter. To Whistler, the subject was an excuse to explore the fundamental esthetics of pure shape, pure form, pure color and the arrangement of these things.

'My picture of a *Harmony in Grey and Gold,*' he wrote, 'is an illustration of my meaning . . . I care nothing for the past, present, or future of the black figure, placed there because the black was wanted at that spot. All that I know is that my combination of grey and gold is the basis of the picture.'

Of the portrait of his mother, Whistler had this to say, 'Take the picture of my mother, exhibited at the Royal Academy as an *Arrangement in Grey and Black.* Now that is what it is. To me it is interesting as a picture of my mother; but what can or ought the public to care about the identity of the portrait?'

Whistler's argument was significant in terms of the subjective esthetics and artistic freedom that lay ahead in another century. But he underestimated the public's sentimental response to the universality of aging motherhood. Whistler had unwittingly created a universal icon. Adamant in his pursuit of the abstract, Whistler used the same design in his portrait of Thomas Carlyle. 'Nature contains the elements, in color and form, of all pictures,' he lectured, 'as the keyboard contains the notes of all music.'

(Page 81)
Flight and Pursuit (1872)
William Rimmer (1816–1879)
Museum of Fine Arts, Boston, Massachusetts

In every generation of American painting there seems to arise those lone artists who either pursue their own esthetic or conceptual road out of step, as it were, with the mainstream direction; or else are so isolated from the mainstream that they have little choice but to rely on their own visions.

Such an artist was William Rimmer, a Bostonian of French descent, whose despair haunted him and hence his viewers all of his life and then some. Rimmer spent his early years in Boston in abject poverty, without friends or social contact of any significance. But the young Rimmer was bright and ambitious with an obsessive interest in all forms of art, anatomy and medicine. He became a physician with more than a passing interest in drawing and painting, a field in which he excelled locally as a teacher. But Rimmer edged toward painting and sculpture and sought the recognition his imagination deserved. None was forthcoming. Rimmer's despair grew, seeded in his early grinding poverty and nurtured by his inability to win public acceptance for his art—this in a climate of genre, reportive, and sentimental art—an art that was increasingly visionary. As Rimmer withdrew, his artistic concepts yielded hints and expressions of tragedy and ominous doings.

In *Flight and Pursuit* there is flawless draftsmanship and masterly control of forms, light and the patterns of light in a strange association of running figures and exotic architecture. Who is running, why they are running, who is in pursuit (only their shadows can be seen in the lower right corner), why they are in pursuit, is a mystery. And the evocation of mystery in this painting gnaws at the mind and remains memorable.

The Gross Clinic (1875) *Thomas Eakins (1844–1916)*

Jefferson Medical College, Thomas Jefferson University, Philadelphia, Pennsylvania

Eakins skillfully painted a number of portraits so disarming in their honesty that many of them met with strong criticism. Eakins used his brush and intellect to arrive at the character of the sitter. More often than not the sitter was unhappy with what the artist had uncovered. Eakins was constantly put upon to make more flattering changes. He usually refused, always trying to get at truthful vision through scholarship. Eakins insisted on using nude models for his classes at the Pennsylvania Academy. He did not think that the study of human anatomy or character could gain anything from the narrow use of traditional plaster casts. His use of the undraped model became a scandal in Philadelphian society, creating loud public outcries of moral indignation. Eakins refused to compromise the necessity of artistic knowledge. He later went on to assist photographer Edward Muybridge in capturing on film for the first time animals and nude human beings in motion, broadening at once the artist's accurate understanding of moving anatomy and the additional possibilities of 'moving' photography as a visual art form.

When Philadelphia opened its spectacular Centennial Celebration in 1876, Eakins was all but ignored. While Winslow Homer and others, deemed esthetically 'safe,' were given major exhibition space, Eakins' $6\frac{1}{2}' \times 8'$ *The Gross Clinic*, a marvel of monumental composition, uncompromising realism and atmospheric illusion, was squirreled away in a Hall of medical equipment exhibitions. Today, the canvas stands as an imposing portrait of great drama made more stunning by the triangulation of its three major parts: the horrified mother or wife, the lecturing Dr Gross and the attending surgeons with patient. All these are connected by the event's bloody actualities and the sharp, selective pattern of light and dark against the dim and muted background.

83

Historical Monument to the American Republic
(c 1876) Erastus Salisbury Field (1805–1900)
Museum of Fine Arts, Springfield, Massachusetts

The Connecticut River Valley of West Central Massachusetts was the home region of Erastus Salisbury Field. There Field plied his limner's trade, painting dry, stiff, nearly flat portraits of the hardy Bay State farmers and their families. From time to time, Field would produce a blowy, intricately detailed portrait where not a thread was missed in the rendered lace yoke, giving the portrait an Elizabethan overtone.

Except for a few months in 1826 when he arrived in the New York Studio of Samuel Finley Breese Morse and observed Morse's ongoing execution of the Marquis de Lafayette portrait slated for the City Hall, Field rarely wandered far from home. Field was well aware of painted solids in space, of form and its modelling, and the basic mathematics and usefulness of linear perspective. He was, to some degree, or as far as his manual skill could take him, artistically literate. These factors alone removed him from the ranks of the so-called 'Primitive' or 'Naive' painters. Field was another one of those solitary figures who marched to his own inner voice. It was not until he had reached his old age did he create the most complex tour de force oil ever seen in America to celebrate one hundred years of American Independence. The 9′ × 13′ *Historical Monument to the American Republic* was as exotic, although not as mysterious as Rimmer's *Flight and Pursuit*. Yet, the carefully rendered forms of the towers and their architectural ornament, the background mountains and overall perspective were only the structural elements that Field needed to do what he did—depict every bit of American history and those who made it in incredible detail. Field makes us peer at another world, so strongly defined, so wealthy and organized that it imposes its stylish presence on us in a memorable commemoration.

Reminiscences of 1865 (1879)
John Frederick Peto (1854–1907)
The Wadsworth Atheneum, Hartford, Connecticut

Like his older friend, William Harnett, John F Peto was a Philadelphian who trained at the Pennsylvania Academy of Fine Arts. And like Harnett, Peto spent the better part of his 54 years creating completely illusionistic still life paintings. Otherwise called *trompe l'oeil*—fool the eye—these works, on first sight, appealed to the need for faithful realism that seemed to characterize the art spirit of the American public during the final quarter of the nineteenth century. The idea that a painted object was invested with such actuality that the spectator was in doubt, never sure, that what was being observed was a painting or a reality, was reassuring to those who believed—and still believe—that the mission of the artist was the duplication of fact. The immediate visual aspect of the *trompe l'oeil* is its obvious startling skill which overrides whatever substance could be inherently present in the work.

Reminiscences of 1865 may be just that—memories—on one level, a collection of objects made more meaningful by their tactility and presence. But on another level, the painting is something else. Peto was a careful composer who took great pains to choose his pieces for their symbolism as well as shape and form and then organized a visual arrangement which put the whole of it in another dimension. Painting in quiet obscurity, Peto, in this instance, fixed both past and present indelibly upon the mind of the viewer. Peto's symbolism may have been private and meaningless to the casual gallery goer. Nevertheless, he breathed an existence into these inanimate things incorporating them into their own space—their own world—and in a sense a very real world apart from our own.

The Cranberry Harvest (1880)
Eastman Johnson (1825–1906)

The Timken Art Gallery, San Diego, California

The World's Columbian Exposition opened in Chicago on 1 May 1893.
It was a mammoth cluster of white buildings housing and celebrating
America's pride and ingenuity, for the most part. Most country's of the
world were represented, however, in what came to be known as the
'White City.' At its heart stood sculptor Daniel Chester French's 65'
'Republic.' In an exposition that featured everything from American
farm machinery and French tapestries to German artillery, there were
9000 paintings from everywhere in the world being shown in the Art
Palace. Most of these were academically competent works of little
intellectual force. The great French artists were virtually snubbed by
their country's selection committee. Degas, Courbet, Manet, Daumier,
Corot were not among the stifling array. They could be found else-

where, however, in the exhibition put on by Americans who collected them. Missing too, were Cezanne, Renoir, Monet and Pissarro. They were nowhere to be seen. Nearly 800 paintings comprised the American section which was a display of the history of American painting beginning with Benjamin West. These were all competent academic expressions that showed little innovation overall and surely no imagery or style that was peculiarly American as differing from European.

Here and there, however, were American genre painters whose substantive qualities escaped the shallow tastes of the hordes of viewers. Among these was the very able, and well-schooled Eastman Johnson's *The Cranberry Harvest*, a painting which had more to do with the expression of form and the arrangement of parts than it had to do with story-telling subject matter or the painting of visual actuality.

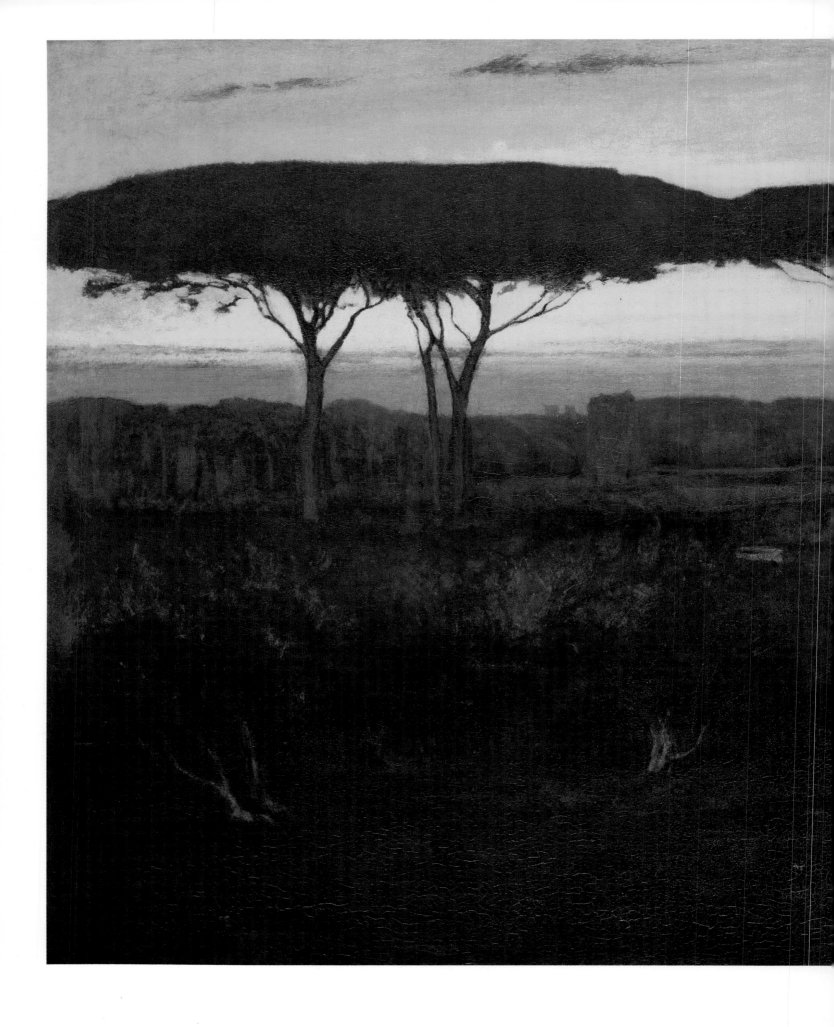

The Monk (1873) *George Inness (1825–1894)*

The Addison Gallery of American Art, Phillips Academy, Andover, Massachusetts

Largely self taught, George Inness spent some six years traveling in Europe and the British Isles studying the 'nature of nature,' as it were. Committed to the landscape his early art revealed little of the inner struggle to paint nature as his mind saw it rather than as it existed in actuality. These early works were tense visions of nature's details. In 1850, or thereabout, Inness, who would become a leading figure in the Hudson River School, left his Montclair, New Jersey studio for a year in Paris. There, he fell under the spell of the Barbizon School, an event that would awaken in him his deep personal feelings about the landscape and change the mode of his expression from panoramic narrative to more introspective interpretation.

The Barbizon School (*c* 1830–1870) was a loosely knit group of about 30 Parisian Painters—among them Camille Corot (1796–1875); Theodore Rousseau (1812–1867); Jean Francois Millet (1814–1874)—who forsook studio art to paint out-of-doors in the woods of Fountainbleau southeast of the French capital. Barbizon was the village in which they met. Their purpose lay somewhere between a new dynamic for painters of nature and rebellion against the rigidity of the academicians. These artists, who were essentially naturalists, opened a small door to Impressionism and tore at the heart of the French art establishment. Inness drew the line, however, and resented being associated with the Impressionism of Monet and company which he called a 'fad.' Inness absorbed the interpretive character of the Barbizon painters, fusing it with his solitary visionary impulses. *The Monk* was more in his mind than in actuality. Its horizontal geometry presents a peaceful landscape synthesizing actuality. In the end it made the panoramas of Bierstadt and Church insensitive, unreal and forced.

Madame X (1884) *John Singer Sargent (1856–1925)*

The Metropolitan Museum of Art, New York, New York

The brilliant career of John Singer Sargent had an auspicious beginning. He was born in Florence, Italy, the ancestral home and mecca of painters of the western world. At 18 he was a serious art student in Paris. By the time he was 25, he was fully committed to portraiture. Until he died in London—age 69—Sargent spent his life traveling back and forth between the United States and Europe painting the world's wealthy and famous.

Sargent's portraits were marked by a vitality not seen before. His slightly unorthodox compositions were fresh and smoothly simple, always set down with a lively brush. The total effects were most always dazzling as befitted the high society that sought his talents. His paintings often seemed to express a mere glance or a flashing moment kept alive forever by his flashing brush. But there was more to Sargent than his well bred paintings of the affluent and powerful. In *Madame X* (Mrs Pierre Gautreau, the American wife of a French banker), Sargent created a remarkable expression of elegance and pride in the simplest terms. Using the severe black and white contrast as the dynamic force of the image, he set off a graceful figure against dim color and no accessories. There are no symbols of wealth or vanity. There is nothing to indicate the woman's social position other than her style—her gown, posture and pose.

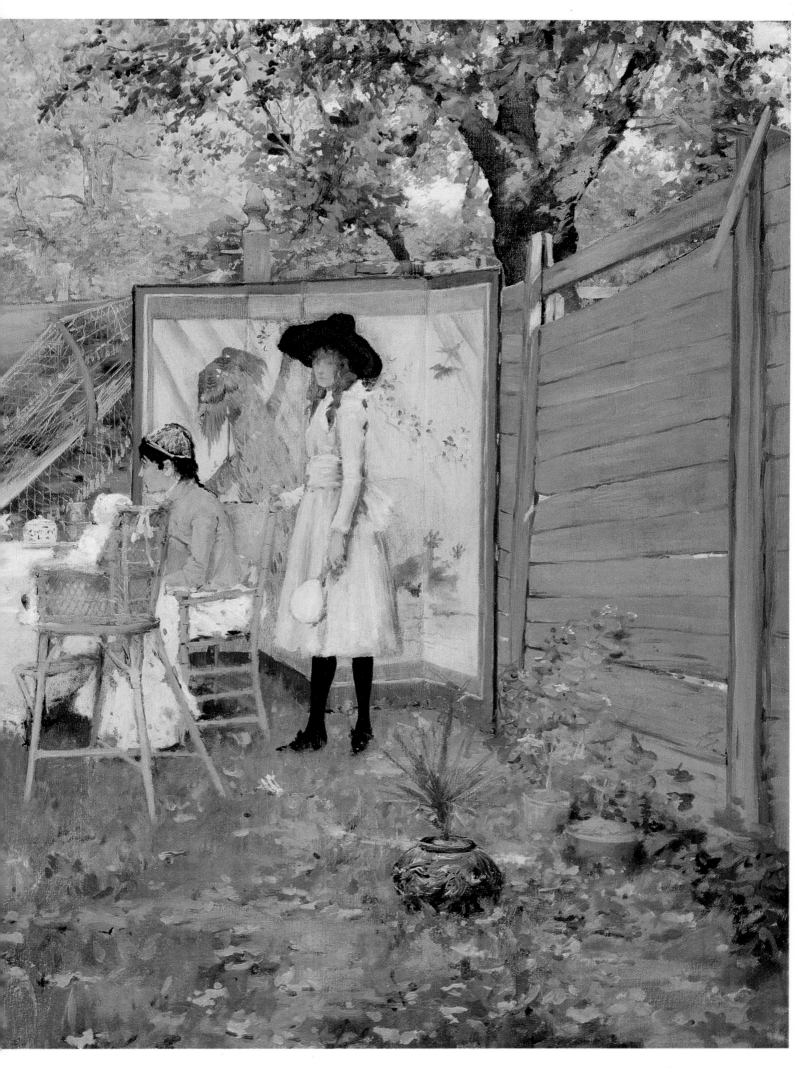

The Open Air Breakfast (*c* 1888)
William Merritt Chase (1849–1916)
The Toledo Museum of Art, Ohio

All of what William Merritt Chase painted indicated a master of technique. It was never a worked-over technique but rather one of surprising speed and freshness that breathed life into the Chase canvases. And for most of his professional life, Chase was much sought after as a teacher of the process of painting, a role in which he exerted enormous influence. Beyond this, Chase's landscapes, still lifes, portraits and interiors exuded a cheerful confidence, elegance and flamboyance that typified the man and his style of life. A familiar scene in New York was the dapper and monocled Chase, a flower in his lapel, walking his snow-white wolfhound.

Chase came to New York from Indiana where he was born and first studied art. After a stint in New York and Germany mingled with general European travel, Chase came back to New York where his fame and fortune soared. Chase's painting, for the most part, reflected the influences of Manet, whom he greatly admired; Whistler, who was a warm friend; Sargent, whose dexterity and flashy elegance was appealing; and various European masters like Velasquez, Chardin and the Flemings, from whom he learned certain technical procedures. From the Japanese prints he studied he learned much about pictorial arrangement.

The Open Air Breakfast emphasizes Chase's vigorous and lively surfaces, so brilliantly realized that the subject matter or substantive content has no particular significance—if indeed there is any substantive matter—to distract the joyful nature of the paint's vitality. Somewhat impressionistic and cluttered, the work is, nevertheless, a remarkable piece of well-knit parts that serve the ultimate expression of the painting process itself.

Moonlight (*c* 1885–1889)
Ralph Albert Blakelock (1847–1919)
The Brooklyn Museum, New York

Few painters have been so transfixed by a single image as Ralph Albert Blakelock. Blakelock's obsession was the Indian at home in the western wilderness as seen at sunset or in moonlight. The Indian tepee or tepees and campfires are usually gloomily small-scaled and pitted against the mighty silhouettes of trees.

Blakelock was one of the more tragic figures in the annals of American art. He was graduated from the College of the City of New York—the city of his birth—and went on to pursue a medical education. He soon gave this up preferring to study painting. Unfortunately, Blakelock was penniless and could afford little in the way of art training. He taught himself. A series of odd jobs took him west where he was struck by that image of Indian life that haunted him the rest of his life. No one in the art world paid the slightest attention to Blakelock, who painted alone in New York, still penniless. The strain of no recognition, no friends and no money was more than he could bear. He suffered a mental collapse in 1899 at age 52 and spent the next 18 years in a mental institution. During that period of time, his paintings became popular, a fact he was not aware of; and his work was sold for sums from which he realized no profit. He was released from the institution in 1917 and died two years later.

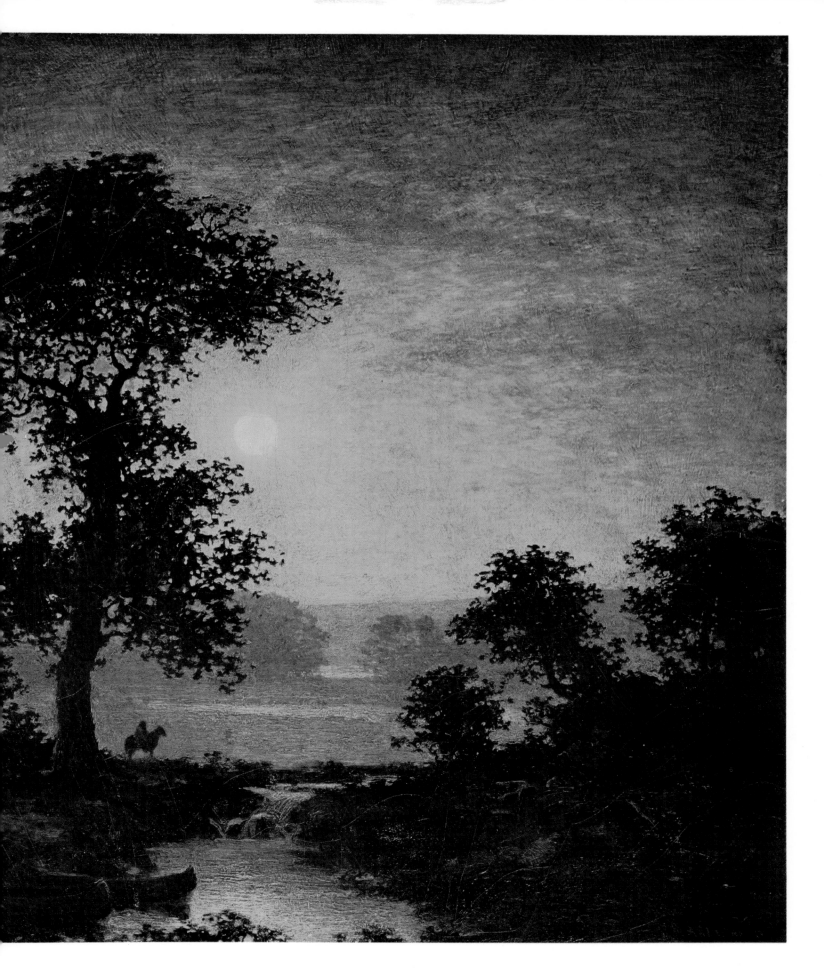

Moonlight is one of those singular canvases of plausible reality that in effect expresses the lonely soul of a man who has come to grips with his seeming insignificance in a vast and ominous world. Blakelock's *Moonlight* was more an inner vision of himself than the depiction of a moody Indian camp.

The Faithful Colt (1890)
William Michael Harnett (1848–1892)
The Wadsworth Atheneum, Hartford, Connecticut

Like the younger Peto, William Harnett's artistic arena was the complete illusion of still life.

An Irishman who came across the Atlantic to Philadelphia to be an engraver, Harnett spent his evenings drawing and painting at the Pennsylvania Academy. He soon abandoned his engraving trade and traveled to Munich, Germany for further study where he spent several years refining his skills and becoming interested in the still life. He returned to New York City where he began to paint his still life 'set-ups' with extraordinary dimensional realism.

While his friend Peto's manipulation of space contained some unexpected geometrical elements from time to time that moved the viewer's eye in and out as well as around the surface of the illusion, Harnett kept his still life up front, so to speak, arranging shapes and forms in connecting relationships. Finally, by relying on a meticulously clear draftsmanship and a dramatic use of light and detail Harnett projected remarkable illusions. But in paintings like *The Faithful Colt*, Harnett seemed bent on extending the viewer's experience with actuality to a heightened reality that exists nowhere but in the painting itself. In this regard, Harnett succeeds in raising the audience's awareness of the reality of the painting, not of life's physical actualities. The truth of the objects is in the painting. And it is the painting, the work of art, that in the end stands alone and apart from ordinary experience.

(Page 103)

A Bachelor's Drawer (1890–1894)
John Haberle (1856–1933)
The Metropolitan Museum of Art, New York, New York

John Haberle was the third member of a trio of *trompe l'oeil* painters whose remarkable skills were used in the service of illusion and heightened realities. The other two members of the 'group' were William Michael Harnett and John Frederick Peto, contemporaries all.

Unlike Harnett and Peto who were Pennsylvanians, Haberle was born and bred in New Haven, Connecticut, and eventually died there, having spent his entire 80 years in the same place. Haberle's New Haven connection was Yale University's Peabody Museum where he worked sporadically, preparing exhibits and displays.

Also, unlike his Pennsylvania counterparts, Haberle used his illusionistic skills with great humor as is evident in his *A Bachelor's Drawer*. Here, Haberle carefully arranges a concoction of rectangular shapes which, according to the artist's nineteenth century standards, are immediately identifiable as an unmarried man's activities and interests—tickets, playing cards, money, a discreetly covered nude, etc—all designed to communicate a devil-may-care but organized carousing life style. Haberle also leaned toward illusions within illusions—visual witticisms—where, for example, he would paint a non-'trompe' painting within a 'trompe.'

100

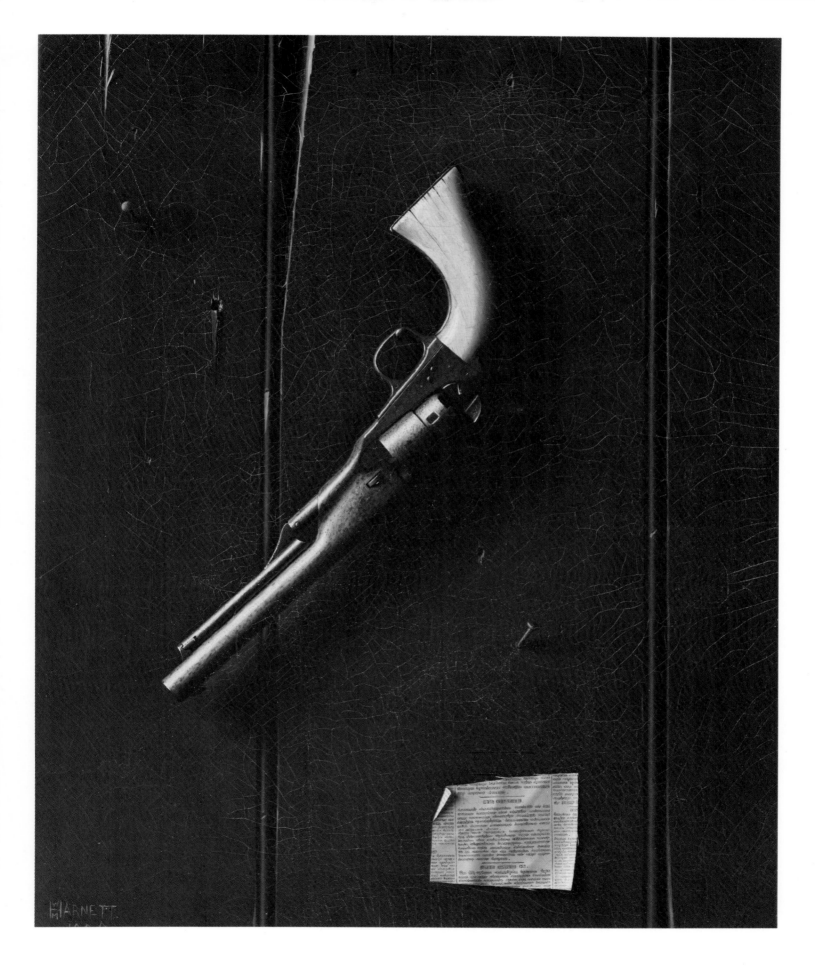

Like his partners in reality, Harnett and Peto, Haberle's illusions were so strong and magical that they overwhelmed all of the artistic elements that supported the illusion. He may have been a witty illusionist, but Haberle was also a precise manipulator of form, shape, volume and atmosphere that removes *A Bachelor's Drawer* from being a mere pedestrian sneaky peek at someone's privacy.

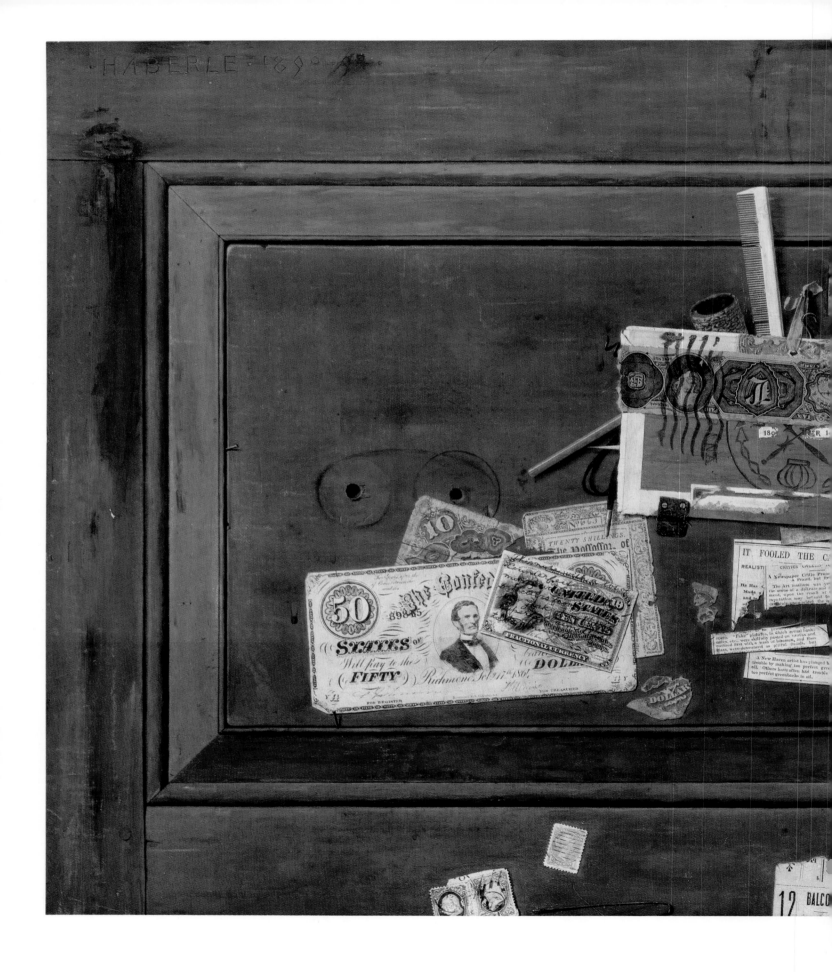

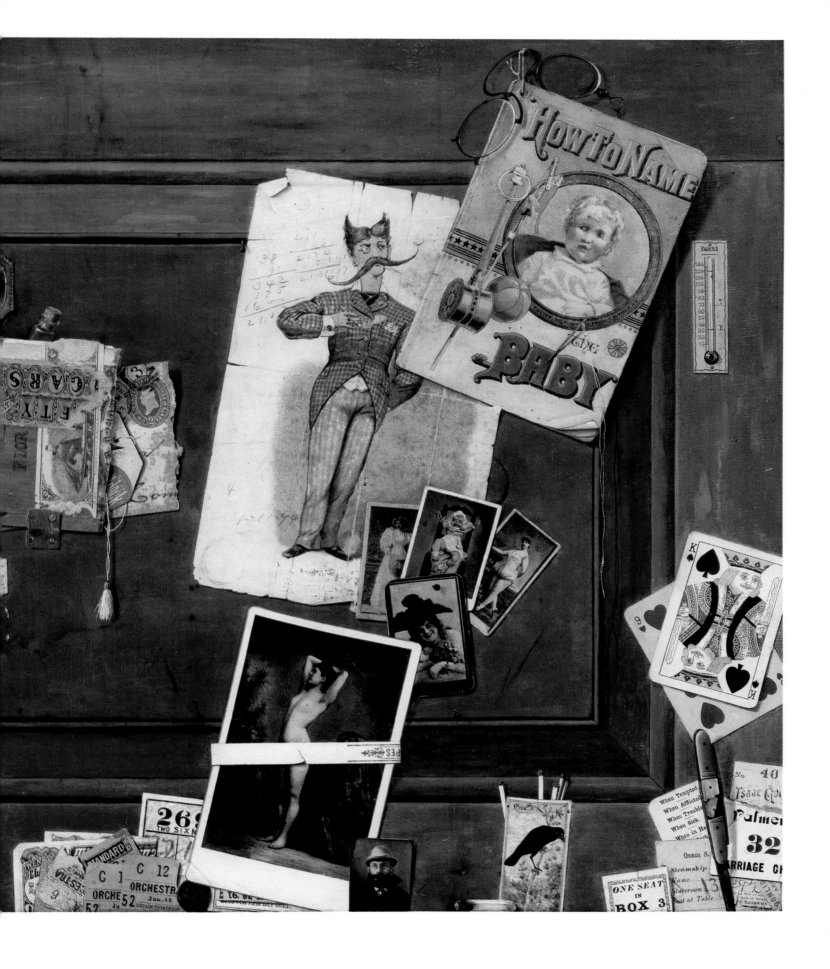

103

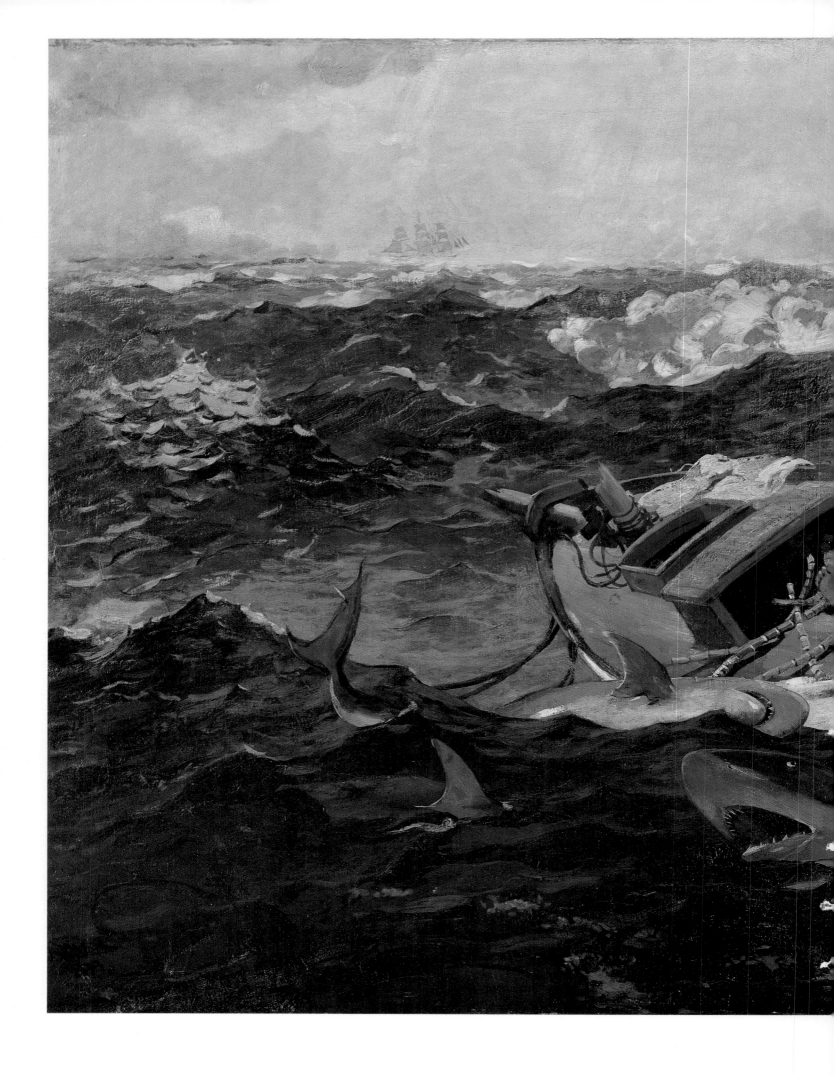

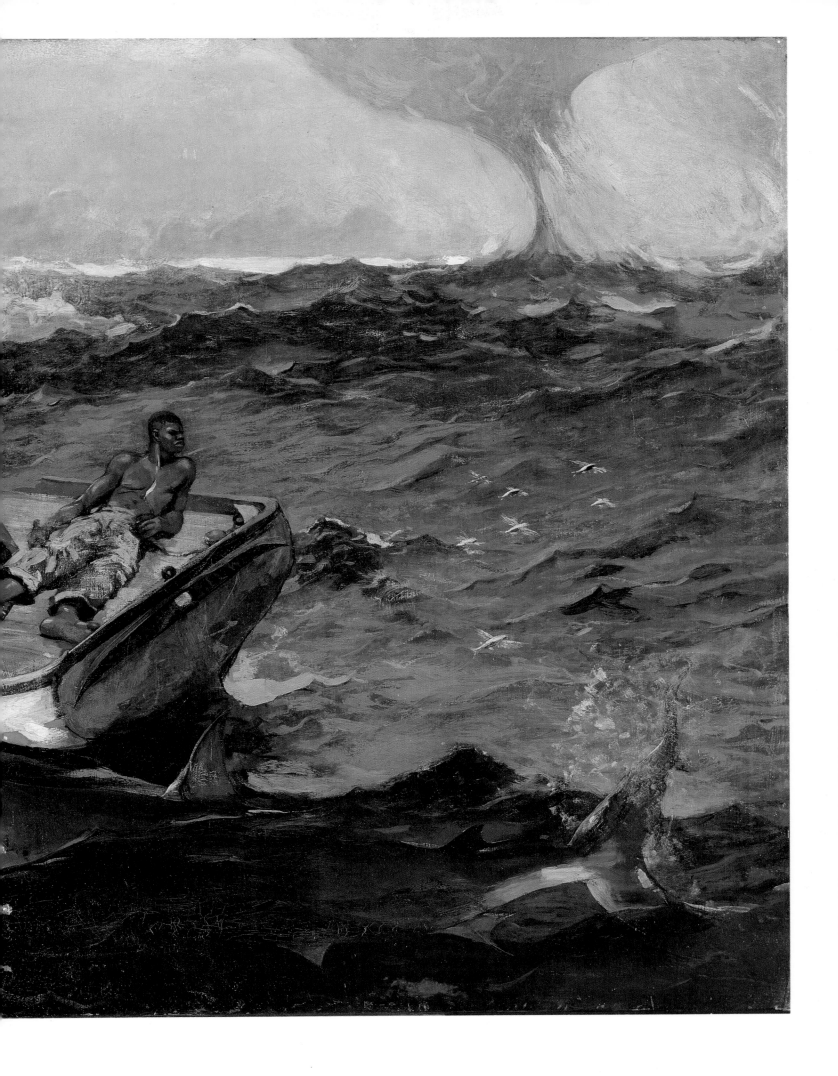

The Gulf Stream (1899)
Winslow Homer (1836–1910)
The Metropolitan Museum of Art, New York, New York

Unlike *Eight Bells*, which seems to pull the viewer into the pictorial environment incorporating one's senses into the spacious wetness of sky, sea and ship, *The Gulf Stream* makes of the viewer an observer, a witness to a possible human disaster.

Homer traveled a great deal from his studio in Maine to Canada and the Adirondack Mountains through the Caribbean region including Cuba, Florida and the Bahamas, and northward along the Gulf Stream to Bermuda. Much of this time was devoted to creating brilliant water-colors that seemed effortless in their execution. In fact, Homer's success with watercolor in the early 1880s marked the true beginning of the rise of an American school of watercolor painting. In any event, *The Gulf Stream* was not a watercolor, but an oil. In the beginning, when first seen, there were the inevitable comparisons with Theodore Gericault's (1791–1824) earlier *Raft of Medusa*, a romantic painting with political overtones; and with John Singleton Copley's *Watson and the Shark*, a romantic painting of a news item. In the 'Raft' as in 'Mr Watson' horror was actively pictorialized. But Homer provides the spectator with a different sweep. Here, in *The Gulf Stream*, terror circles the derelict boat and its lone passenger. Adrift in a swiftly running sea and encircled by ominous weather—a water spout—and a school of sharks, terror threatens and we are uncertain of the outcome of the drama frozen on the canvas.

Afternoon Wind (1899)
Louis Michel Eilshemius (1864–1941)
The Museum of Modern Art, New York, New York

Newark, New Jersey-born Louis Michel Eilshemius spent his formative years in Germany amidst wealth and privilege. He returned to America in his teens to study agriculture at Cornell University. After a brief stint with art at New York's Art Student's League, he returned to Paris. There he enrolled in the classes of Adolphe William Bouguereau (1825–1905), a dominant figure among conservative French painters and a remarkable technician. Unable to stay put, Eilshemius spent the next 20 years traveling around the world, painting both mundane landscapes and visionary works, inventing homeopathic cures for various diseases, writing and composing music. All the while his fortune dwindled. In 1908 he met Albert Pinkham Ryder who invited him inside his tenement studio, an invitation not offered to many people. Eilshemius exhibited his work in New York City from time to time without recognition. He continued to turn out a large body of work until 1921 despite his obscurity. In 1921 he gave up. He was only 57 years old. He died a pauper in the charity ward of a New York hospital, having been paralyzed the last nine years of his life.

Afternoon Wind rises from the compelling inner visions of Eilshemius and remains compelling on the canvas. Eilshemius was fascinated with floating figures and the fantasies they awoke within him. Perhaps the most extraordinary aspect of *Afternoon Wind* is not so much Eilshemius' ability to extract his vision from some mysterious internal realm and fix it to a canvas, however unevenly, but to do it with such clear power as to leave the spectator believing in the reality of the fantasy.

Geronimo (c 1900) *Henry Cross (1837–1918)*

The Thomas Gilcrease Institute of American History and Art, Tulsa, Oklahoma

The lure of the West infected many adventurous Easterners. Not the least among these was the large, rotund, mustachioed Henry Cross from upstate New York. By the time Cross was 16 and exhibited a strong drawing talent, he had run away from home several times to join the circus. In 1853, his parents sent him to Paris to study with Rosa Bonheur (1822–1899), noted animal painter. Cross returned sometime later, went West with the P T Barnum Circus as a sign painter and settled in Chicago in 1860. Two years later he traveled through the troubled Indian Territories witnessing the Sioux uprisings in southern Minnesota and painting more or less a catalogue of the personalities that crossed his path. These not only included the many portraits of Indians but such other presences as Wild Bill Hickock (1837–1876).

Notable among his portraits of Indians was that of Geronimo (1829–1909). Geronimo sat for Cross while serving a sentence of life imprisonment at Fort Sill, Oklahoma. Geronimo had been chief of an outlaw band of Chiricahua Apaches who terrorized the Arizona Territory between 1876 and 1886 after having balked at being put on a reservation by the United States Government. His capture was at the hands of US Army Apache Scouts.

Typical of Cross' manner of idealization versus reality, Geronimo's likeness and figure accessories are faithful down to the last detail comparing more than favorably with very sharp photographs taken of Geronimo during his imprisonment. Cross, however, places his renegade Apache against a stormy background in a symbolic gesture while capturing in the stern, stiff countenance the hate in the man, a man who three years after this portrait was painted became a Dutch Reform Christian.

Chief Geronimo. Apache

The Spielers (1905) *George B Luks (1867–1933)*

The Addison Gallery of American Art, Phillips Academy, Andover, Massachusetts

Until George Luks came along, no American artist felt compelled to respond to the seamy side of city life. A large and vigorous man, impatient, a prodigious drinker, Luks enthusiastically depicted aspects of urban lower class life with good humor and cheer. There seemed to be a link between the boisterous Luks and the robust Dutchman, Franz Hals (1580–1666).

Born in Pennsylvania, Luks began his training at the Pennsylvania Academy. He continued his art education in Düsseldorf, London and Paris. He rejected the technical and bravura elements of European academic instruction and returned home to find his 'Americanism.' After having covered the Spanish-American War as an artist-correspondent for the *Philadelphia Bulletin*, Luks became a cartoonist for the *New York World*, producing a version of a very popular comic strip, *The Yellow Kid*. He was employed by other publications as well providing political cartoons and on-the-spot sketches of city disasters—this before the era of photo-journalism. It was in this milieu that Luks found his direction—the genre of city life—its poorer aspects, a subject no one thought fit for a canvas. The lusty Luks became a target for those of the establishment who preferred better breeding in art. His painting was rejected at every turn, while he himself was suspected of 'socialistic and anarchistic' connections. In 1908, he joined with that group of American painters, calling themselves *The Eight*, protesting the entrenchment of tradition and their own rejection. In so doing they set a new course for American art.

In *The Spielers*, Luks' slashing brush captures two giggling street urchins in a moment of good cheer, fun and hope. Memorable is the unaffected imagery and the good humor in what otherwise could have been grim fare.

(Page 113)
Park on the River (c 1902)
William Glackens (1870–1938)

The Brooklyn Museum, New York

The careers of William Glackens and George Luks were very similar, however much different they were as painters. Like Luks, Glackens was Pennsylvania-born and began his art education at the Pennsylvania Academy while illustrating for Philadelphia newspapers. He, too, went to Europe to study, remaining briefly in Paris exhibiting his art. And like Luks, he returned to the United States to cover the Spanish-American War as an artist-correspondent for *McClure's* magazine. And Glackens, also, defied the establishment as a member of the famous *Eight*. But unlike his friend and colleague, Glackens was less buoyantly disposed toward his art. The slums and hard times in the city were not his subjects. The city landscape, its parks and squares, were more to his liking than the shabbiness of the disenfranchised portrayed by Luks.

Fundamental in much of Glacken's work is the color and tonality of the city's outdoors applied and manipulated in a highly studied manner related to the look of the work of Pierre Auguste Renoir (1841–1919). Whether Glackens was interpreting the nature of Washington Square Park in New York, a roller skating rink or *Park on the River*, he lifted the commonplace out of its banality with form and style and a coloration that edged toward life's unaccountable joys.

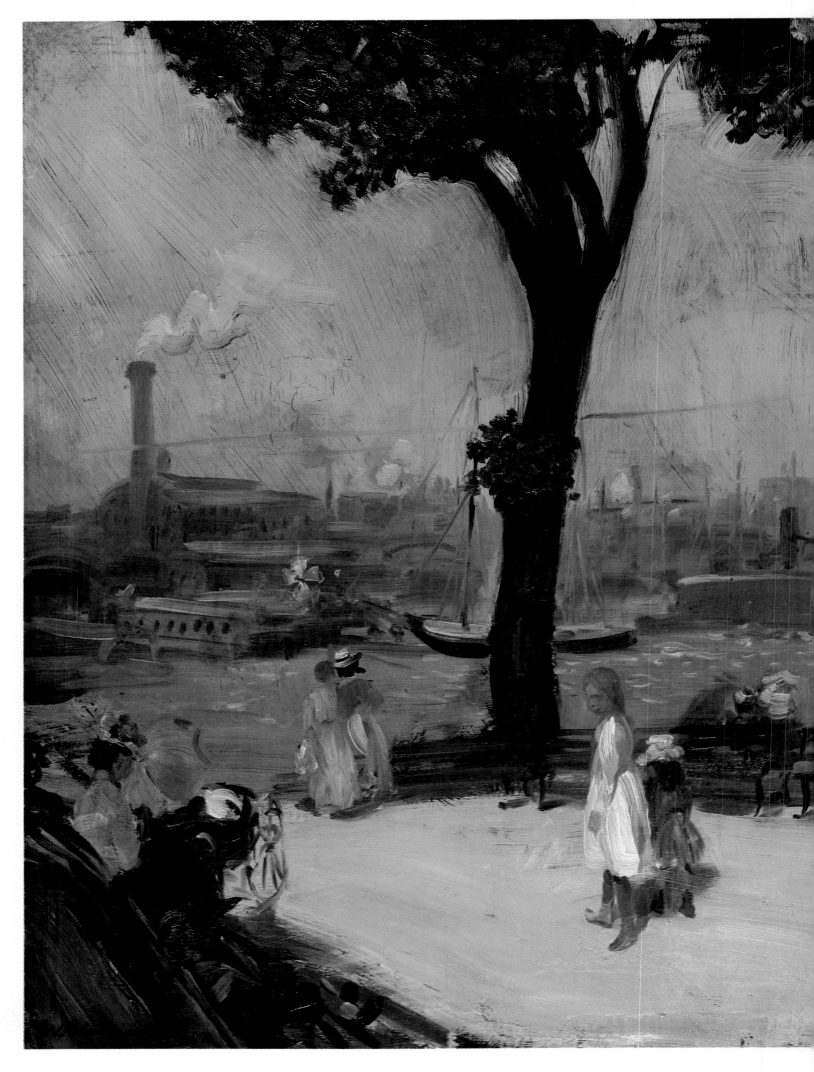

Unicorns (c 1906) *Arthur B Davies (1862–1924)*
The Metropolitan Museum of Art, New York, New York

Of all the members of *The Eight*, the one who least resembled the 'Ash-Can' group was Arthur B Davies. Davies had little interest in the cityscape genre mode of his colleagues nor was he interested in painting a logical existence of nature. He was a romantic, a visionary, a dreamer, another one of those individualistic painters who marched to their own inner visions and fantasies and upon whom the artistic styles of his day had little impact. Like most visionaries, Davies was withdrawn and private. Yet, he was liberally disposed and open to new directions, encouraging those who searched for new areas of expression and new sets of esthetic values. He had little patience with the established traditions of academic art and proved so when he took a leadership role in bringing to the United States the International Exhibition of Modern Art—the Armory Show of 1913—which became a watershed—a turning point in the history of American painting and sculpture.

114

Davies was a native of Utica, New York. He spent his formative years studying art at the Chicago Academy of Design and the Chicago Art Institute before moving to New York City and a brief interlude in Italy.

Like his *Unicorns*, Davies filled the woodlands of his mind with young women and legendary beasts. There was a cool harmony to all of these rhythmical scenes—an airiness—a lightness—a peculiar longing that rose from the landscape-figure connection. Davies projected his dreamworld carefully and laid bare the uniqueness of his mind and sensuality.

Wake of the Ferry (1907)
John Sloan (1871–1952)

The Phillips Collection, Washington, DC

John Sloan once said, 'Painting is drawing, with the additional means of color. Painting without drawing is just "coloriness," color excitement. To think of color for color's sake is like thinking of sound for sound's sake . . . I am interested in the use of colored tones to build solids and as an added means to composition.'

John Sloan, who spent 17 years teaching at New York's Art Students League (1914–1931), was another Pennsylvanian with roots in the Pennsylvania Academy who threw in his lot with the rebellious *Eight*— the Ash Can School—in 1908. Like Luks and Glackens, he too drew the human scene for Philadelphia newspapers, went on to illustrate books and magazines and collaborated with his fellow 'Eighters' in mounting the 1913 Armory Show bringing modern Art to America.

Sloan was a genre painter of the cityscape—the backyards, back alleys, saloons, restaurants, streets and waterfronts. A superb draftsman, Sloan structured the compositional elements of his pictures with infinite care and solid drawing upon which he composed his color elements. Never without atmosphere, Sloan always caught an American essence in his paintings. But in *Wake of the Ferry*, he went far beyond anyone's national characteristics and created a painting of power and dimension, whose hypnotic tilt puts the viewer squarely on that slippery deck gazing aft at the murky weather. The simplicity of the silhouetted ferry sections together with the lone unidentifiable figure framing the receding environment is mysterious enough. Nevertheless, it is Sloan's design, his manipulation of values, color, subordination of non essentials and the positioning of parts that give the painting its monumentality, not the subject.

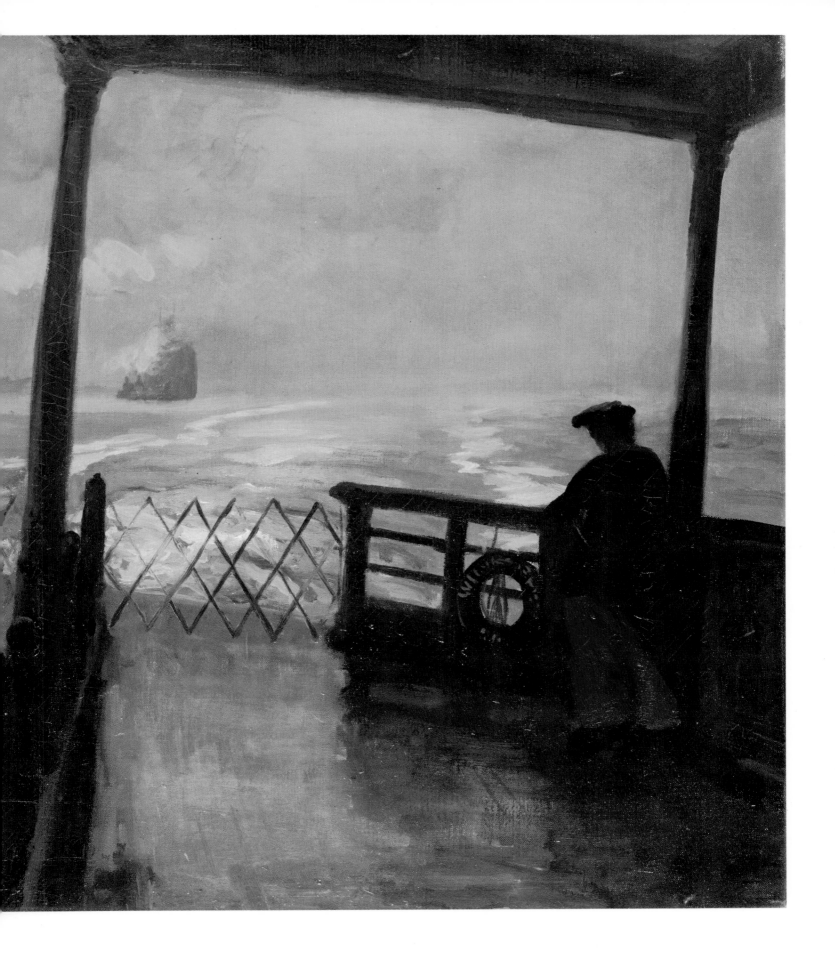

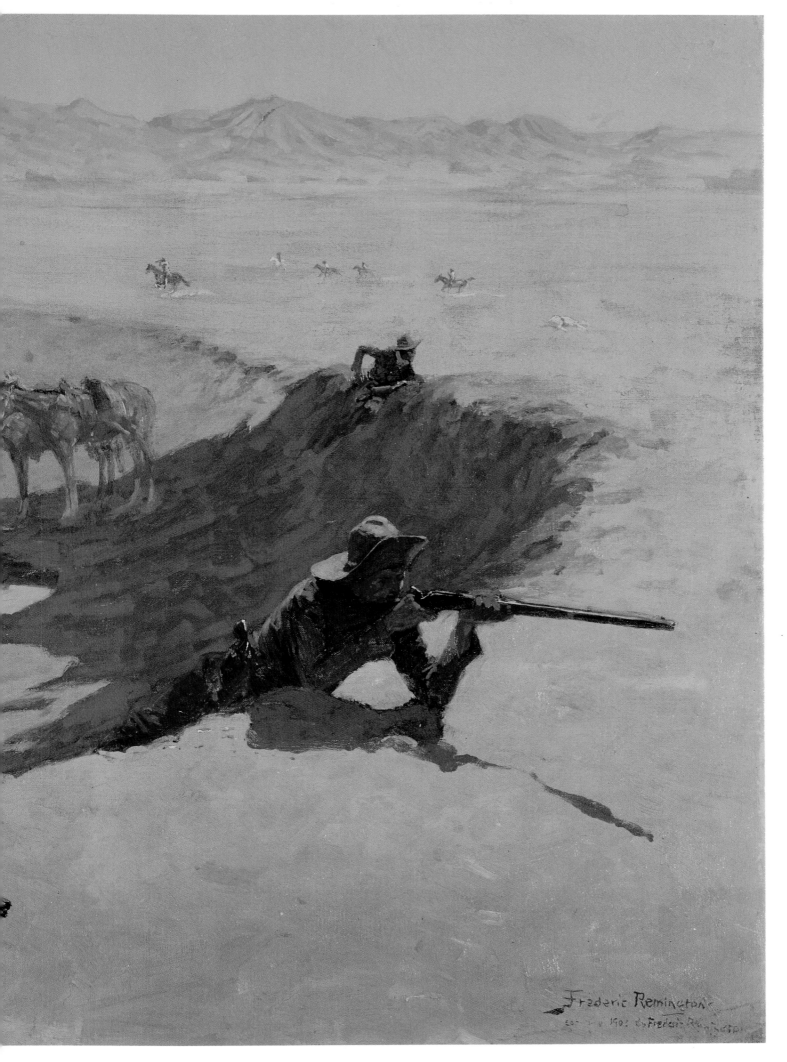

Fight for the Waterhole (1901)
Frederick Remington (1861–1909)
Museum of Fine Arts, Houston, Texas

One cannot conjure up an image of the Old West without reckoning with the writings, drawings, paintings and sculpture of Frederick Remington. He was the major chronicler of the spirit and vastness of the territories of the Western United States of the 1880s and 1890s. It was a natural unspoiled environment peopled by cowboys, Indians, hustlers, gunslingers, ranchers, territorial marshals and the US Army. Remington himself participated in the expeditions, adventures and work parties as a veritable eyewitness to the fading of a lawless wilderness and frontier.

Remington came from a wealthy and sophisticated upstate New York publishing family. By the time he was 19 years old he had had enough education, which included some two years at Yale University's Art School where he managed to play football for the famous Walter Camp. The lure of adventure was magnetic. Remington left the comfortable world of New Haven and New York and went west as a cowboy. Eventually, his drawings began appearing in books and magazines back East where his fame and popularity was instant. Remington satisfied the Easterner's thirst for the romance of the yet-to-be-tamed 'Wild West.'

Remington's enthusiasm for adventure and the West was enlivened by his quick pen, sure draftsmanship and a sense of pictorial drama, as seen here in *Fight for the Waterhole*. A virtual American icon that has no bearing whatever on the debates regarding the esthetic nature of painting, it reaches out to the adventurous yearnings of all that is so deeply afloat in the well of American dreams.

Stag at Sharkey's (1909)
George Wesley Bellows (1882–1925)
The Cleveland Museum of Art, Ohio

The total span of the painting career of George Bellows was approximately 19 years, 1906–1925. Yet, in that short period, Bellows created a body of work of some of the strongest and most memorable canvases seen in America. Their robustness and directness stamped them as American. In fact, Bellows was one of those rare American painters who never set foot on the European continent or anywhere outside the United States, for that matter. His portraits, sporting subjects, cityscapes and allegories were all rooted in the American genre. Filled with human experience, his canvases were painted with a gusto that reflected the enthusiastic personality of the nation during the first quarter of the 20th century. These works were further marked with the same honesty and buoyancy that permeated the art of *The Eight*—the Ash Can School. Although Bellows was the youngest member of that group he did not exhibit with them.

Bellows was born into a wealthy Ohio family and attended The Ohio State University at Columbus. There he intended to begin a career as a professional baseball player. Instead, he went to New York to study with Robert Henri, the spiritual leader and voice of the Ash Can school.

Of all of Bellows' work, *Stag at Sharkey's* leaps out as an American icon. This remarkably dynamic canvas is at once a representation of an American fascination—boxing—and a symbol of the scrappiness and power of the young and as yet untested United States.

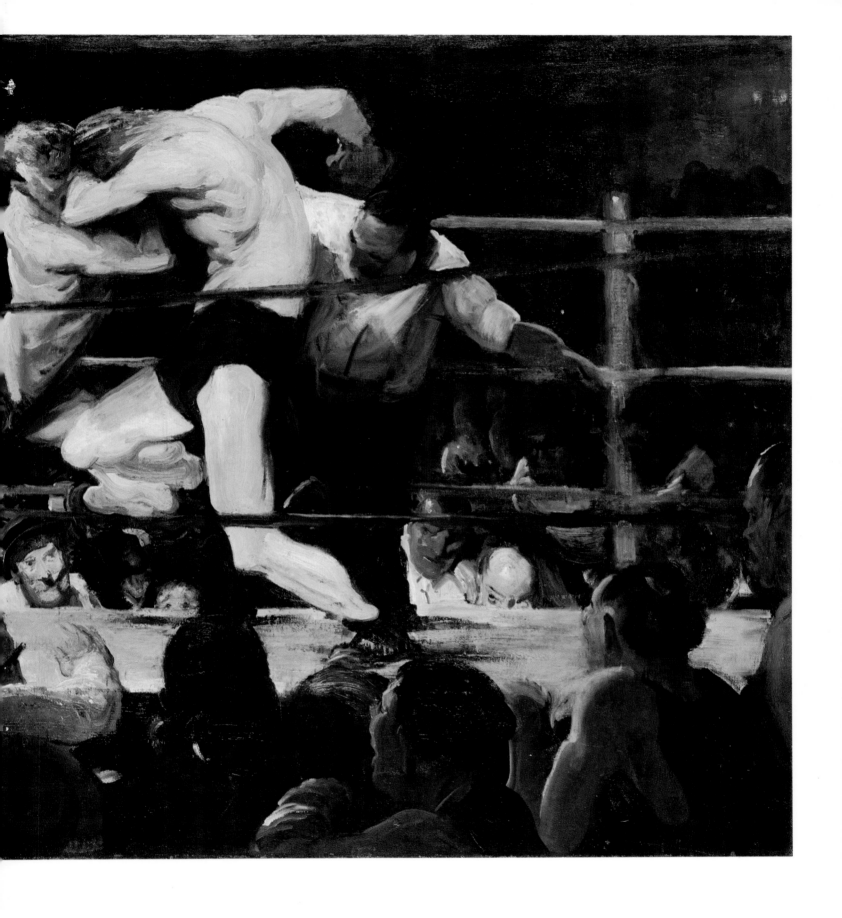

Death on a Pale Horse (*c* 1910)
Albert Pinkham Ryder (1847–1917)
The Cleveland Museum of Art, Ohio

To the painters of his era, Albert Ryder was an eccentric, one of the more enigmatic artists who committed an unfathomable imagination to canvas. Withdrawn from the pragmatic, egocentric and ambitious currents of art, Ryder ably articulated his solitary position: 'The artist needs but a roof, a crust of bread, and his easel, and all the rest God gives him in abundance. He must live to paint and not paint to live.'

Living in a world whose imagination did not extend beyond visual realities, Ryder plowed on with his inner visions, a true romantic, receiving hardly any notice. Having the more acceptable modes of representational painting in mind, Ryder wrote, 'Imitation is not inspiration, and inspiration only can give birth to a work of art. The least of Man's original emanation is better than the best of a borrowed thought.'

Ryder was not the complete recluse most would have him. Born in New Bedford, Massachusetts, Ryder came to New York City when he was about 20 years old. There he studied art privately and at the National Academy of Design. In 1893, he traveled through Europe. Between 1873–1888, a period of some 15 years, Ryder was a regular exhibitor at the National Academy of Design and the Society of American Artists. His work was included in the now celebrated Armory Show of 1913.

Ryder's imagination rose from an ominously stormy region suggesting deep inner conflicts. While all of his art was based on literary themes and was eerily lit, there was one exception: the haunting *Death on a Pale Horse*. Here, Ryder used the suicide of a man who had bet his life savings on a horse and lost to deal with death allegorically.

(Page 125)
The Rope Dancer Accompanies Herself with her Shadow (1916) *Man Ray (1890–1977)*
The Museum of Modern Art, New York, New York

Philadelphian Man Ray very quickly associated himself with the modern currents of art after seeing the Armory Show in 1913. He was 23 years old, intensely imaginative, and with the instincts of an explorer and pioneer. In 1915 he had his first one man show in Manhattan. A year later, he helped found the Society of Independent Artists. In 1920, he co-founded the Société Anonyme with Katherine Drier and Marcel Duchamp—an iconoclastic group devoted to advancing both the eccentricities of the avant-garde and the more serious perceptions of the avant-garde.

Man Ray was a generalist in the service of his imagination, originality, the new, the different, the untried. He was as comfortable with offbeat still and moving photographic images as he was with abstract and surrealist painting or eccentric sculpture. These were unaccustomed, alien and dehumanizing imageries that expressed a contempt for tradition while reflecting anxiety over the quality of life offered by twentieth century technology. While many of Ray's contemporaries had experimented with these new European ideas but discarded them in favor of more representational modes in an attempt to fend off European primacy in art, Ray opted for Cubism, Dadaism and any experimental road however artistically extreme.

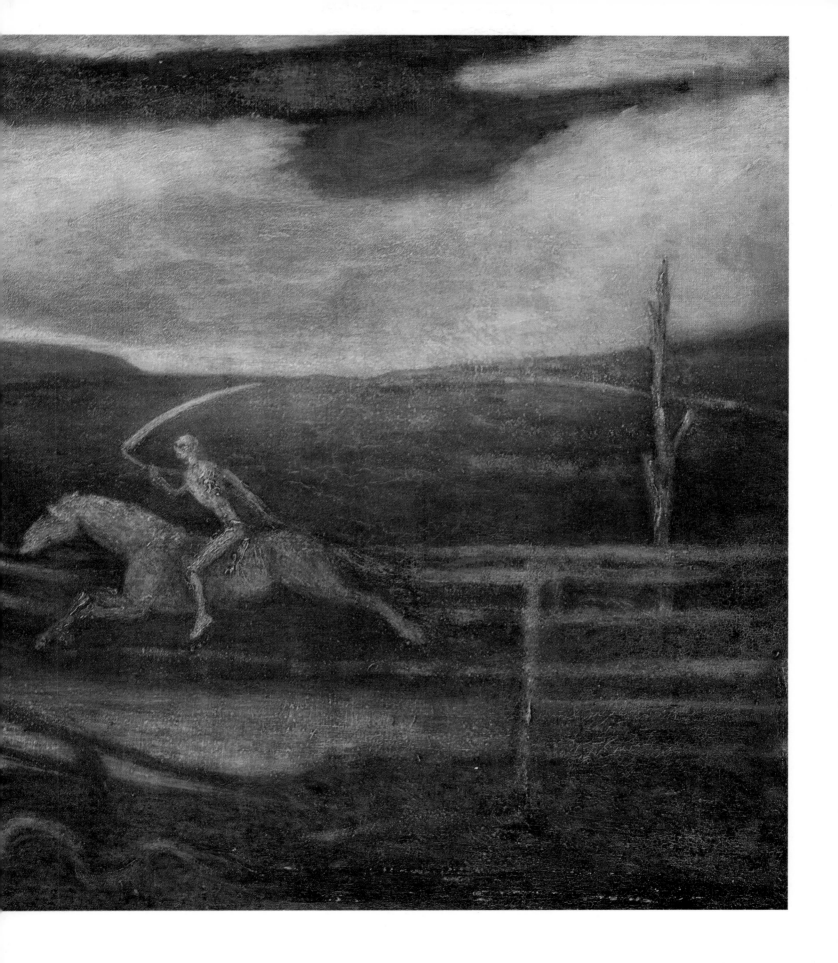

In the 'Rope Dancer,' Ray worked in the flat, sharp patterning and delineation of Synthetic Cubism—a non-objective spin-off of Analytical Cubism. No other American had pursued this mode with any seriousness. Ray's arrangement is an intricate design of movement that takes on a seemingly everchanging rationale of its own. It is a complete abstraction of tightly interrelated parts that constantly recharges itself.

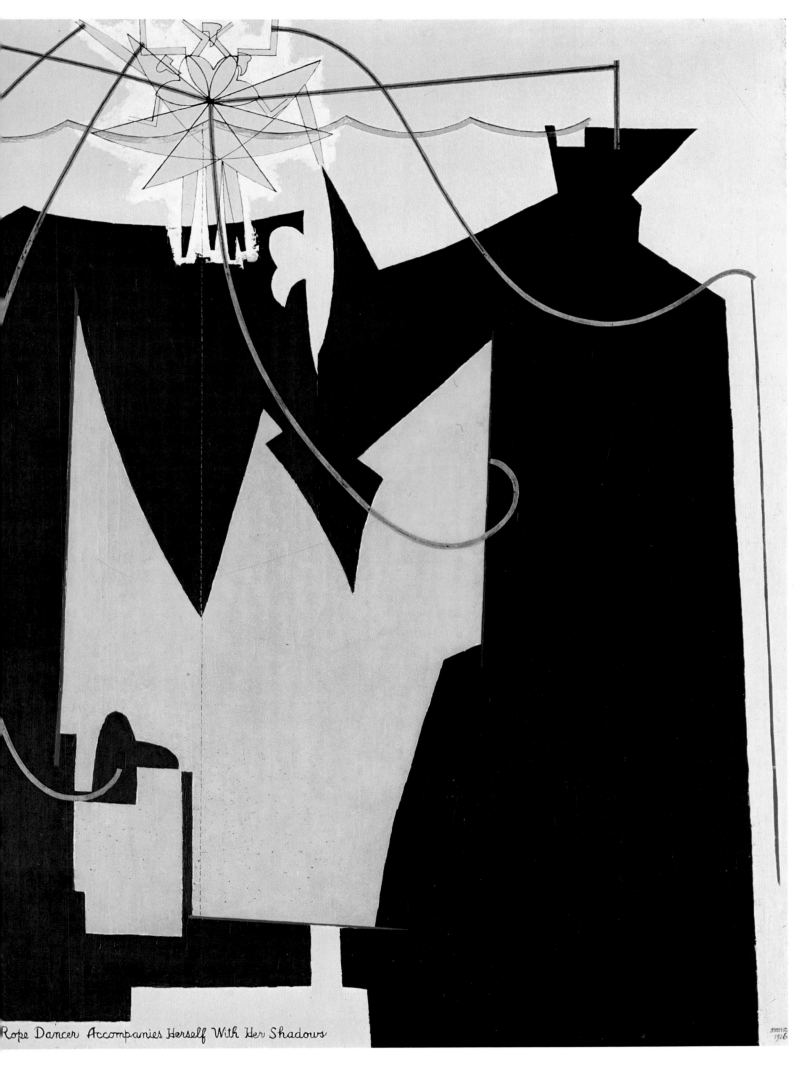

Rope Dancer Accompanies Herself With Her Shadows

127

'Oriental.' Synchromy in Blue-Green (1918)
Stanton Macdonald-Wright (1890–1973)
The Whitney Museum of American Art, New York, New York

Young American painters looking for the promise of the 20th century turned to Paris early in the century for direction. They flocked to the Academie Julien, the Sorbonne, and L'Ecole des Beaux-Arts. Americans abroad between 1900–1914 witnessed the restlessness of artistic change that would alter the art of the western world. There were the Fauves—the 'wild beasts'—Henri Matisse (1869–1954), Maurice de Vlaminck (1876–1958), Andre Derain (1880–1954)—who sent vibrations through French art with their brutal use of color. There were the Italian Futurists—Giacomo Bala (1871–1958), Umberto Boccioni (1882–1916), Gino Severini (1883–1966), who 'visually' marched to the rhythm of machinery and the ultimate war to reshape the world. There was the cubism of Pablo Picasso (1881–1973) and Georges Braque (1882–1963) who explored another direction.

Virginian Stanton Macdonald-Wright, age 17, arrived in Paris in 1907 and joined Matisse's class. There he met Morgan Russell (1886–1953) and the two founded the Synchromist Movement. Synchromism (*eg*, with color) relied on color in the same way symphonic music relied on sound. Where the former was visually tonal, the latter was auditorally tonal. They rejected objective representation and recognizable form, becoming pioneers of non-objective art. Russell was the complete non-objectivist using color for the sake of color. Macdonald-Wright, however, built his synchromist abstractions on the figure but nearly obliterating it in the process. In '*Oriental*' the figure is submerged beneath the color patterns with vague hints of its initial presence. The Synchromists brought non-objective painting to America when they exhibited in the 1913 Armory Show in Manhattan.

The Bridge (1922) *Joseph Stella (1880–1946)*
The Newark Museum, New Jersey

Joseph Stella was 16 years old when he emigrated to the United States from Italy in 1896. Settling in Pittsburgh, he soon began to paint pictures whose color was as dim as the sooty cloud that perpetually overhung the city. Stella returned to Europe in 1910 in time to be caught up in the challenging visions of Pablo Picasso, Henri Matisse and Amedeo Modigliani (1884–1920), all of whom he met. Two years later, Stella saw the large Futurist exhibition in Paris where the art of Gino Severini, Giacomo Balla and Umberto Boccioni, among others, demonstrated their new theory of visual sensation—*Divisionism*—that spun off another visual innovation—*Cubism*. 'Everything moves, everything runs, everything turns swiftly . . . objects in motion are multiplied . . . a galloping horse has not four legs: it has twenty and their movements are triangular,' it was said. It was the Futurists who in their shrill Manifesto (1909) called for the obliteration of the past and saw war as their instrument.

Stella was impressed. He returned to the United States and became obsessed with the symbols of the new and dynamic age, neon lights, speed, the Brooklyn Bridge, crowds and more. In *The Bridge*, which seems to shimmer with vitreous-like color and whose symmetry, dramatic patterns and sharply delineated design, thrusting forward and backward, Stella creates a powerful tension as if the Bridge were straining to release itself from its own cables.

The City from Greenwich Village (1922)
John Sloan (1871–1951)
National Gallery of Art, Washington, DC

There is an aspect to the work of John Sloan, a genre painter at war with the Academy and tradition, that deserves notice. From the beginning, Sloan's subject was the city. His interest was the exploration of form and its relationship to color. In this regard he used his subject ably. In his early years, structural drawing, development of form and veiling it all in color was as important to him as breathing modernity into the stuffy Euro-American tradition. In later years, form and color in a Sloan painting were nearly synonomous. While Sloan was not a pioneer in form description or in the particular relationship between drawing and color in the building of form, he was a pioneer in subject selection and usage. Interpreting the teeming or lonely life of the city— not an ordinary city, but New York City— its elevated trains, concrete canyons, massive buildings, atmosphere and motion—the cityscape— Sloan challenged tradition and placed himself among the progressive painters of any era. Beyond mid-life, Sloan's interpretations took on a romantic mellowness that spoke more about his passion for the City's streets and skyline, its life and energy, than his early overriding quest for new ways to express form. *The City from Greenwich Village* makes this all too evident. There is still studied drawing and the building of form enhanced by the careful distribution of lights and darks. But none of this seems to be self-serving in the interest of artistic essentialties. Sloan has used his brush to give us an idea about 'city,' not its appearance or its artistic essentialities stripped of subject matter.

Ruby Green Singing (1928)
James Chapin (1887–1975)
The Norton Gallery and School of Art, West Palm Beach, Florida

In 1915, not many American artists had absorbed the imagery of Cezanne and the Post Impressionists. But 28-year-old James Chapin of New Jersey, who had left his Cooper Union classes in Manhattan for the ateliers of Paris and Antwerp, Belgium, did. But Chapin's understanding of the French modernists had more of an effect upon his later teaching at the Pennsylvania Academy of Fine Arts and upon his own learning process than it did on the visual quality of his art. Nevertheless, Chapin saw the Post Impressionists as a platform upon which to build his own personal style. Chapin was a superb draftsman and colorist who easily could have slipped into a more popular polished artistic mode. Instead, not long after returning home from his European studies, he opted for a freer, more expressionistic direction in painting small town America and portraits.

Chapin saw his artistic commitment as an emotional response to human presence rather than as an intellectual response to artistic principles of painted visual relationships. Like the moderns, whose full impact was yet to be felt in the America of the 1920s, Chapin liked to keep his options open so that he could apply himself in different ways to the subject rather than impose a formulized technique on every concept.

His portrait of *Ruby Green Singing* is singularly elegant in its simplicity and passionately disposed in a humanizing warmth. Chapin captures in the stance and angle of the figure a quiet and indelible dignity without resorting to posturing cliches. There is a disarming ease in the handling of form, texture, color and value. There is an unsentimental honesty in the characterization.

I Saw the Figure 5 in Gold (1928)
Charles Demuth (1883–1935)

The Metropolitan Museum of Art, New York, New York

Charles Demuth, stricken with an incurable disease, lived in the house of his birth in Lancaster, Pennsylvania all of his 52 years. He did study at the Pennsylvania Academy and visited Europe on two occasions. On his second trip abroad (1912–1914) he fell under the spell of Cubism, a new invention of Pablo Picasso's and Georges Braque's, an invention that would alter the direction of 20th century art. The 'cubists' were interested in representing form in space where the form was reduced to their solid geometric essentialities. They broke down objects to their basic cubic, cylindrical or globular structure and reassembled the various planes into a different order.

Demuth built on what he perceived in cubism as appropriate to his own inclinations. He took a more analytical approach while turning it inward to satisfy his particular imagination and taste. From time to time, Demuth worked with a cool precision that connected him to another group of artists called the 'Immaculates' or the 'Precisionists,' among whom was Charles Sheeler. These painters were primarily interested in the face of technology and the communication of the precision of industrial power. But Demuth's interests lay elsewhere— in non-objective art, for example. Within that frame of reference, he produced a series of 'poster portraits,' precisely rendered. Among these was his symbolic representation of the great physician-poet, William Carlos Williams. Here, Demuth symbolizes both Williams' activities and personality in *I Saw the Figure 5 in Gold* using initials, a nickname, a middle name, headlights and a number 5 red fire truck. It was an innovation in the realm of portraiture that offered an imaginative iconography to relay a person's significance and traits through symbols and design rather than a mirrored or impressionistic illusion of physical reality.

Self Portrait (1929) *John Kane (1860–1934)*

The Museum of Modern Art, New York, New York

John Kane came to art late in life. It was not until he was 67 years old that he first exhibited a painting. Scottish-born Kane came to the coal fields of Pennsylvania in 1879. He was 19 years old. The young Kane was not fit for much more than a life of hardship which indeed was to become his lot. He tried every kind of menial work but just spent a life of moving from one job to the next. Finally, while working for the railroad, he was involved in an accident that cost him a leg. Recovering from his misfortune, the only work he seemed able to do was house painting and eventually picture painting. Most of Kane's paintings were typical of the untrained and unsophisticated painters of pictures in that they were often painstakingly devoted to detail, without atmospheric illusion and somewhat flat. They were not unlike the work of the long gone itinerant limners.

However, untrained, Kane nevertheless had a good eye and a strong and determined hand that permitted him to bring sharply into focus the strain of his life. The grimness of his *Self Portrait* is as unrelieved as was his life. Painted when he was 69, the work is at once a depiction of what Kane was in his younger years—lean, hard, muscular—and an image of his old age—a stony countenance of futility. There is magic to the painting in its innocence and a power in the strangeness of the arches with which he has created a rigid set of haloes for himself. Kane's *Self Portrait* is folk art of extraordinary dimension.

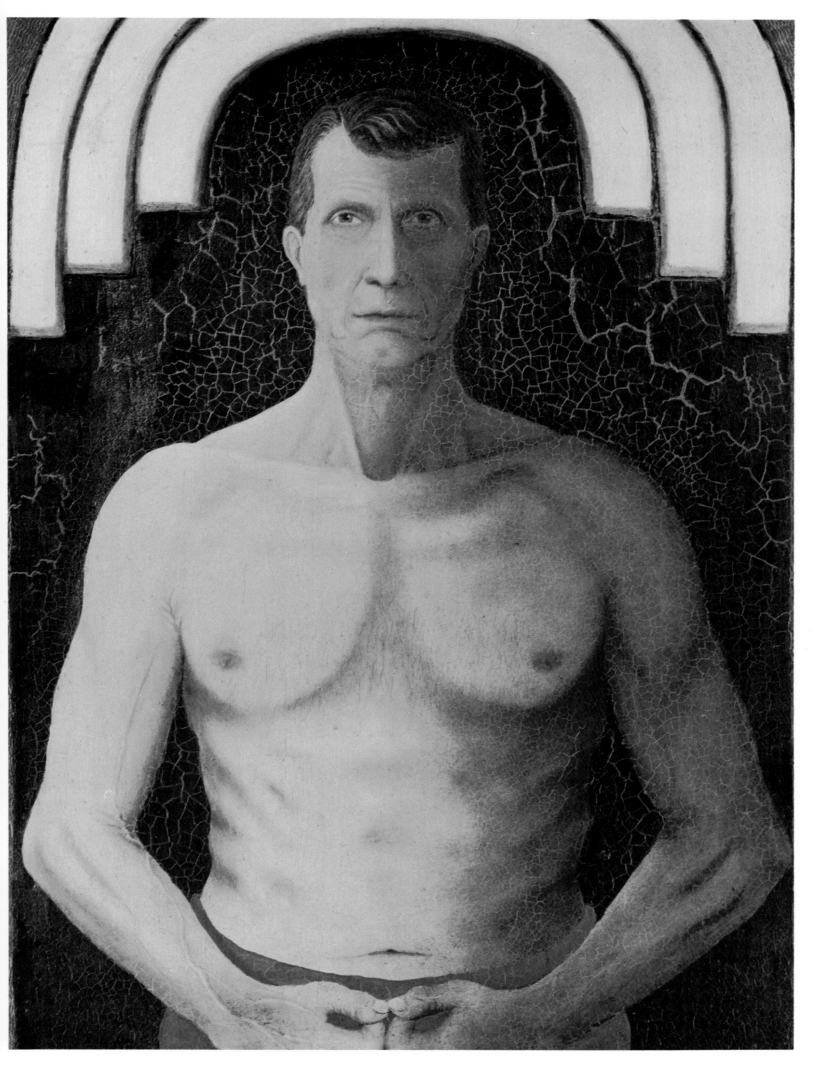

Yellow Cactus Flower (1929)
Georgia O'Keefe (1887–)
The Fort Worth Art Museum, Texas

Using nature as her artistic seed, Georgia O'Keefe developed a highly visible, personal, and monumental style without parallel in American painting. Perhaps more symbolic than abstract—although the abstract element is clear, strong and determined—O'Keefe's paintings of simplified, enlarged and isolated natural forms express the spirituality of nature—of Georgia O'Keefe herself.

O'Keefe came East to New York from Sun Prairie, Wisconsin after a brief succession of jobs as a public school art teacher and advertising artist. In New York, she met Alfred Stieglitz (1864–1946). Stieglitz, whom she later married, was an innovative photographer, antagonist of the Academy, and impressario of the modern movement. Well-connected with Parisian avant-gardists, Stieglitz founded his '291' gallery in New York where he exhibited and promoted those young American artists, including O'Keefe, who strove for a new language of vision to communicate their free creative spirits. It was a different perspective than that of Robert Henri, a contemporary who also railed against academic tradition but who favored a free-spirited representation of the American scene.

Georgia O'Keefe moved to the sun-splashed Southwest in the late 1920s. There she began to make visible the concept that art and one's senses were inseparable. For O'Keefe, sensuality was realized in the stark design of her floral forms and other natural elements that overwhelmed the space of her canvases. So large and up-scale were these forms that they no longer were what they seemed to have been. Instead, they were transposed into spiritually conceived, smoothly defined poetical images of lyrical fantasy.

(Page 141)
Early Sunday Morning (1930)
Edward Hopper (1882–1937)
The Whitney Museum of American Art, New York, New York

The American scene—the cities, small towns, tenements and mansions, lighthouses, backyards and backroads, dark theaters, dark streets, gas stations and more—was Edward Hopper's milieu. But the quiet loneliness and often utter desolation of the soul was Hopper's real subject. Hopper considered himself to be an unyielding realist. Yet, the quietly intense subjectivity of his moods seem to offer more than the mere appearance of objects in nature as seen under a light. Hopper's realism was the realism of soul—the look of feeling.

Hopper was born in Nyack, New York. He received his first artistic insights from Robert Henri whose search for a national image put his stamp and influence on American painters who kept an open mind about 'modernism.' Hopper spent some time in Europe admiring the impressionists but navigated toward etching and illustration which occupied much of his time until 1924 when he turned his full attention toward painting.

Early Sunday Morning presents the visceral hopelessness of small town America as the Great Depression swept the land. It is a work that says much without triviality. American in its sunny environment, it is, nevertheless, a deadly comment on the state of loneliness. Its strict horizontality emphasizes the relentless sigh of emptiness.

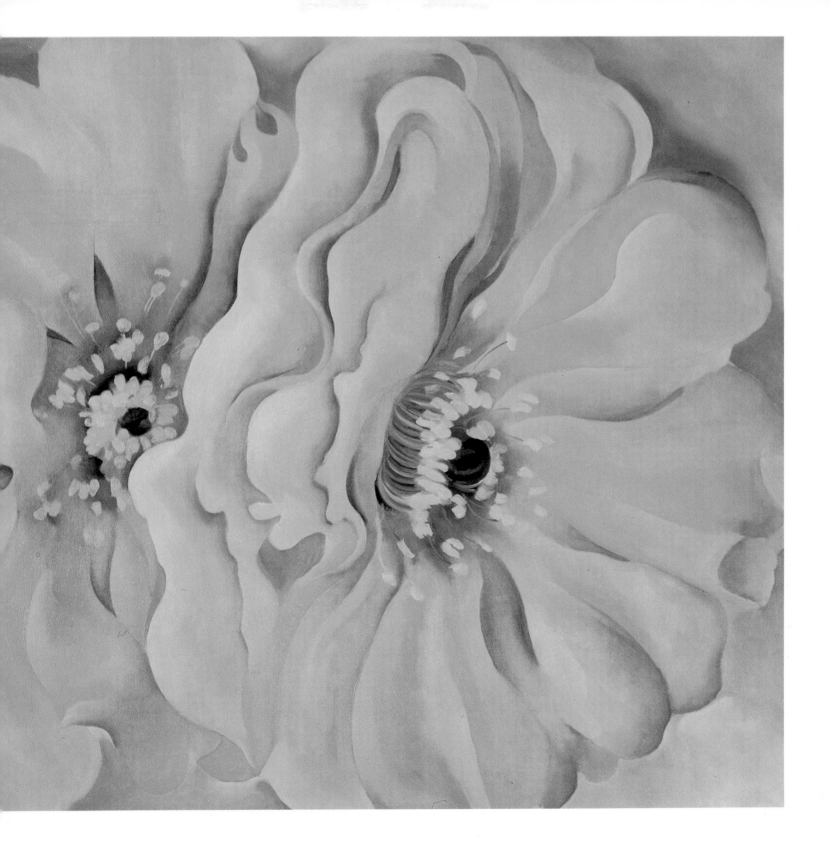

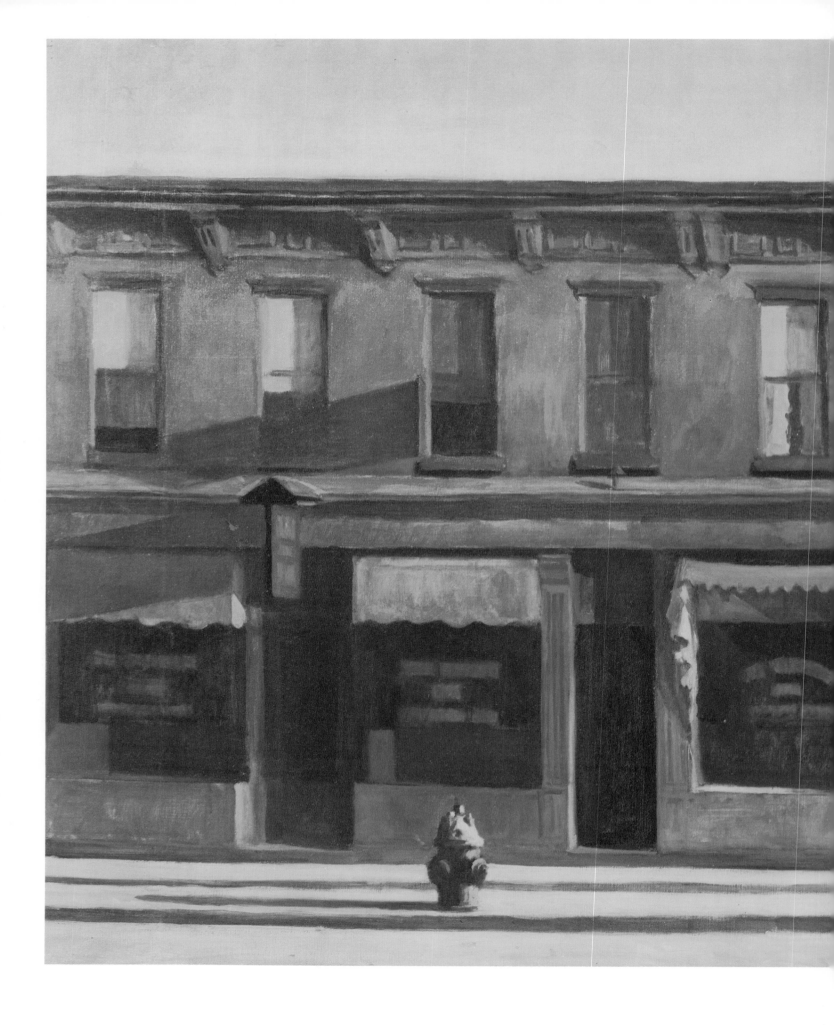

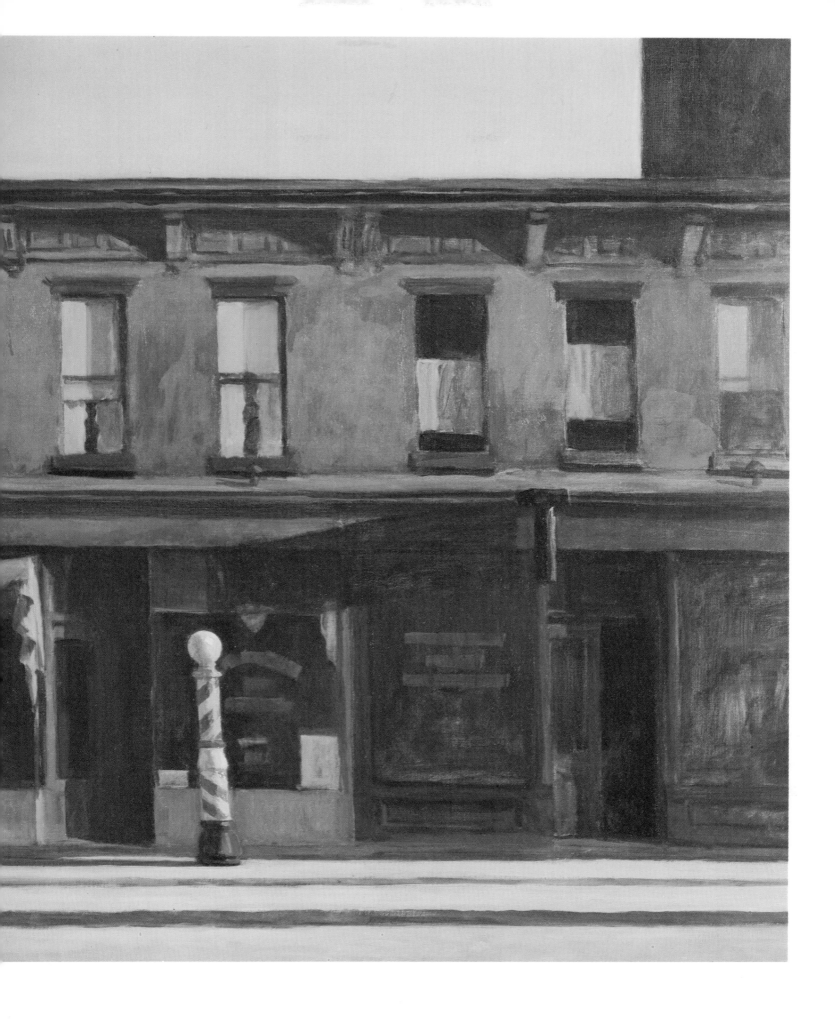

Why Not Use the 'L'? (1930)
Reginald Marsh (1898–1954)

The Whitney Museum of American Art, New York, New York

Everyday street scenes, whether they be the shabby New York Bowery of the 1930s or George C Tilyou's Steeplechase Amusement Park in Coney Island of the 1940s, was Reginald Marsh's arena. But Marsh's erstwhile genre depictions took on a strange unreal appearance that belied his avowed 'realism.'

The pattern of Marsh's education flowed contrary to his contemporaries who were flocking to Paris and Munich to absorb the technical prowess of the Germans and the visual excitement of the French moderns. Marsh was born in Paris. His parents were American painters who sought inspiration in the primacy of European Art. But Marsh was sent home to America to attend Yale where he illustrated for the *Yale Record*, an extracurricular activity that led him to illustrate for *Vanity Fair* and the *New Yorker* after graduation. It was a vocation that Marsh soon left behind to pursue his painting and printmaking. His goal was to portray the life of New York in the manner of the Old Masters. And this he preached in his classes at the Art Students League. Here, he stressed a handling of the figure that was nearer Peter Paul Rubens (1577–1640) than most understood. But what Marsh succeeded in doing was to produce a romantic, almost fanciful genre of great vitality that echoed the Baroque Age. And this he did, for the most part, with Chinese ink, egg emulsions and watercolor in a half drawing, half painting method that produced muscular form, filling his space with dimension and movement. While not a political commentator, Marsh did paint social comment. Often it was more deliberate and moving a statement than those caught up in the frenzy of his line and brush. Such a work is the 'L.' Quiet and near stony, the formalized bulk of the image captures the essence of urban meniality. The people in Marsh's subway have been caught in an eternal transit.

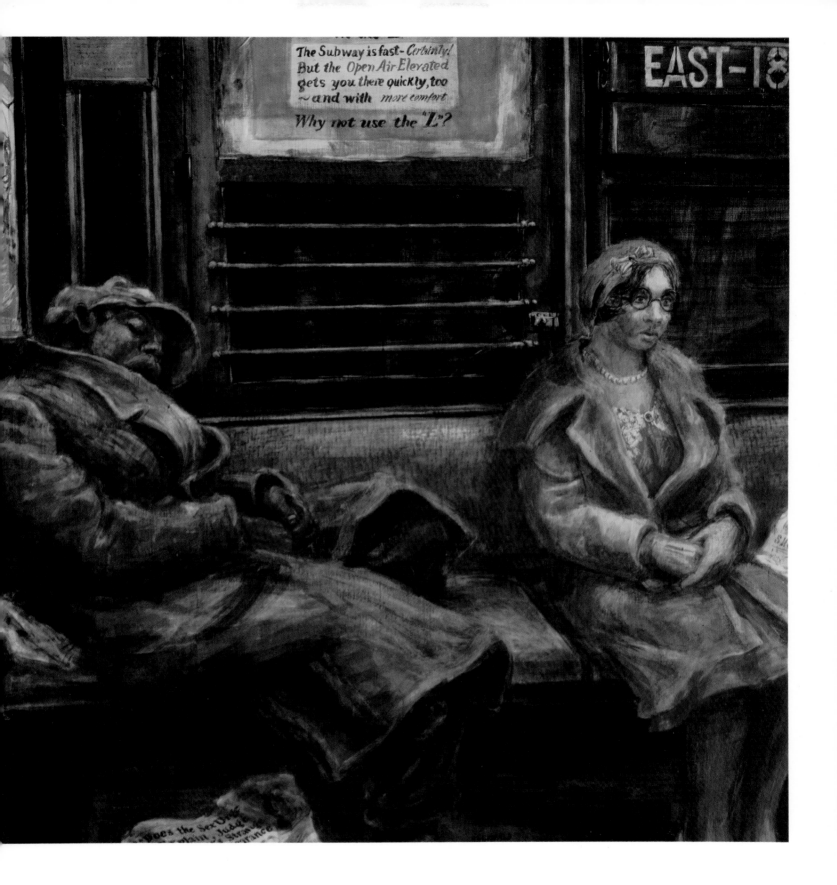

143

American Gothic (1930) *Grant Wood (1892–1942)*

The Art Institute of Chicago, Illinois

Grant Wood knew America and especially Iowa better than any place on earth. And this revelation came to him in Paris after World War I where he was enjoying a Bohemian life studying art at the Julian Academy. Thoroughly convinced that there was no cultural future in midwestern America, he had gone to Paris to learn the Impressionist tradition. Disenchanted with Impressionism, he moved on to Germany where he became enthralled with early German masters, an influence that would remain with him always. Previous to his European experience, Wood had attended the University of Iowa and the Chicago Art Institute. In any case, Grant Wood returned home to his 'no nonsense' Quaker roots. There he began to paint the only images he knew in the only way he felt comfortable—carefully composed, precisely and sharply executed, with every detail under the complete control of his extraordinary draftsmanship.

During his lifetime, Grant Wood was hailed, acclaimed and celebrated as the most American of America's painters. The accolade was understandable with the instant popularity of *American Gothic* quickly followed by *The Midnight Ride of Paul Revere*.

American Gothic clearly represents the sturdiness of rural America. Moreover, its very symmetry, immobility, verticality and meticulousness depicts the narrow and suspicious world in which these simple people lived their lives. Such painting came at a time when the Philadelphia and New York enclaves of genre art were being decentralized in favor of a more 'regional' approach. America was moving westward—slowly. And artists like Grant Wood were staying home—out of New York—to find their inspiration and strength in their own origins.

(Page 147)
Engineer's Dream (1931) *Thomas Hart Benton (1889–1975)*

Memphis Brooks Museum of Art, Memphis, Tennessee

As a teenager in Paris in 1908, Thomas Hart Benton was readily influenced by the cubist excitement that was injecting the world of art with a new and more modern energy. But young Benton was never out of touch with his essentially conservative midwest origins. Rejecting French modernism he soon returned to small-town realism that was more lastingly influenced by the late Italian Renaissance and the expressive distortions of Domenico Theotocopuli—'El Greco' (1541–1614).

Benton's general interests ranged over everything that was fundamentally American—American history, folkways and folklore and common occurrences or toil. None of this was politically motivated. Social realism or social protest was not implicit in the Benton works. For the most part, Benton gravitated toward the historic and everyday realities or fantasies of his native Missouri and the rest of the Midwest. He was a 'regionalist' at a moment in the course of American art that offered regionalism as a strong native movement.

Benton's art was distinguished stylistically from nearly everything around it by very powerful linear rhythms that swung back and forth through his paintings reasonably remaking or distorting every shape

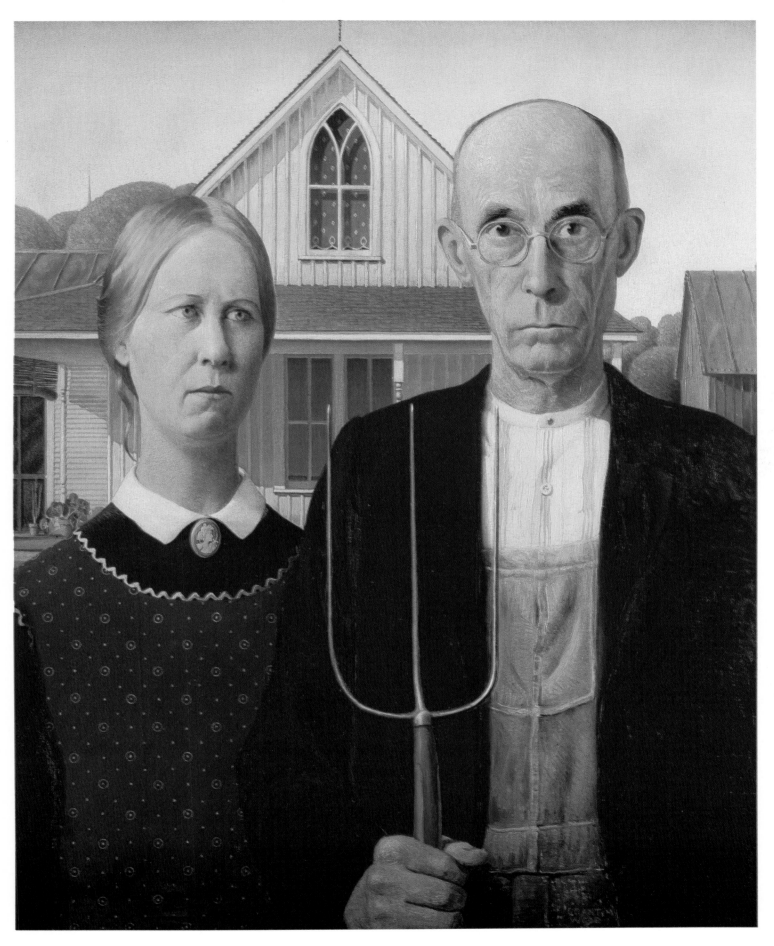

and form according to where Benton directed the viewer's vision. *Engineer's Dream* possibly falls in the area of fantasy folklore. The bridge is down. A flagman is trying to stop the locomotive before disaster strikes. That simple incident in Benton's convoluted rhythms becomes a dynamic and impressionable nightmare not only to the dreaming engineer but to the gallery goer as well.

The Midnight Ride of Paul Revere (1931)
Grant Wood (1892–1942)

The Metropolitan Museum of Art, New York, New York

There was no real attempt on the part of Grant Wood to use his meticulousness to create either an illustration or an historical reproduction of Paul Revere's famous ride. It should be said at the outset, and for the record, that there were others who rode that night—Dr Samuel Prescott, William Dawes, Ebenezer Dorr, among them—who were more effective than Revere. Nevertheless, thanks to Revere's various memoirs and the faulted version of the ride by Henry Wadsworth Longfellow—'Listen my children and you shall hear. . .'—Revere became the heroic figure riding perilously through the night, a symbol of American courage, liberty and strength.

Here, Grant Wood formalizes and freezes a legendary factor in American history. And this he does with an eagle's eye view of the event far below with the landscape, structures and road serving more as a stage than as an environment. There is romance here but not in the painting's atmosphere. It is in the doll house scale of the parts. A powerful stylist, Wood manipulates his forms, shapes, light and dark in a fixed yet constantly rolling movement that circulates the canvas. There is a strange stiff innocence and perfection implicit in the design. It is a tightly controlled abstraction with recognizable elements. It tells a story without being maudlin. It is fantasy in its crispness. But however removed it is from the illusion of actuality as one might expect of traditionally painted historical pageantry with all the buttons in the right place, Wood plants the event firmly in our consciousness where reality exists and eternalizes for all Americans a romantic moment in American history, another American icon.

The Passion of Sacco and Vanzetti (1931–1932)
Ben Shahn (1898–1969)

The Whitney Museum of American Art, New York, New York

Four years following the 1927 execution of Nicola Sacco and Bartolomeo Vanzetti for the 1920 murder of a Massachusetts paymaster and guard, Ben Shahn painted a series of gouaches dealing with their fate. The Sacco-Vanzetti case was a cause célèbre world-wide. Many, including Shahn, believed that the two Italian aliens, professed anarchists, were convicted for their philosophical beliefs and origins, rather than on the evidence which never connected them to the crime with certainty. Shahn's visual response, direct and pungent images of an event he likened to the Crucifixion, moved him to the van of the social realists painters.

Born in Russia in 1898, Shahn came to the United States in 1906. He attended New York City schools, colleges and the National Academy of Design. He worked for years as a lithographer in a commercial printing plant. His avowed artistic purpose was to communicate a socio-political point of view. He claimed not to have an esthetic raison d'etre. Shahn fitted the public perception of a 1930s propagandist-artist, perhaps similar to Honore Daumier (1818–1879). But unlike Daumier, whose biting art did not overtly court the art establishment, Ben Shahn did not entirely reject esthetic avenues of expressionism, despite his denials of artistic fundamentalism.

In *The Passion of Sacco and Vanzetti*, Shahn relates the caricatured three member Lowell Committee (whose final report led to the execution) with allegorical propriety to both the dead men in their coffins and to the formality of the establishment's judicial architecture which includes a portrait of presiding Judge Thayer upholding the law. The various distortions belong to expressionist painting derived chiefly from Matisse. The severity of the Shahn design, its angularity and rigidness, is symbolic and relentless in its angry accusation of justice allegedly denied.

Six O'Clock (1936) *Charles Burchfield (1893–1967)*
The Everson Museum of Art, Syracuse, New York

Born in Ashtabula, Ohio, Charles Burchfield spent five years at the Cleveland School of Art (1911–1916). But when he left the art school he worked as a cost accountant in an automobile parts factory until 1921 with one brief military interruption in 1918. Whatever art Burchfield managed to do during this period he did in his spare time, chiefly watercolors of bits and pieces of nature. Many of these had overtones of the macabre and communicated a deep brooding quality. Between 1921–1929, Burchfield worked as the principal designer in a wallpaper factory in Buffalo, New York. He quit to devote his full time to painting. Now his preoccupation was with the depressing industrial districts in the Buffalo area, the lower class landscape.

Burchfield's earlier and melancholy obsession with flowers and streams or other natural forms now manifested itself in the watery and snowy environments of his urban views.

In his *Six O'Clock*, Burchfield makes a straightforward presentation of a workingman's street at dinner time. The drabness of the street, its near seediness, is hardly made warmer or more comfortable by the view through the windows of an ordinary, hardworking family having dinner. The dullness of the row of houses are only made more dreary by the newly shoveled snow and the drifts of snow. The picture is relentlessly chilling. The crescent moon lends a strange note of fantasy to what otherwise is a realistic image of an aspect of life of industrial America. But the power of the painting lies in Burchfield's ability to take the viewer inside the monotony after first depicting the look of the exterior.

(Page 155)
American Tragedy (1937)
Philip Evergood (1901–1973)
Collection of Mrs Gerritt P Van de Bovenkamp, New York, New York

The turning point in Philip Evergood's life was the Great Depression (c 1929–1937) and the social problems it engendered. The impact upon Evergood's thinking was nearly permanent.

Raised in comfortable New York surroundings, Evergood's Australian-born father sent him to the playing fields of Eton and Cambridge in England for his education. But Evergood gave up his athletic and academic pursuits in 1921 for London's Slade School of Art. Later he returned to New York to study with George Luks; went back to Europe and finally came home to New York in 1931.

Until the Depression, Evergood occupied himself with biblical themes. As the Depression increased in intensity, he turned his picture-making toward the socio-political problems of the country, most notably civil rights and racial discrimination.

His major work dealing with the subject of Man's inhumanity to Man is the *American Tragedy*. Recalling Francisco Goya's (1746–1828) painted response to Napoleon's invasion of Spain (*The Execution of the Madrileños*) and the terrorization of ordinary citizens, Evergood's painting was likewise a blunt and unforgiving protest. *American Tragedy* deals with the terrible riot that occurred 30 May 1937 on the South Side of Chicago during the strike at a Republic Steel plant. The terror in the painting becomes more shocking as the waves of police and blood-letting shatter the warm and sunny day. Symbolically, the scene is dominated at its center by a pregnant woman and a defiant man.

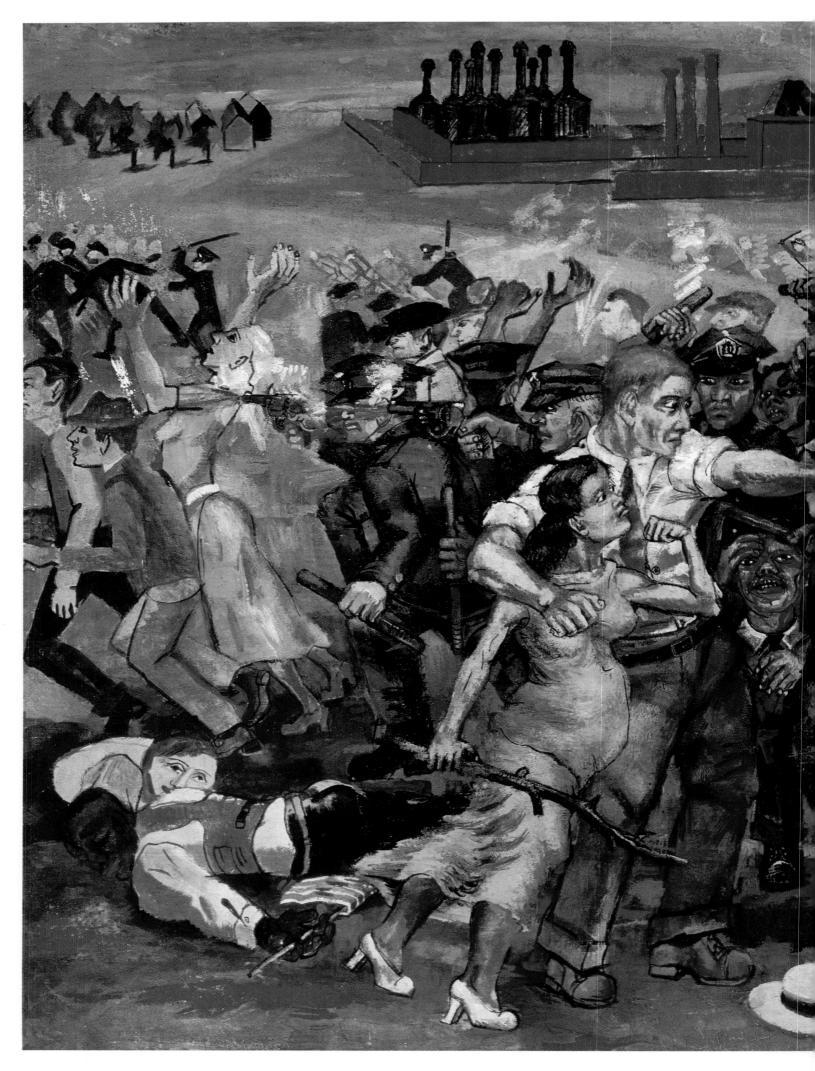

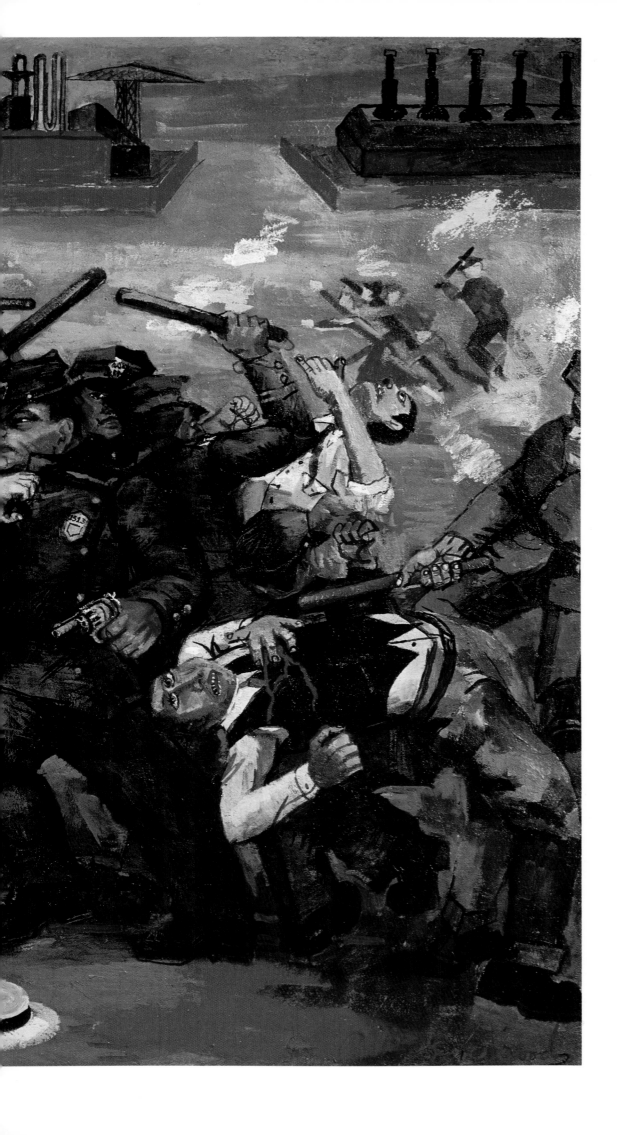

Trio (1937) *Walt Kuhn (1880–1949)*

The Taylor Museum, Colorado Springs Fine Arts Center, Colorado

Brooklyn born William 'Walt' Kuhn was among those painters with newspaper or magazine illustration backgrounds who associated with the now famous, pioneering 'Eight.' During the first decade of the twentieth century, Kuhn worked off and on as a cartoonist contributing his work to the *New York Sunday Sun*, the *World*, *Judge* and *Puck* and publications in San Francisco. All the while he pursued his painting, studied in Paris and Munich, became involved in the 1910 Exhibition of Independent Artists, co-founded the Association of American Painters and Sculptors, and helped establish the 1913 Armory Show.

A man of great vitality and many moods, Kuhn's early work—landscapes—was derived from French Impressionism. However, it hinted a tenseness and vigor that would later emerge into a personal style—figurative—via experimentation with synthetic cubism.

Kuhn's major expressive interest focused on circus performers—clowns, acrobats, trapeze artists and the like—and the brooding romance of stage makeup and costume hiding some dark and moody element. The harshness of the color, the bold and bare description of the form, the simple muscularity of the subject matter, all worked to serve an image of unforgettable grimness. These later paintings, and chief among them *Trio*, not only reflected Walt Kuhn's dynamic energy but a visibly restrained emotional drive that led him to a mental institution.

(Page 159)

Wisconsin Landscape (1938–1939)
John Steuart Curry (1897–1946)

The Metropolitan Museum of Art, New York, New York

The Great Depression of the 1930s struck deeply at the security of the entire nation. Americans, overdrawn on the American dream, frustrated and bitter, waited for the dream to return. American will had sagged, at least temporarily. Into these seasons of yearning and discontent stepped the Regionalist painters—Thomas Hart Benton, Grant Wood, John Steuart Curry and others—whose portrayal of America's heartland stirred the memories and reawakened a spiritual interest in what America had been and ought to be. The ghost of Robert Henri preached on, insisting that the American scene depicted with a free but conscientous brush was and always will be an expression of American values.

Curry's midwestern roots—Kansas and Wisconsin—served him better than his brief and non-productive sojourn among the moderns of Paris, an interlude so discouraging that he nearly gave up. Returning to the United States in 1928 he painted a childhood memory, *Baptism in Kansas*, which immediately won him a wide audience and the patronage of Gertrude Vanderbilt Whitney. Curry followed his success with more nostalgic visions of his midwest from *Tornado over Kansas* and the historical terror of John Brown's bloody excursions into Kansas to *Wisconsin Landscape*.

Curry's view of the land, however, is as dramatic and appealing as is the compelling muscularity of his John Brown. There is a grace and grandness to the space that Curry spreads before the viewer, expressive of his experience and shared by the American consciousness.

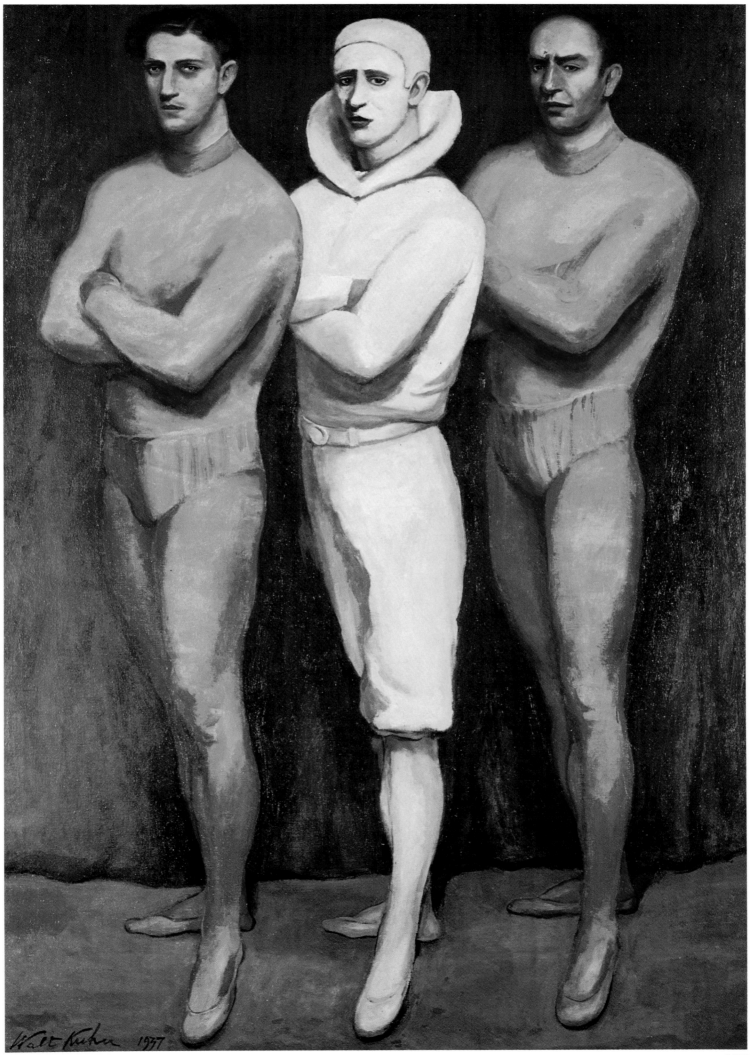

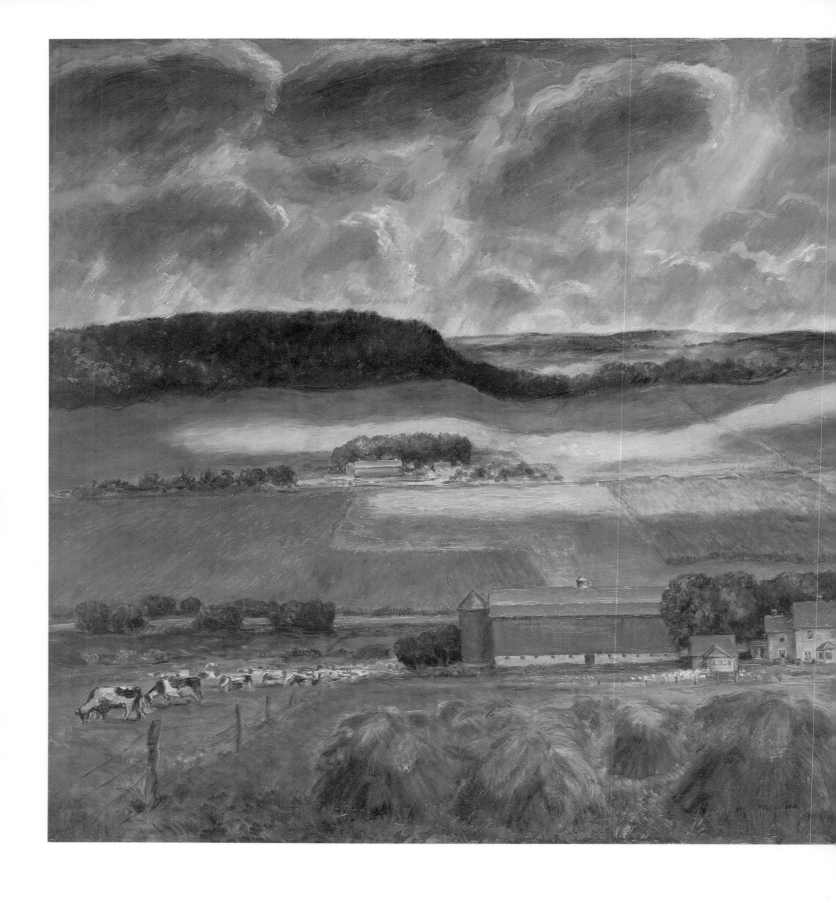

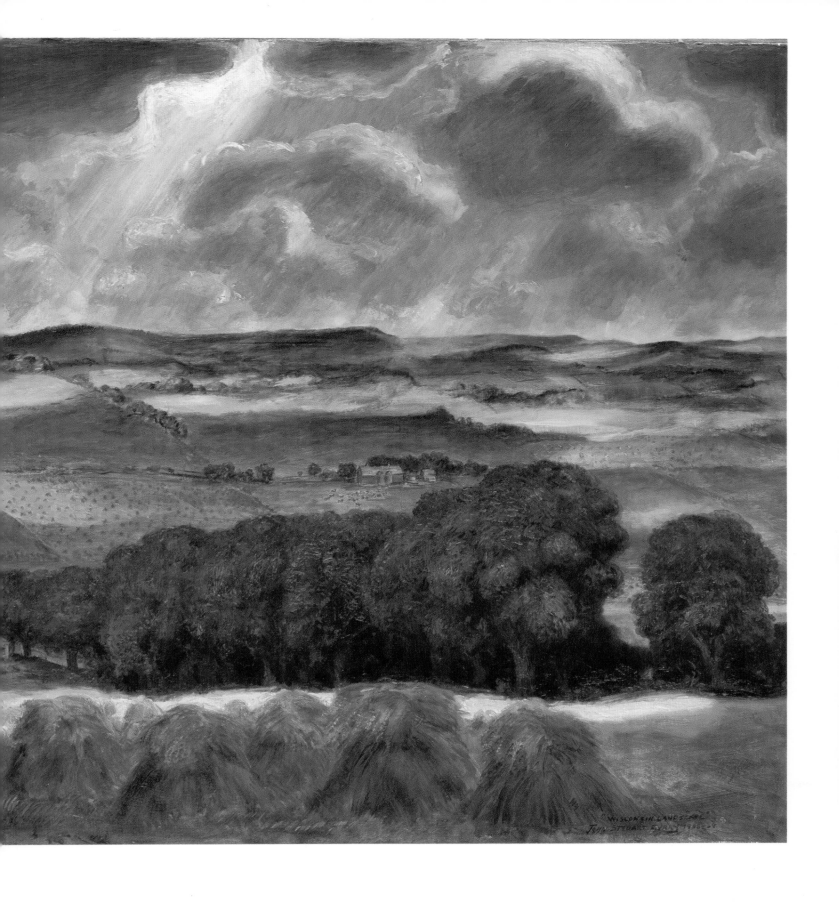

Rolling Power (1939) *Charles Sheeler (1883–1965)*

Smith College Museum of Art, Northampton, Massachusetts

Few painters used man-made equipment and environments—railroad yards and rolling stock, industrial sites and factory smokestacks, farms and barns, bridges and trusses, and the like—so completely in the service of their intellects rather than in the appearance of the objects as did Charles Sheeler. Born in Philadelphia and a product of the Pennsylvania Academy of Fine Arts and the classes of William Merritt Chase, Sheeler belonged to that group of painters, the 'Immaculates' or the 'Precisionists,' who depicted realities in clearly defined geometrical symmetries that edged toward a visual mathematical perfection.

Sheeler's paintings were stark and cool, composed of cleanly rendered forms all organized in a careful pattern that willy-nilly presented an unmistakeably idealized view of the structures and machinery of the modern age. There is a detachment in the art, an impersonal approach that makes no statement with respect to texture, weight or composition of the material portrayed. There is only the form and the patterns or dynamics of geometry created by the relationship of one form to another. Moreover, Sheeler's art contains no atmosphere and certainly no atmospheric perspective. Nevertheless, Sheeler's clearly defined reality has primacy over nature's changing actualities. As all this applies to *Rolling Power*: what emerges is not fascination with railroad equipment but symbolization and a highly organized and meticulously crafted abstraction.

The Wave (1940) *Marsden Hartley (1877–1943)*
The Worcester Art Museum, Massachusetts

For nearly the first 60 years of his life, Marsden Hartley struggled to find a style and imagery that expressed his restless, emotional tie to nature, to the landscape, to the seascape. Born in Maine, his esthetic uneasiness launched a life of searching travel. Beginning in Cleveland where he went to study art, his journeys took him to New York and the classes of William Merritt Chase; to the National Academy of Design for more study; to France; Germany; the American Southwest; Mexico; back to New York and Maine. During all those years Hartley's paintings reflected the strong influences of his traveling connections. The Fauves and Cubists—Matisse and Picasso—had a very marked influence on his early work, work that was seen in the Armory Show of 1913. The German expressionists infiltrated his ideas. Hartley himself had been consistantly moved by the art of Albert Pinkham Ryder, whose mysticism and romance paralleled his own, while Cezanne lurked in the restless shapes and fractured color with which he expressed his perception of natural forms.

During the late 1930s, Hartley turned his attention finally to the place he knew best—Maine. And during the last half dozen years of his life, he created blunt and highly emotional paintings of the life and look of the Maine environs. His art was as rugged and as powerful as the Maine coast. At times it was nervously grim reflecting the intensity of his feeling. Always direct, as in *The Wave*, Hartley's art came right at the spectator with an unmistakable expressive image. Powerful, emotional, *The Wave* roars beachward shattering the space that Hartley's design and color creates within the canvas.

Blind Bird (1940) *Morris Graves (1910–)*
The Museum of Modern Art, New York, New York

The distraught birds of Morris Graves' creativity significantly address the individualism, originality and imagination that distinguishes twentieth century American painting.

Graves belongs to the Pacific Northwest where he was raised and where he studied with Mark Tobey. Tobey, a midwesterner who had gone to Seattle to live and to the Orient via Europe to wonder at Chinese brush drawing, tried to synthesize the art of East and West. He developed a highly introspective and poetical art that took a distinctively personal route in the evolution of twentieth century abstraction.

Graves also traveled through the Orient, chiefly Japan. More contemplative and removed from the world's seething currents, Graves, like Tobey, went beyond the mere appearance of modernity and evolved a highly personal imagery whose linear or calligraphic approach communicated an edginess. Without doubt, the Orient and the far Northwest had a direct influence over Graves. There is mystery to Graves' symbolic implications, evocative of oriental art. And in his very haunting *Blind Bird*—a gouache—there are hints of the mystique of another world.

Graves' art is inward—subjective—and separated from conventional levels of understanding. Yet, there is visual comprehension, the unmistakable bird. That image—*Blind Bird*—is insistent and hypnotic, tirelessly drifting in and out of our awareness.

Office at Night (1940) *Edward Hopper (1882–1967)*

The Walker Art Center, Minneapolis, Minnesota

There is an odd and disturbing still life aspect to Hopper's studied figurative interior, *Office at Night*. The subject environment, a business office, is unusual enough and at first glance hardly seems to merit artistic visibility. Yet, the choice is an intriguing innovation and a reasonable part of the genre schema—a view of ordinary experience. Into this enclosed space, Hopper has set with great deliberation simply stated forms, two figures, some furniture and papers. Nothing moves. All is still, quietly composed and waiting under a grim overhead light. The stark immobility of life in a barren office at night is penetrating. And we, the viewers, patiently wait for the man at the desk to finish his reading and make a decision. There will be none, at least not within the time zone of this painting. Everything is fixed and frozen in an instant of time selected by Edward Hopper.

Whether or not Hopper intended to include the narrative or illustrative aspects of the scene and describe what such a moment looks like—the appearance of a sparsely furnished office at night and its inhabitants is irrelevant. What he has done by design and by instinct is to include the viewers into his harsh realization of eternal 'aloneness' and the desperation that ticks beneath the surface. There is no escape from this office, so firmly fixed in its painted place. There is no escape from Hopper's intensely noiseless imagery of abandonment. Once more Hopper has inextricably linked us to the universality of loneliness. This is not a painting of an activity but a view of our souls through Hopper's window.

(Page 169)

One of the Largest Race Riots Occurred in East St Louis (1940–1941) *Jacob Lawrence (1917–)*

The Museum of Modern Art, New York, New York

During the 1930s and 1940s a number of artists aimed their art at the social problems besetting America: the meager subsistence of rural people; alleged miscarriages of justice; urban hoplessness; black disenfranchisement. The country was reeling from economic disaster— the Great Depression; from natural disaster—the Dust Bowl in the West; from geo-political apprehension—Adolf Hitler and the coming war.

Among the so-called social realists was an angry black artist, Jacob Lawrence. The 'realism' was not descriptive of the appearance or rendering of the painting but rather of the message the painting delivered. Lawrence targeted the historically poor relations between white and black Americans.

Granted a commission by the Federal Arts Project of the Works Progress Administration (WPA)—an experiment in government patronage of the arts to provide economic relief for artists—Jacob Lawrence created a series of panels called generically *The Migration of the Negro*. One of these panels, the 'Race Riot' proved to be a powerful and memorable communication of black feeling.

166

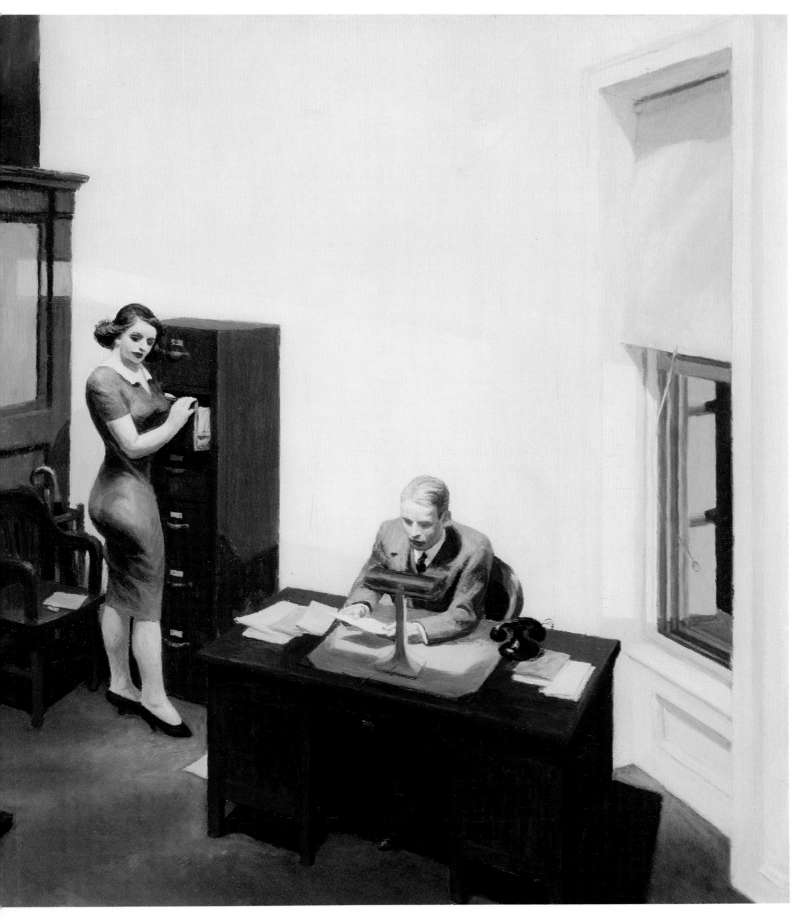

The severity of the painting relies on the stark handling of the five figures. Every angle, every tone, every position succeeds in serving the brutality of the subject. Seeming to be scissored into shape, the sharpness of the image, the quick contrasts in value, the standing, the kneeling, the falling, the fallen, the sticks and knives, all drive home a message of violence, discontent and waste. The painting's horizontal nature hints of death and tragedy.

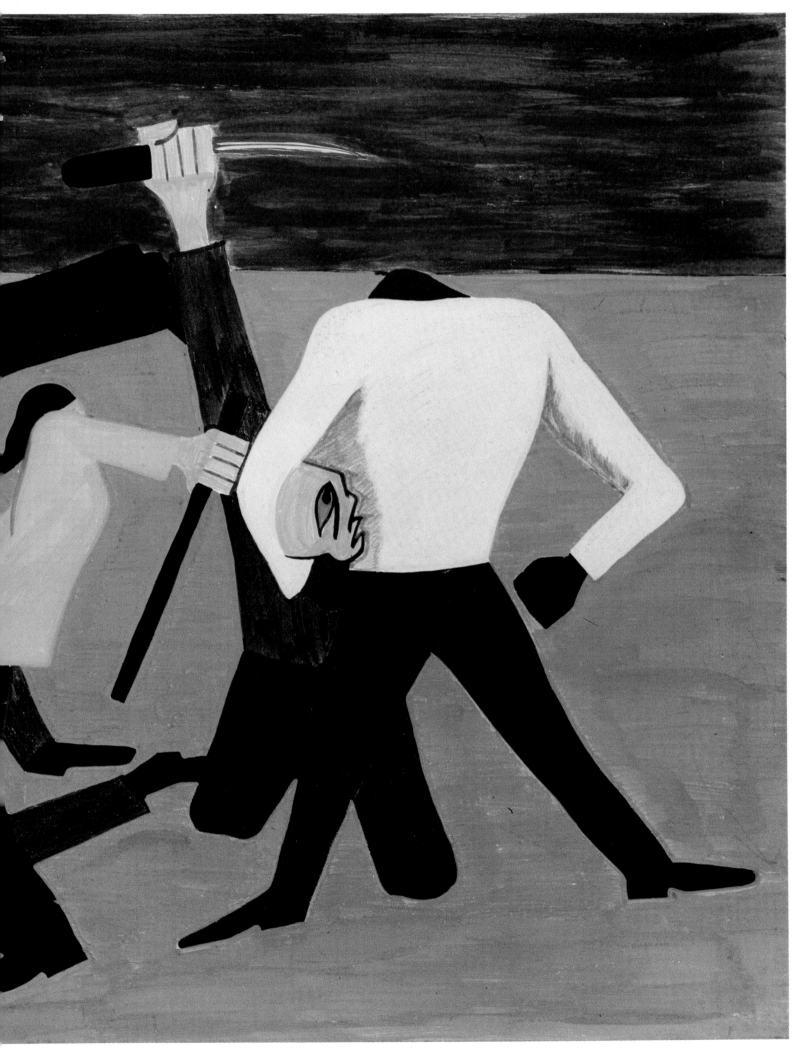

San Francisco Street (1941)
Mark Tobey (1890–1976)

The Detroit Institute of Arts, Michigan

An individualist among individualists, Mark Tobey marched to his own drummer creating very busy, highly complex calligraphic paintings that hint of Persia, the Far East and their mystical or, perhaps, their religious implications.

A midwesterner by birth, Tobey eventually gravitated to the Northwest, having been a commercial artist in Chicago; a student at the Chicago Art Institute; a world traveler visiting and studying in Europe, China, Japan and the Near East; and teaching in England where his various friendships brought him into further contact with oriental art.

All of these experiences served Tobey in the evolution of his imagery. His use of line and space to express motion was also well served by the abstract mode. The tonal quality of Tobey's art creates an occult atmosphere that causes his free calligraphic line to softly move and flicker with ever-changing possibilities within the single picture. *San Francisco Street* is alive with light, motion, atmosphere and energy. The pale blues, violets and white lights suggest the vitality of a city street at some mystical instant between sunset and night. Nevertheless, the painting, in its abstract expressiveness, edges toward the non-objective and the enigmatic.

Mark Tobey had a great influence over the art of Morris Graves. But however separated he himself was from the modern currents that were moving inevitably from the Fauves of 1905 to the Abstract Expressionists of 1955, Mark Tobey's art had a decided impact on the thinking of Jackson Pollock, too. In that respect, Tobey, the mystical visionary, was a conduit to the later Avant-Garde movements and the Abstract Expressionists.

(Page 173)
The Nighthawks (1942)
Edward Hopper (1882–1967)

The Art Institute of Chicago, Illinois

Again Edward Hopper moves relentlessly on the subject of loneliness and the city is his background. This time he focuses on a short-order restaurant, undistinguished, devoid of ambience, bald and unfriendly. The only sign of life in an otherwise clean but deserted city are the late nighters at the counter and the counterman. There is a depressing hollowness that sighs through the city street, the dark windows and doorway across the way. If there is any sound at all in the well-lit eatery, Hopper does not let us hear it. He has put it all behind glass. The introspection of the customers makes them seem like mannequins, yet there is a quiet desperation to them that adds to the heartless sobriety of the scene. These people seem not to care about each other. They are tired and used. They are there in the restaurant but somewhere else in their remembrances oblivious of the very stools they sit on.

The whole of the design seems to go somewhere. The restaurant form thrusts dynamically into the middleground. The street comes from a point at the left and courses quickly behind the restaurant and disappears into the shadows. Yet, nothing moves. Hopper keeps it all rooted, stuck to their places by the severity of the horizontal geometry made rigid and structural by the various vertical elements. The silence and desolation is complete.

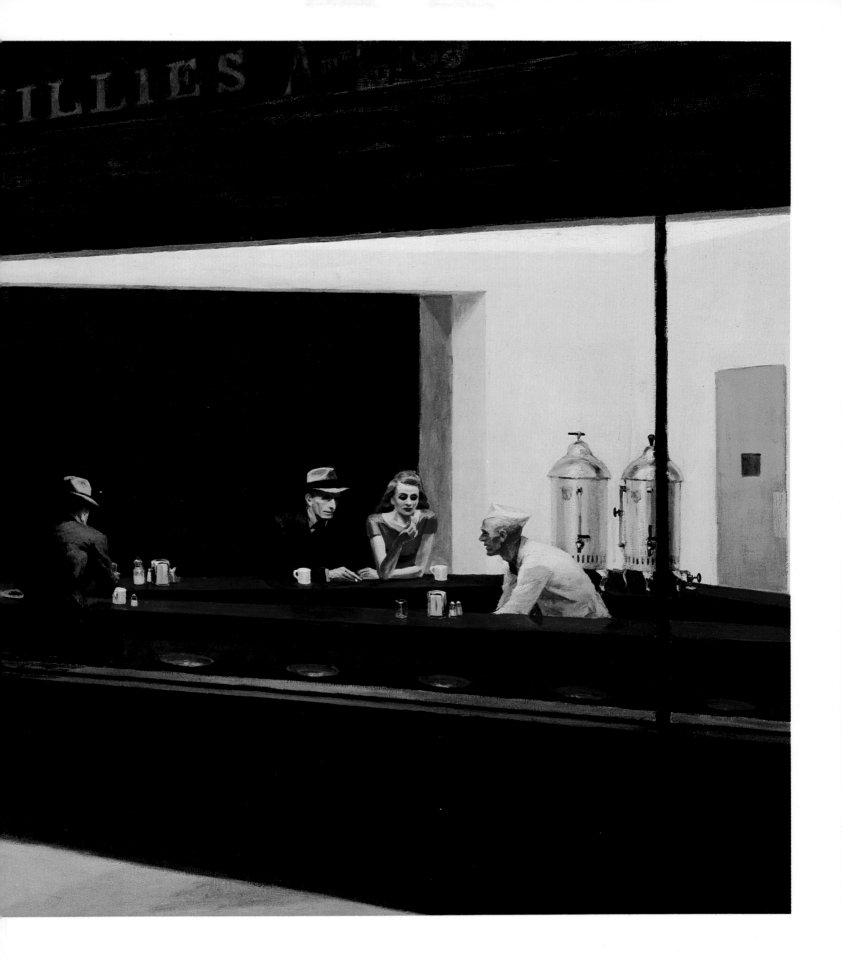

John Brown Going to His Hanging (1942)
Horace Pippin (1888–1946)

The Pennsylvania Academy of Fine Arts, Philadelphia

Horace Pippin belongs to that group of naive or so-called 'primitive' painters who began to flourish in the United States during the nineteenth century. They were different than the untutored limners who concentrated on painting portraits for a living and whose commentary on their life and times, however implicit in their work, was, nevertheless, by default, not by choice. Painters like Horace Pippin, on the other hand, had something to say. It mattered little that they were untrained, unpolished, and out of the sophisticated mainstream. What mattered was not their technical achievement but their insight and vision.

Pippin was black and poor. His Pennsylvania origins knew southern slavery. His grandparents were slaves. Pippin went to war in 1918 and was wounded. He began to paint his bright, well defined, carefully rendered but unsmiling pictures while recovering from his wounds. It was not until 1940 that Pippin's work was seen in public.

His painting of John Brown trussed and being carted off to his execution on a cold and leafless December day, 1859, is a remembrance of a descendant of slaves for a man who honored violence in behalf of slavery's abolition. John Brown was a hero to the Pippin family. Horace Pippin's grandmother witnessed the execution. Regardless, the painting is superbly patterned and controlled, evoking a period and an event while it chills its viewers, recalling the chill that John Brown himself had inflicted on the entire nation.

July Hay (1943) *Thomas Hart Benton (1889–1975)*

The Metropolitan Museum of Art, New York, New York

As the art of Thomas Hart Benton matured, so did the clarity of his design and color. Still insistantly rhythmical; still leaning on a strong, moving linear pattern, Benton showed an increasing awareness for more deliberate distribution of values that heightened the dramatic and decorative flavor of his art, which was already dramatic and decorative.

Disturbing at times, were the figure distortions, especially on a small scale. These bordered on the grotesque, a reminder of Benton's willingness to produce a graphic style that had a common denominator and could be quickly and easily understood by even the most uninitiated public. The epitome of such style was and is the American newspaper cartoon—begun in Ohioan Richard Felton Outcault's 1896 brainchild, *Hogan's Alley*, later called *The Yellow Kid*. Within ten years, young Benton was creating cartoons for local Missouri newspapers.

Nevertheless, in *July Hay*, all of Benton's rhythmical warp comes together in design, color and content to establish a marvelous image of summer toil that has a distinctly American stamp to it. Not a very large canvas (approximately 2′ × 3′), it is so well conceived in scale, so highly controlled, so rich and abundant in its properties, so flowing in its movements that it assumes aspects of monumentality, becoming another American icon.

Sea, Fish, and Constellation (1944)
Morris Graves (1910–)
The Seattle Art Museum, Washington

There is very little connection, if any, between Morris Graves' art and the modern movements of his time. There is however, a connection between Graves' interest in Far Eastern mysticisms and philosophies and the symbolic eeriness of his art. Graves is an individualist moved by the mysteries of his own fantasies that are both highly personal and publicly mesmerizing.

The precision of Graves' draftsmanship and the deliberate use of paper to carry his linear, watery images—as opposed, for example, to the weight and bulk of oil paint on canvas—signals the artist's determination to communicate his shapes, forms and spaces with particular effects. And these effects are the mystical illusions and mysterious visions of a poet.

In the swirling calligraphy of *Sea, Fish, and Constellation*, Morris Graves seems to have probed the universe and returned with its image. The turbulence beneath the stars and the fish at one with the forms of the sea transmits a primordial state. Yet there is an uncanny and inexplicable quiet to the awesomeness of the event. Unsettling, too, is the relationship between the unstable sea and its life and the constellation, immobile in its symmetry. There are powers at work in it that contrast, powers that work on our imagination.

(Page 181)
Out for Christmas Trees (1946)
Anna Mary Robertson 'Grandma' Moses (1860–1961)
Private collection; © 1973, Grandma Moses Properties Co, New York

Long accepted as an American 'primitive' in the most sophisticated salons of art, Grandma Moses remains a phenomenon in American art and life.

Born on a farm in upstate New York, Grandma Moses lived a quiet American dream for 101 years. Afflicted with arthritis in her seventies and unable to work her stiff fingers through the intricacies of embroidered scenes, she simply switched to oil painting to create the same bucolic scenes. There was no formal art training in her background and little worldly experience with the history of art. Grandma Moses' approach was more naive than primitive in the sense that she did not live outside of a society whose education allowed its members to understand visual mathematics (perspective) and whose vision was not limited to silhouetted shapes but included form in space. And Grandma Moses' art shows ample evidence of perspective and form.

In any case, her work captured the naivete and simplicity of her own past and of a bygone time. Her work was a memoir, brightly painted and full of good feeling. To this Grandma Moses injected a magic that could only have happened out of the mellowness of her fortunate and pleasant longevity. *Out for Christmas Trees* is as picturesque as it is anecdotal. Cleanly handled, Grandma Moses adds a singular and innate sense of design to the painting, moving the viewer's eye here there and everywhere around her familiar past. And in that past is a universal American experience presented with extraordinary charm—an American icon.

178

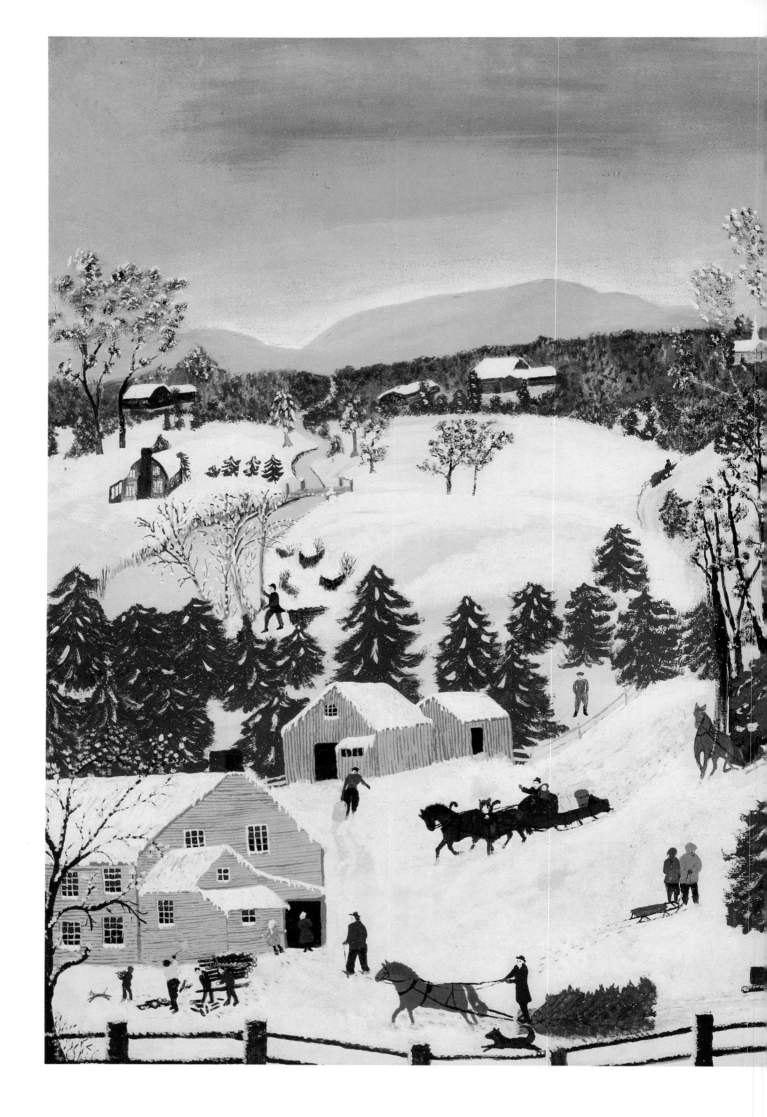

180

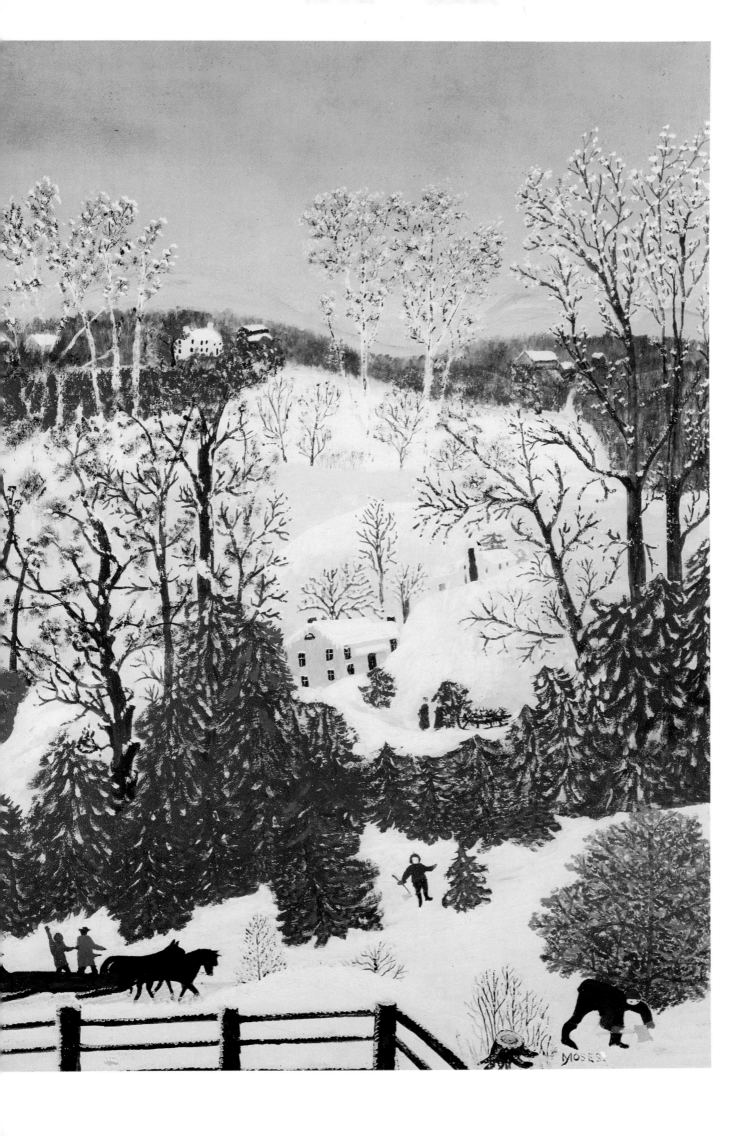

Hunger (1946) *Ben Shahn (1898–1969)*
Auburn University Permanent Collections, Alabama

Beginning with the wartime 1940s, Ben Shahn's imagery took on a more intense personal characteristic. The social messages were being delivered with more conviction as Shahn himself became more immersed in all that was not right in the behavior of the world's few toward the the world's many. There seems to be a poetical force at work that engenders more sadness than anger and shrillness. Obviously, the impact of war on such a grand scale upon the helpless, including the participants, had its visceral impact upon Shahn, the social commentator, the social realist. Yet Shahn's protest from the beginning, from the 1930s, never pulsated with temper. There was always a non-accepting dignity to his view of things. Shahn let the expressive nature of his design, his color, his form and shapes communicate the irksome tides in the affairs of mankind as he understood it. Shahn was a humanist of the Left. His art and style were strong in their individualities.

Typical of the quiet reserve that Shahn projects in monumentalizing human terror is his gouache *Hunger*. Here, a single finger of a sad, hollow-eyed boy begs imploringly. The resolution of form decreases as the view moves from the density of the head to the flat tone and line of the hand. The figure leans. It keeps the viewer off balance, never comfortable. But Shahn, in his infinite skill as an artist, never permits the integrity of the figure and its meaning to dissolve into a charade. The painting was also lithographed as a poster by the CIO's Political Action Committee with the imprint: *We Want Peace* REGISTER VOTE. It was seen nationwide and has remained a symbol of America's eternal interest in the unfortunate of the world.

(Page 185)
Spring (1947) *Ben Shahn (1898–1969)*
The Albright-Knox Art Gallery, Buffalo, New York

Ben Shahn's preoccupation with the human condition is often at its most memorable when the people he portrayed were seen against a spaciousness or seemingly endless backdrop. The brick wall in his *Vacant Lot* (1939) is vast and endless but the figure, small as it appears, survives to challenge the wall. With obvious symbolism, Shahn depicts some harsh realities. The red forest in *Peter and the Wolf* (1943) is endless as the two masked protagonists face each other. The gravelly beach of *Pacific Landscape* (1945) is endless and so is death in the small still figure lying on the unrelieved terrain.

Finally, there is *Spring*. Here, too, the landscape is endless as the linear geometry of the path and fences converge quickly on a single distant point. The lovers in the foreground are ordinary, dryly romantic, not quite relaxed, not altogether exhausted. It almost seems as if Shahn himself had come to the end of his war, at least momentarily. The social humiliation of the depression years has long gone, melted, as it were, by the onrush of war's anguish. It is 1947. World War II has been over for two years. An exhausted peace has descended on the world. The road to somewhere is implicit in Shahn's one point perspective. There is a past as seen in the two small figures skipping rope. And most importantly, there is a future—the symbolism of both the converging lines of perspective and the prone lovers who traverse the entire foreground. The painting, *Spring*, is a picture about renewal. And in the desolate ambience that Shahn provides, the past, the present and the future collide in an eternal rhythm.

182

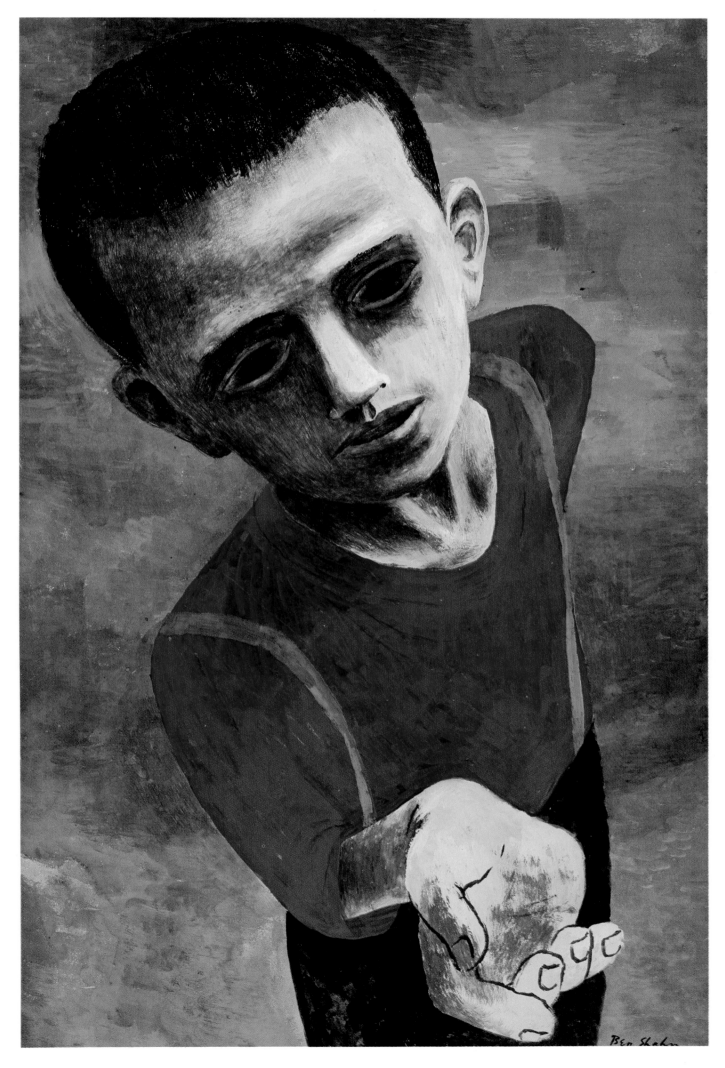

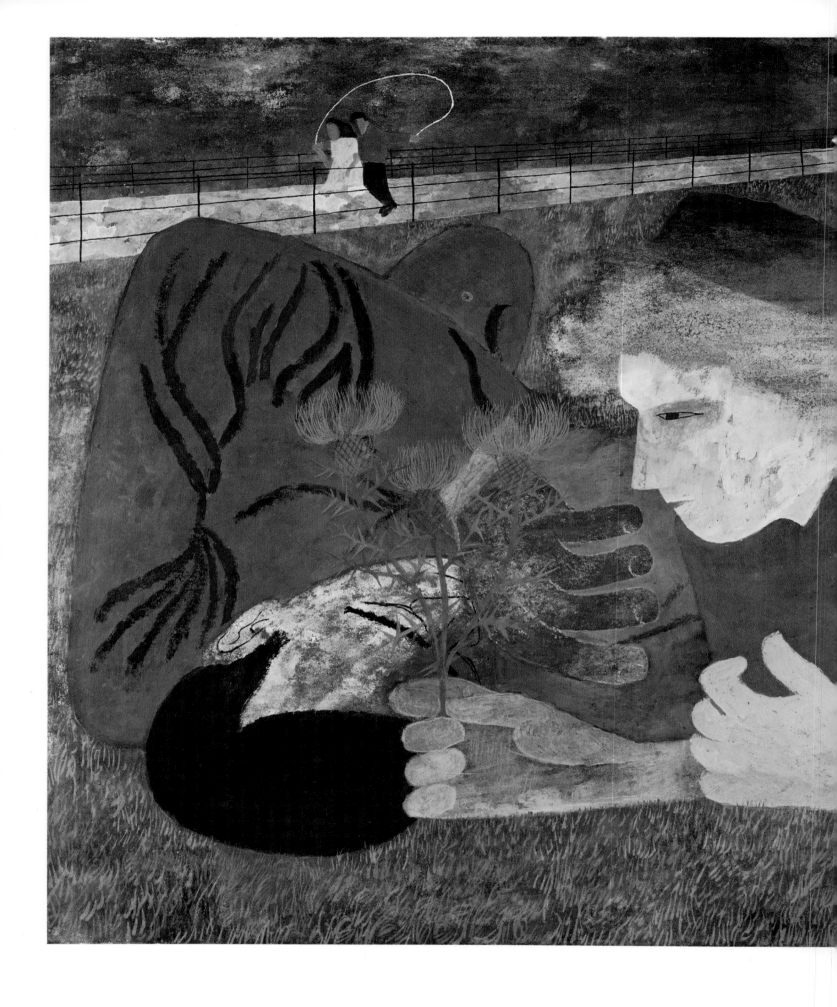

184

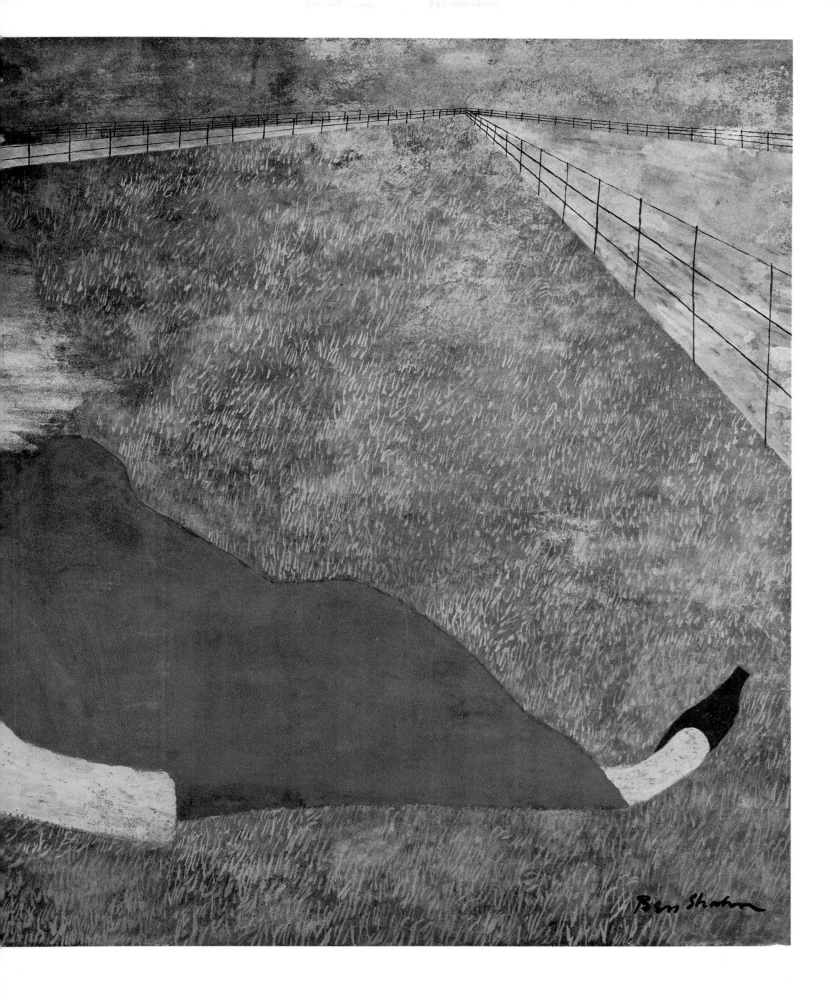

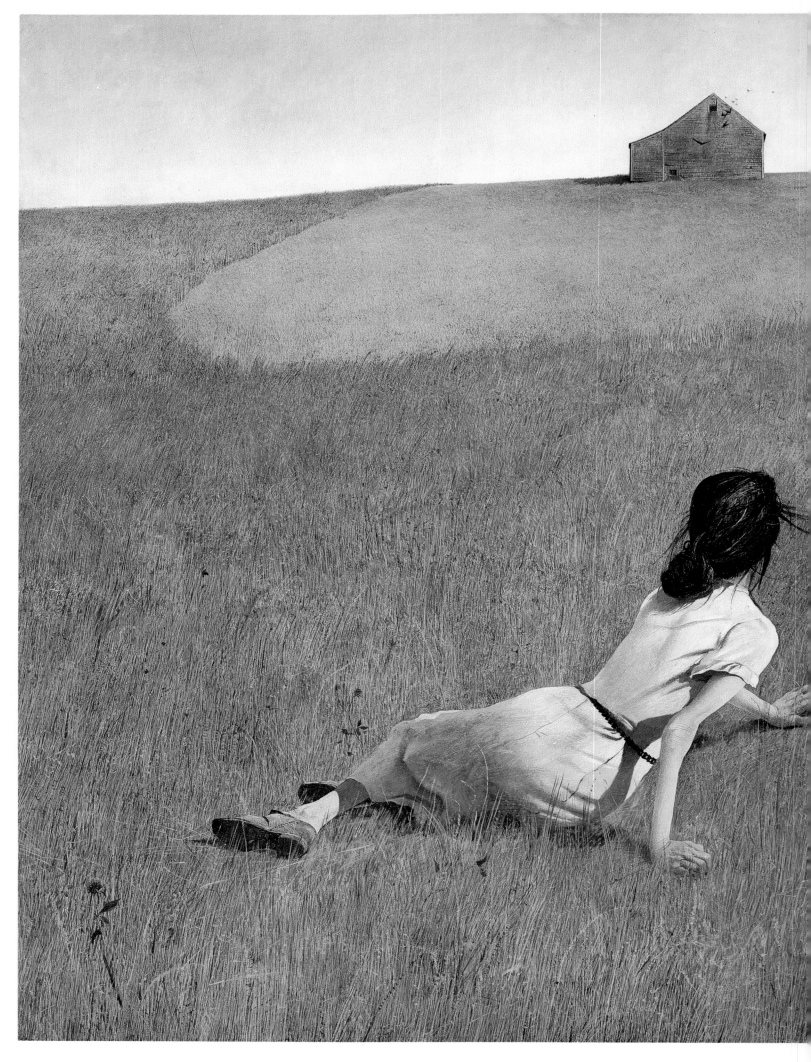

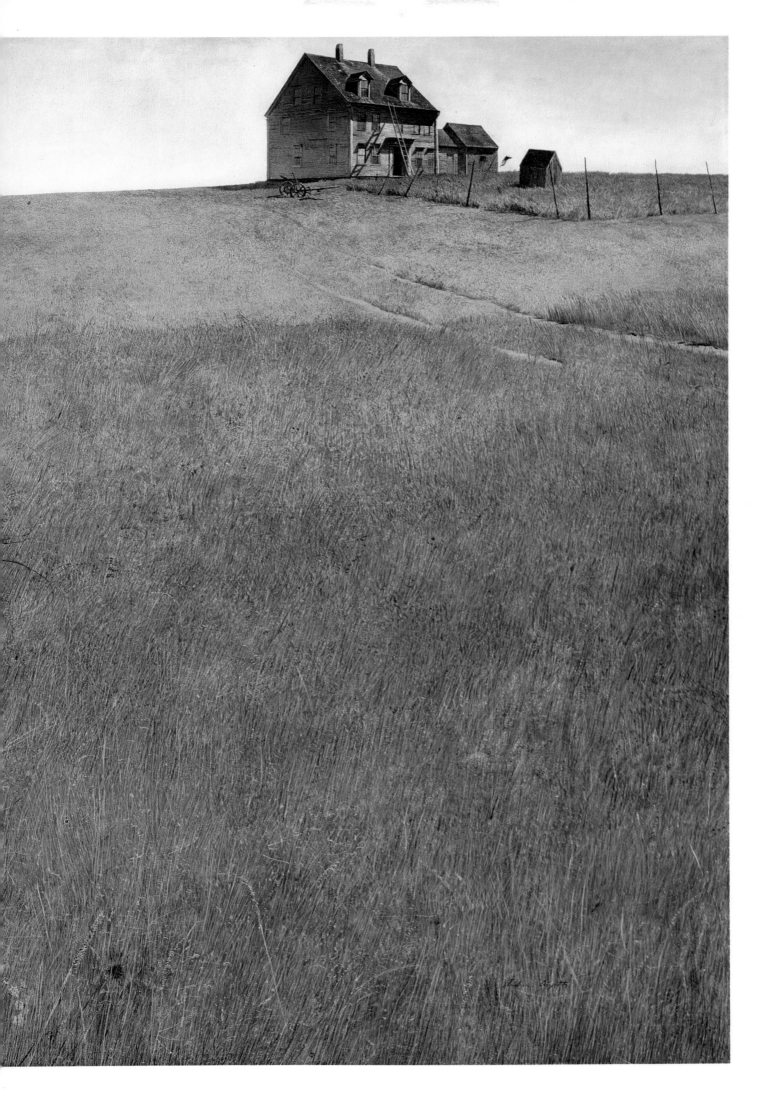

Christina's World (1948)
Andrew Wyeth (1917–)
The Museum of Modern Art, New York, New York

Chadds Ford, Pennsylvania evokes an instant image of a family dynasty of artists—the Wyeths. N C Wyeth first came to Chadds Ford toward the end of the nineteenth century to study with Howard Pyle who worked and taught in his studio nearby in Wilmington, Delaware. Eventually, the Wyeths remained in Chadds Ford where Andrew was born, the youngest of five children. The young Wyeth's training was nearly wholly at the hands of his father. By the time he was 20 he had had his first one man show in Manhattan.

Wyeth is a romantic realist with symbolic overtones. Recalling Edward Hopper's preoccupation with loneliness, Wyeth, too, draws attention to a state of loneliness, or perhaps, singularity. But unlike Hopper, whose loneliness is dramatically desolate and one of quiet desperation, Wyeth's loneliness is one of quiet longing.

The very popular *Christina's World* not only describes a rural spaciousness that Americans respond to but reflects Wyeth's romantic bent that rises from the people and settings of the Brandywine Valley and the state of Maine. There is in the painting a sense of longing that even the artistically uninitiated can identify with. The reach is established by the high horizon and low position of the immobilized figure. The landscape is almost barren and the whole of the work is left uncomplicated, void of nonessentials.

In describing a group of paintings which included a similar work by Andrew Wyeth, Lincoln Kerstein wrote, 'These pictures are essential rather than anecdotal. They attempt to define qualities and conditions . . . their reference moves outward toward a universal legibility rather than inward toward a limited correspondence.'

Number 1, 1950, Lavender Mist (1950)
Jackson Pollock (1912–1956)
The National Gallery of Art, Washington, DC

The Abstract Expressionist movement of the 1950s was an American innovation with evolutionary lines of development. So strong was its presence that it transferred the energy of modern painting from Paris to New York. Parisian artistic momentum had been sapped by the war. Abstract Expressionism, however, owes as much historically to Henri Matisse and the Fauves—the 'wild beasts'—who in 1905 outraged Paris with the violence of their art, as it does to American brusqueness. Matisse, Maurice de Vlaminck (1876–1958), and Andre Derain (1880–1954) had ruptured the academic rigidity of Adolphe Bougereau (1825–1954) and Gustave Moreau (1826–1898). They released ideas about creativity and picture making that dealt with pure painting. Content was of little consequence. Pure form, shape and color and the very act of producing these things was of great consequence.

Among those who experimented in the 1940s and carried the fauvist ideas further and into the 1950s sweeping the art world with a restless

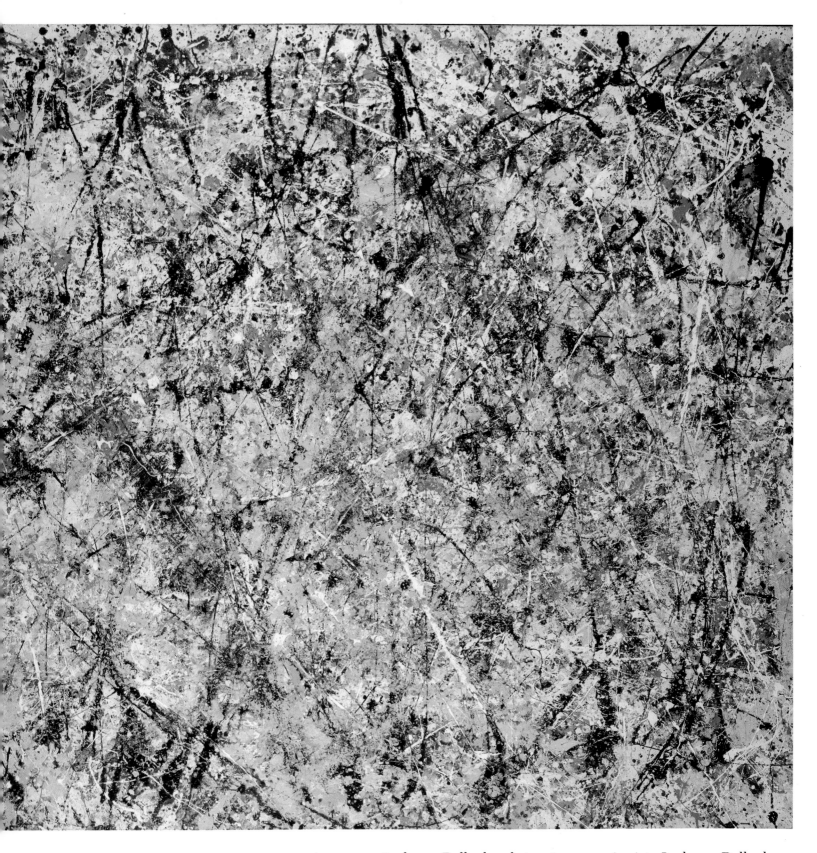

vigor was Jackson Pollock, abstract expressionist. Jackson Pollock, a
midwesterner, had studied with Thomas Hart Benton at New York's
Art Students League and had participated in the Federal Arts Project
of the Works Progress Administration during the Depression. To
Pollock and others, impulsive response to subjective sensation,
together with improvisation, was the artist's ultimate freedom. It
made little difference whether the resulting image was set down with a
brush or a dripping can of paint in the late Pollock manner. In the
end, the painting was its own content. Pollock's *Number 1, 1950,
Lavender Mist* stands as that quintessential work that propelled con-
temporary American art into new realms while impacting on less
adventuresome art.

Number 10 (1950) *Mark Rothko (1903–1970)*

The Museum of Modern Art, New York, New York

Although Mark Rothko's career was linked to the abstract expressionists, his late works, upon which rests his reputation, were not quite created in the mold of the abstract expressionists. There were paradoxical elements to his large 'color field' paintings that belied their intent. For one thing, the abstract expressionists relied on impulsive creativity—a very physical and almost arbitrary approach to the canvas. Their goal was to produce a sensuality that had no root in intellect. Intellect was bound by rules. Sensuality was the ultimate condition of being free. Thinking was not on demand. Feeling was expected. For another thing, there was no particular humanist or moral bent to abstract expressionism. It was the unconditional painted result of a physical act generated by impulse.

Rothko's art, however, evolved into a highly intellectual approach, a more contemplative dealing with emotions tied to color that he viewed as eternally human and even religious in its all enveloping environment. Large scaled, Rothko meant them to be viewed closely so that the spectator was captured totally by the painting's color aura.

In *Number 10*, the Russian-born, Yale-educated Rothko, created a poetical visual illusion that in its largeness and simplicity, in its quietude and diffusion, is so far removed from the convoluted sights and sounds of modern life and art that it becomes at once and in that context the epitome of meditative art.

(Page 193)

Spring No. 1 (1953) *John Marin (1870–1953)*

The Phillips Collection, Washington, DC

In his last year, at 83, John Marin looked ahead. He was occupied with ideas of creation, renewal and the sheer joy of being alive in a world brilliant with sun, washed clean by rain and splashed again by the sun. He said all this in his *Spring No. 1*, painted in the contemplative environs of his Maine home.

Marin was an individualist always seemingly outside the realms of artistic schools and their manifestos or analytical justifications. He preferred his art to deal with his feelings about the world as he perceived it. Yet his imagery and visual philosophy were closely connected to the French Fauves and the later abstract expressionists.

Born in New Jersey, Marin did not seriously pursue art until he enrolled at the Pennsylvania Academy at age 29. At 35 he set out for Paris where he spent the next six years observing the abstract phenomenon that would reshape artistic perceptions and where he met the photographers Edward Steichen (1879–1973) and Alfred Sieglitz (1864–1946) both of whom supported avant garde art and helped to advance Marin's career.

Marin's fame rests on his tonal watercolors and a few late oils in which he expressed the abstract forces, tensions and movements of the landscape, cityscape and seascape. The patches of color often laced with line, sometimes explosive, sometimes not, were always fresh, never murky and deeply expressive of the content. As Marin aged, his painting became increasingly more abstract. *Spring No. 1* in form and content was the ultimate expression of the supreme individualist.

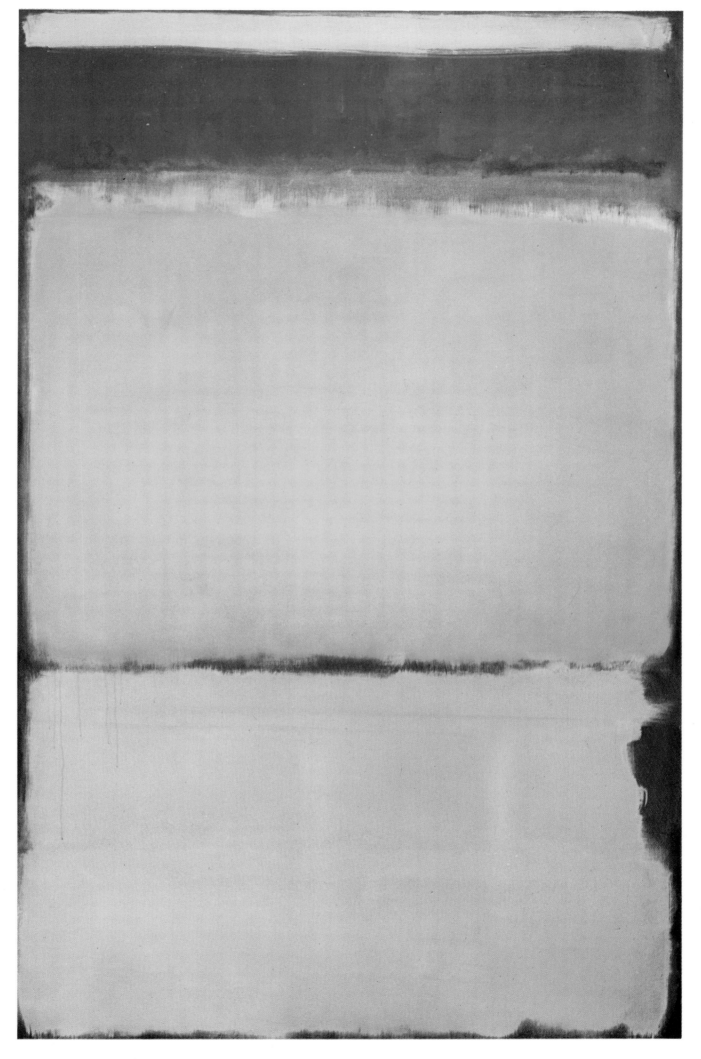

American Shrimp Girl (1954)
Philip Evergood (1901–1973)

The Hirshhorn Museum and Sculpture Garden, Smithsonian Institution, Washington, DC

Social protest was never more forcefully represented in America than with the art of Philip Evergood, William Gropper (1897–1977) and Ben Shahn. But even the most committed, the most dedicated artists who aim their brushes, paints and canvases at humanitarian causes— at Man's inhumanity to Man—must rest from time to time. They must allow other visual possibilities to emerge from the well of their artistic creativity.

Evergood, never far from symbolism in his social commentary and always seemingly in reach of allegory, easily moved in and out of the regions of fantasy. In his *American Shrimp Girl* he produces a vigorous figurative illusion centered full length on canvas bursting with energy. Like a Madonna surrounded by choruses of cherubim, seraphim, angels and archangels, Evergood's all-American girl—virtually an American Madonna of the Sea—is engulfed by the vitality of the gulls fluttering around her head. As the eye moves about the picture it cannot help but be taken in by the business and formality of the portrait. The canvas overflows with the produce and trappings of the sea, not to mention the seaside environment. Divided in half by the figure's large presence, the painting achieves a lively rhythm in its asymmetrically balanced parts.

Allegory, fantasy, symbolism—Philip Evergood has romantically used a regional activity and welded all its parts into a strong and impressionable image that is alive with curiosity, space and a sense of being.

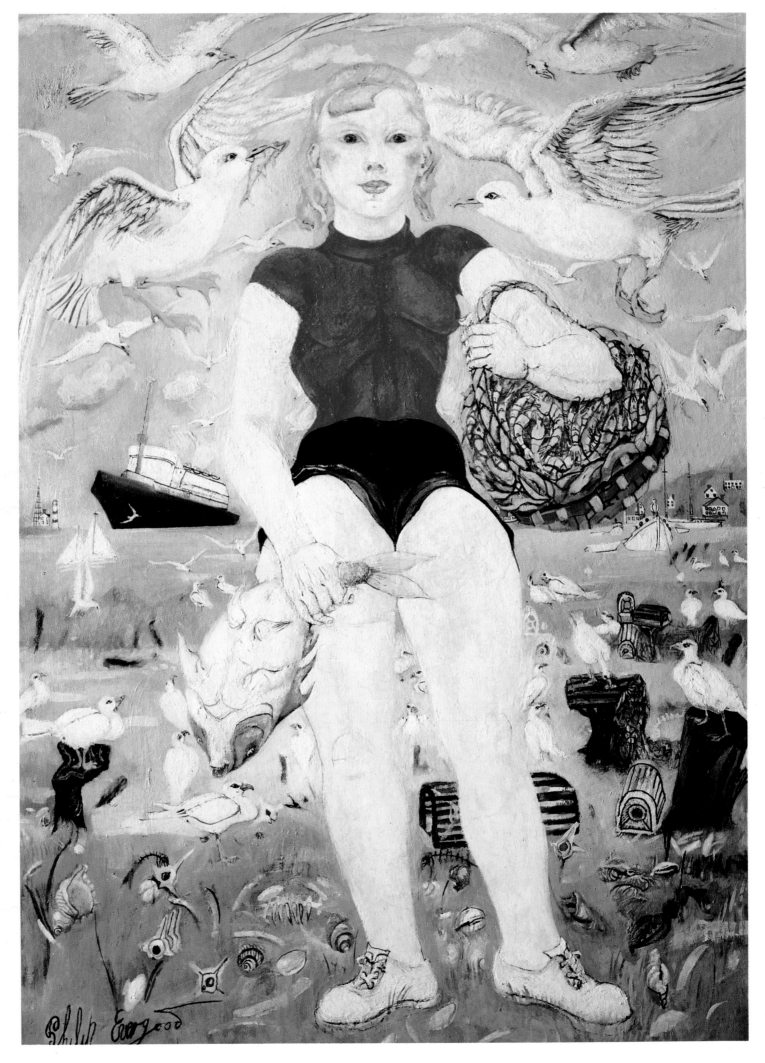

Election Night (1954) *Jack Levine (1915–)*
The Museum of Modern Art, New York, New York

Trained at the Boston Museum School of Art, Boston born and Boston bred Jack Levine rattled the foundations of the staid Boston establishment with his pungent paintings of the corruption of society. Levine never forgot the slums of his childhood. His recollections of the inequities of the poor and the hopelessness of the wretched seediness of poverty surface again and again in his art—not as objective or obvious portrayals—but as bitter satire.

Not all of Levine's work is laced with the caricature of bitterness and satire, however. His biblical portrayals of the 1940s are in a different cast. Nevertheless, the sting of his social commentaries and their relentless caricatures attracted wide attention. Levine's early life molded his frame of mind. And although the Levine family had put the slums of Boston behind them, Jack Levine threaded his way through the Great Depression painting under the egis of the Federal Arts Program of the Works Progress Administration where his point of view matured.

A keen observer of the human element, Levine, nevertheless, enjoyed the plasticity and luminosity of pigment and the painting process. The vitality and gusto of his application, together with its purpose, put Levine squarely in the camp of the Expressionists. The sullen, partying politicians of his *Election Night* need no further explanation to the politically alert and often skeptical American viewer. The driving power in the painting is derived from its vigorous physical appearance, its obvious satirical statement and its impact on a politician-wary public who in their traditional skepticism make an immediate connection with the image.

(Page 199)
Golden Gate (1955) *Charles Sheeler (1883–1965)*
The Metropolitan Museum of Art, New York, New York

With expectation, Charles Sheeler again engages our attention and our senses with his remarkable skill and extraordinary eye. Sharp and impersonal, *Golden Gate* is an upwardly thrusting, fast moving image taken from actuality and invested with a different reality.

Consistency is a hallmark in the work of Charles Sheeler. And constant always is the geometricized image. It is an image rooted in structures and itself structural in all its aspects. Deliberately void of superfluous detail, distracting textures and alluring atmosphere, Sheeler communicates the essence of man-made forms.

Stark in its precision and under its cool light, *Golden Gate* is an arrangement of pure form removed from actuality and standing as an artistic or esthetic entity independent of its content, the bridge.

In addition, the total representation is monumental in its skyward reach, effectively symbolizing the inexorable thrust of technological progress. Sheeler, too, calls our attention, purposefully or not, to the fact that hard edge precision of recognizable forms need not be visually monotonous. There is a glimmer of romance and eye stimulation to Sheeler's measured draftsmanship that rises from the sleek visual appearance of his art.

196

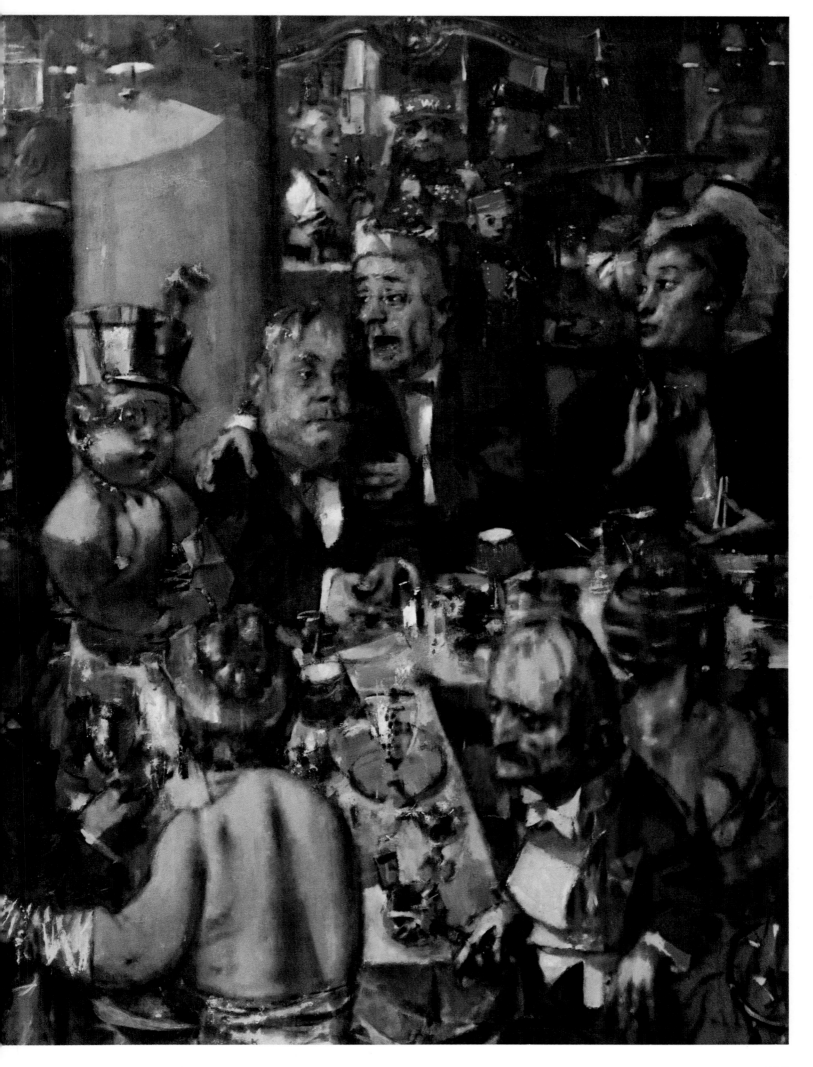

198

Gotham News (1955)
Willem De Kooning (1904–)
The Albright-Knox Art Gallery, Buffalo, New York

Long considered a major figure in the Abstract Expressionist movement, Willem De Kooning, nevertheless, slightly sidetracks the school. De Kooning never abandoned a representational aspect to his abstractions. The most outstanding example of his use of natural form, however expressively perceived, is his series *Woman*. The pure abstract expressionist, the action painter, was totally committed to the non-objective element. The forms and shapes of pure abstract expressionism were non-derivative of nature and emerged only as expressions of the subjective. De Kooning, on the other hand, expressed subjectively shapes and forms derivative of nature.

De Kooning came to the United States from Rotterdam, the Netherlands, in 1926. At 22, he was already immersed in the modern directions of European art.

Much of De Kooning's art of the post World War II period seemed to express a constant anxiety. It is reflective of a personal world constantly on the edge of chaos saved somehow by the formality of the rectangle within which it is expressed. *Gotham News* contains an urgency in its violent imagery and turbulence that strongly draws attention to the relationship between an unpredictable and unreliable civilization or society and the anxiety caused by the human being's inability to control his destiny within it. Beyond the imagery, De Kooning's painting manner gives more plasticity to the pigment, which in turn gives more form and substance to his offering.

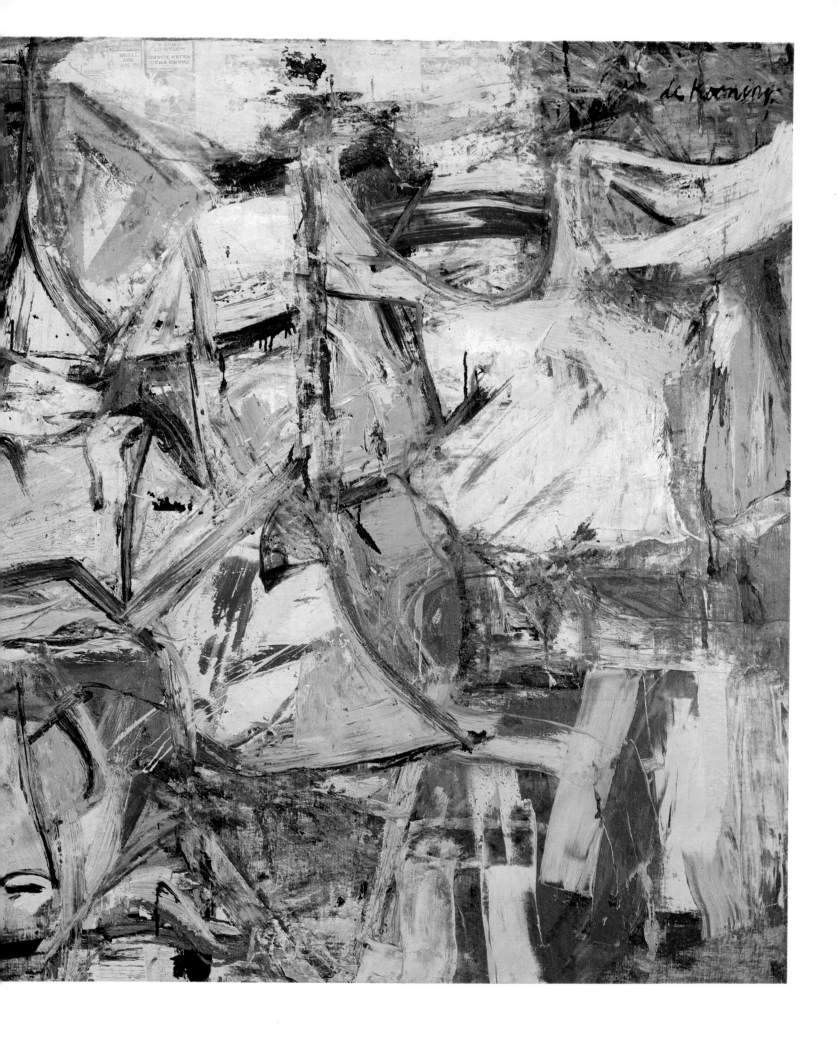

1957-D No 1 (1957)
Clyfford Still (1904–1980)

The Albright-Knox Art Gallery, Buffalo, New York

Similar to Mark Rothko, the linkage between the abstract expressionist movement and Clyfford Still is not all that firm. Still was too deliberate an abstractionist and altogether too formal a creator to be convincingly identified with the action painting and impulsive, unrestrained solutions of abstract expressionism. Still, whose abstract roots and direction, like the abstract expressionists, was in Matisse and the Fauves, was too searching a thinker to declare his own art to be the ultimate freedom. Nevertheless, Still spent what seemed to be a lifetime of complaining about all the labels that were affixed to his art over the years. In fact, he ignored the New York scene for 15 years, having concluded that New York lacked the integrity to accept the purity of his massive canvases.

Still was a westerner, born in North Dakota but educated in the far Northwest. He did come East from time to time to teach and exhibit. Having delved in and rejected the surreal abstractions that formed one of the way stations between the Fauves and Abstract Expressionism, Still's natural and artistic inclinations put him in pursuit of pure painting—of painting for the sake of painting whereby the art emerges from the subjectivity inherent in the work itself. But Still's art, like Rothko's, was highly controlled. The black, yellow and white regions touched with red of *1957–D No 1* have been deliberately ordered by the painter in what is a visual symphonic arrangement and not without sensuality. It implies form and space where none was rendered. There is mystery in its constantly unfolding contrasts. It is a conscious revelation of the unconscious.

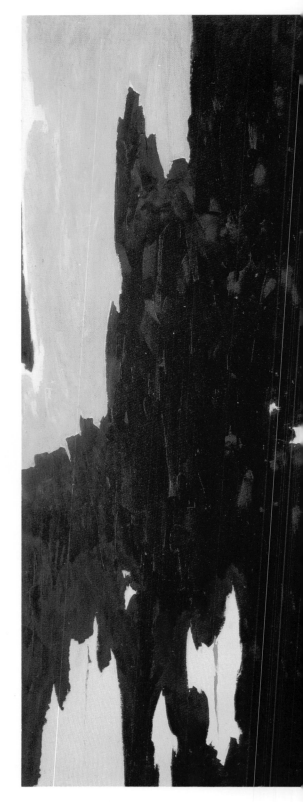

(Page 205)
Flag (1958) *Jasper Johns (1930–)*
Leo Castelli Gallery, New York, New York

Pop Art is less of an artistic phenomenon but more of an historical moment in the evolving perceptions of contemporary life as expressed by younger artists.

Rebellion against tradition took a wrenching turn in 1905 when Henri Matisse led his 'Fauves' into unorthodox avenues of expression. The iconoclasm of young French intellectuals and artists grew out of the intransigence of the establishment which continued to perpetuate a set of sociological rules that no longer applied to the modern world. Italian Futurism belonged to the same outcry. While Picasso and his Cubists led art in one direction, Matisse's Fauvists led straight to the Dadaists, the Société Anonyme, surrealism, abstract expressionism and latter-day artistic eccentricities. The ultimate arena of spontaneous free expression had been reached in the 1960s. It had begun in Europe and clearly manifested itself in the art of the so-called New York School. Out of this whirling energy of creativity came the Pop Artists, Jasper Johns among them, who sought a more authoritarian or disciplined expression of

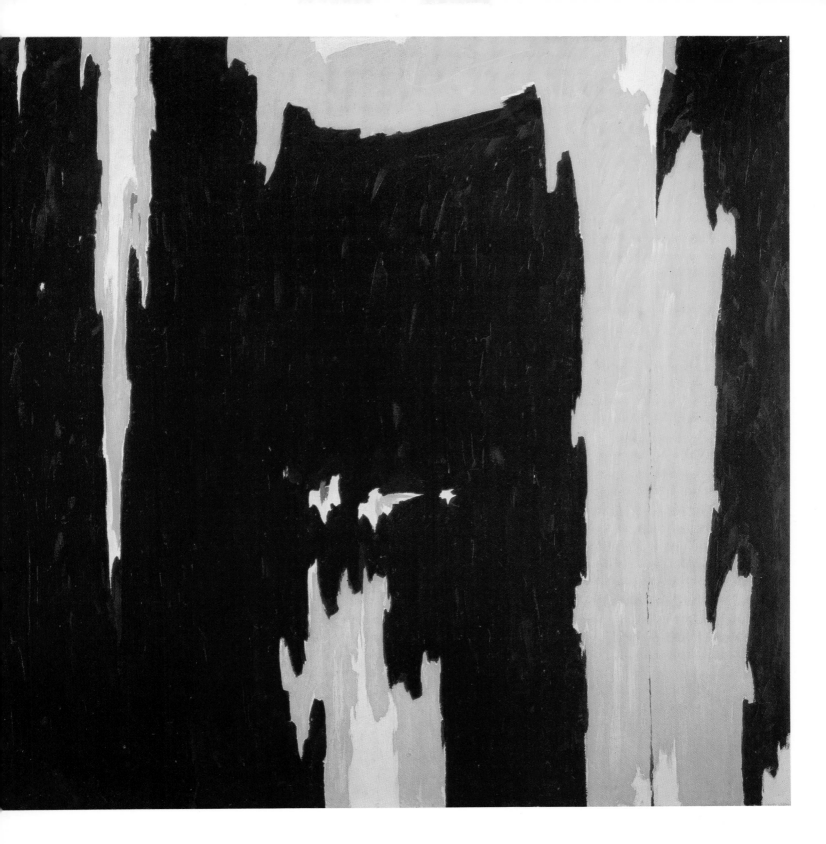

the twentieth century at mid-life. It was rooted in still life, symbolic realism and the genre painting of long gone generations. The symbols of society are never obscure but obvious and relatable—coffee cans, comic strips, flags, etc—directly painted, simply stated and often large scale, never far from Dadaism.

Johns, who was born and trained in South Carolina, based much of his 'pop' art on real objects. From time to time he would incorporate the real item in the painting making his connection to the Dada movement apparent. In his 'flag' paintings, one of which is seen here, Johns seems to communicate the United States flag without a situation, without charged emotions for or against. Yet, there it is, a strong symbol, however detached for art's sake.

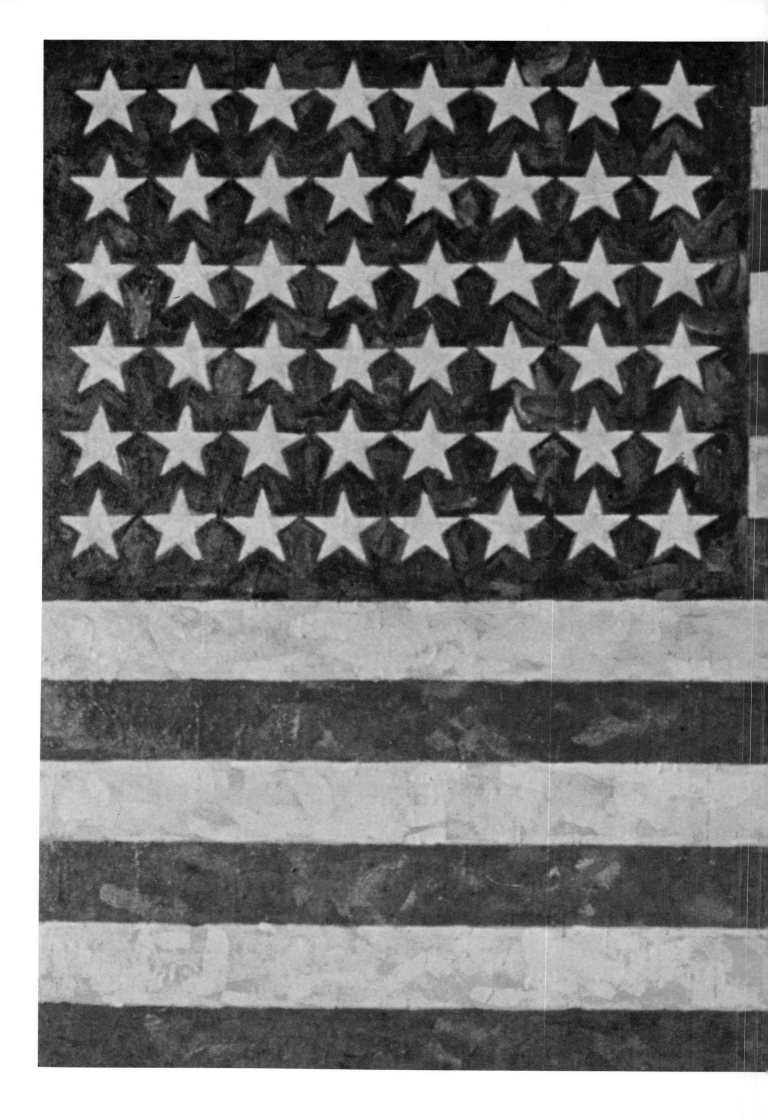

Homage to a Square: Apparition (1959)
Josef Albers (1888–1976)

The Solomon R Guggenheim Museum, New York, New York

Walter Gropius, architect, founded the Bauhaus in Wiemar, Germany in 1919. Four years later, Josef Albers became a member of the faculty. The basic philosophy of the Bauhaus was the unification of the arts under the egis of architecture. Architecture was to assume a central authoritarian position while all other artistic disciplines (*eg* painting) performed under its direction. Such an arrangement was based on the strong belief in post war Germany that industry was the essence of twentieth-century life and that all the arts had to be keyed to industry, an echo of the earlier Italian Futurists. Since Gropius considered architecture to be the highest and most necessary form of art, it followed that all other forms would be mere functionaries within an architecturally designed environment. The Bauhaus moved to Dessau and Adolf Hitler (1889–1945) shut it down in 1933. The Nazis were displeased over some Bauhaus concepts including the usefulness of abstract painting.

Undeterred, Albers and other Bauhaus elite, including Gropius, came to America to teach their philosophy. Albers taught drawing, color and design at Black Mountain College and at Yale University's School of Art. At Yale, Albers extended his influence over a broad horizon of students receptive to his concepts dealing with the interaction of color. Albers supported his concepts of teaching with extremely austere paintings of color harmonies contained within rigid square shapes. There was no depth dimension to the art other than what was provided by the reaction of one color upon another. The square became Albers' theme and identity. He created a multitude of variations on that theme including *Homage to a Square: Apparition*. And with each variation, the spectator was disarmingly led into different, tightly controlled realms of non-objective color.

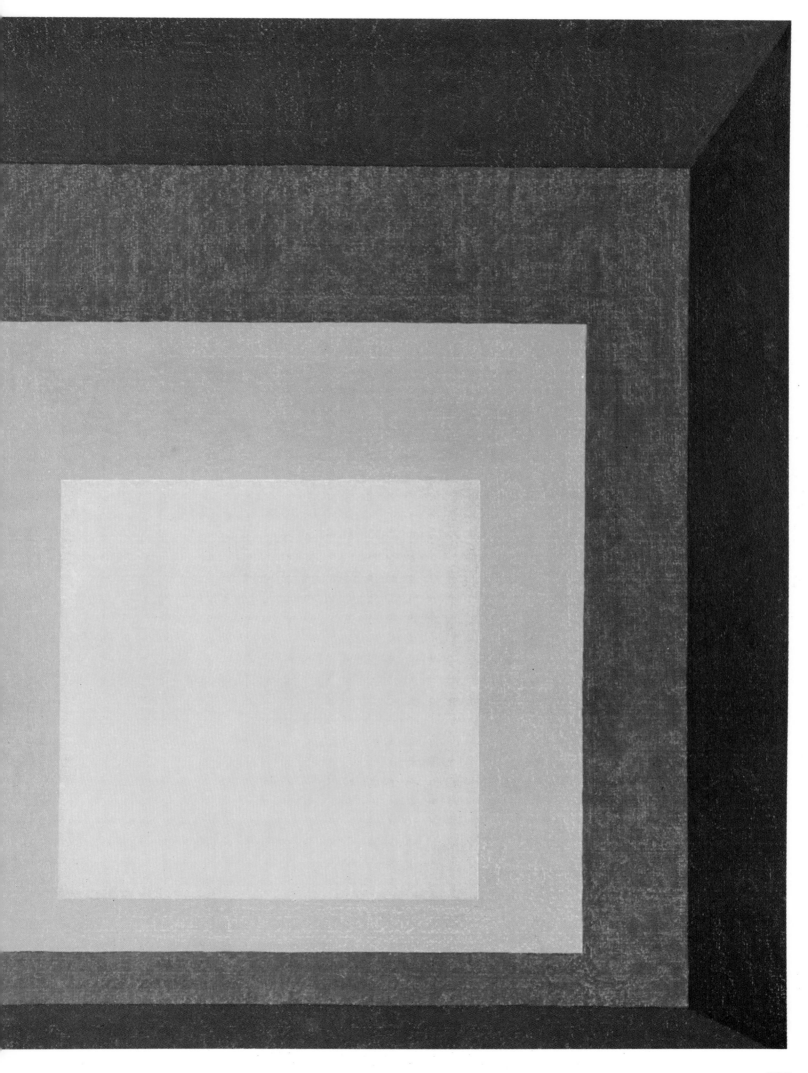

Beach Blankets (1960) *Milton Avery (1893–1965)*
The Wichita Art Museum, Kansas

Greatly influenced by Henri Matisse and the Fauves, Milton Avery continued to pioneer the flat tonal possibilities of color in landscape, still life and figure representations. In fact, so close was Avery to Matisse's style and new wave of decorative color experience that he became a direct link between the new and innovative French vision led by Matisse, and the later schools of American colorists from Mark Rothko to Kenneth Noland.

Born in New York but raised in Hartford, Connecticut, Avery pursued his perception of close harmony of massed color—of large, well, organized areas of pure flat color. His concentration on color pattern, muted and neutral in his early years, extended and livelier in his later years—was so intense that within his well managed color areas there was little need to further the representation of a figure, for example, with unnecessary detail. It was in the orchestration of shaped color that Avery's work emerged strongly to influence younger generations of American painters. Paintings like *Beach Blankets* created in his sixty-seventh year not only underscored Avery's later inventiveness but continued to underwrite his connection to the art of the twentieth century as a first generation avant gardist. While Avery's painting invites the inevitable comparison with Matisse, it should be noted that his color and its application was less compulsive, more subtly controlled, and however thinly spread, more substantive with regard to its opaque, transparent or luminous effects.

(Page 211)
O, Fearful Wonder of Man (1961)
Henry Koerner (1915–)
Museum of Art, Carnegie Institute, Pittsburgh, Pennsylvania

Viennese born, Viennese trained, Henry Koerner emigrated to the United States in 1938. He was 23 years old. Koerner came to America when his native Austria was welded to Adolf Hitler's Third Reich. From the beginning, his overt realism, at times edging toward photographic illusion, rarely strayed from the severe social implications and symbolism that affected Central European art following the First World War (1914–1918). Koerner bonded his social commentary to a painterly appearance that owed debts to Paul Cezanne's (1839–1906) color and form; to Peter Breughel's (1525–1569) allegories on human folly and to the post World War I German Expressionism typified by Max Beckman (1884–1950) whose disenchantment with the thrust of European civilization opened new and more powerful vistas of social satire. 'Die neue Sachlichkeit,' it was called—*the new objectivity*. The near Armageddon of World War II (1939–1945) underscored Koerner's interest in humanity's waste, greed and absurdity. Targeting society in general, Koerner indulges himself and his audiences with wit and bite, creating kaleidoscopes of the human presence that shift from this posture to that.

In *O, Fearful Wonder of Man*, Koerner deftly designs a tapestry of his Pittsburgh environs—an approximately $7\frac{1}{2}' \times 8\frac{1}{2}'$ microcosm of the world's varietal life. Here, he offers a personal symbolism while joining real and surreal elements in the painter's grab bag of historical viewpoints. Yet, in the 16 panels that comprise the total work, Henry Koerner somehow leaves a vast and endless presence of painted energy that never fails to haunt the viewer with the restlessness of humankind, if not with one's own uncertainties.

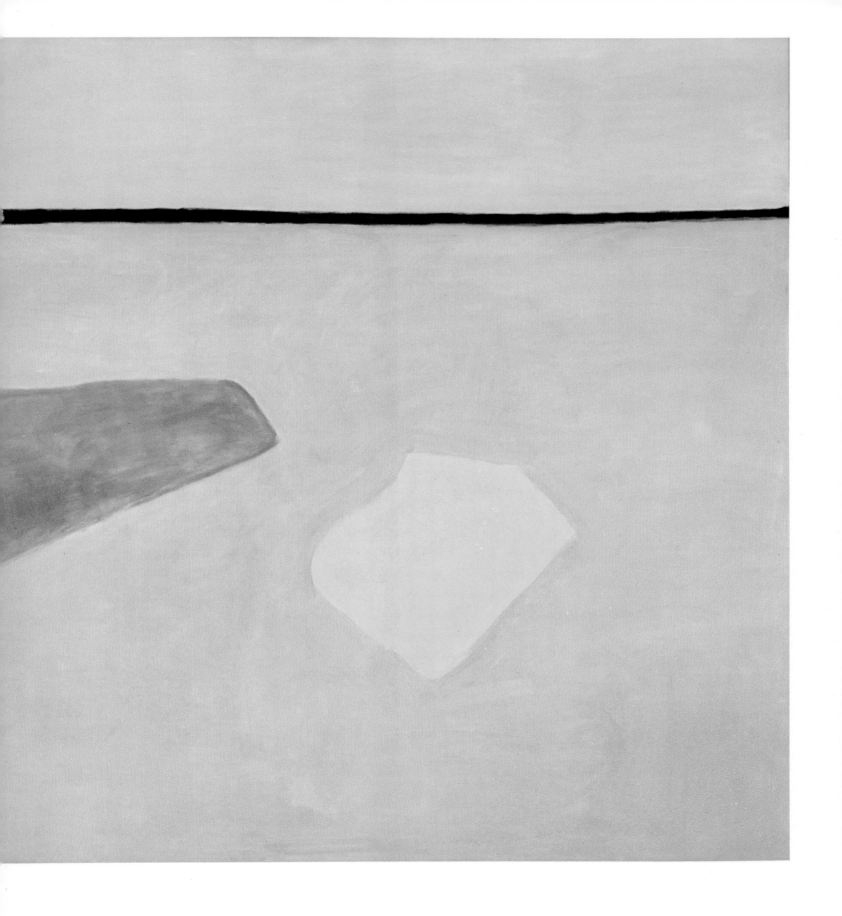

100 Cans (1962)
Andy Warhol (1929–)

The Albright-Knox Art Gallery, Buffalo, New York

A soup can is not often thought of as a compelling symbol of life and times in mid-twentieth century America. Repeated over and over again, however, it hounds us with its monotony, impressing its unimportance upon our minds. That mental image of soup cans becomes effective and indelible, a symbol of an instantly recognized aspect of modern life. Painting that deals with the commonplace is a conceptual thread and visual need that runs all through the history of American painting. Andy Warhol, however, takes the common object further by moving it into the realm of symbolism and commentary—Pop Art!

Born and educated in Pittsburgh, Pennsylvania, Andy Warhol began his professional life as a commercial artist. He has since moved from painting to printmaking to films. Warhol and Pop Art emerged in the 1960s, challenging the supremacy of the abstract expressionists whose impulsive art reflected, among other things, disenchantment and escape as it chased its emotional ends. Pop Art was more cynical. Characteristic of much of Warhol's effort is the constant repetition of a single common image—a soup can, Coca Cola bottle, Marilyn Monroe, Elvis Presley, and more. The same concept of repetition occurs in his films. None of this, by Warhol's measure, adds up to a personal statement. Warhol offers only the images of his time. Nothing more. Nothing less. Yet, there is a presence to *100 Cans* as it relentlessly passes judgment on the importance of the unimportant. This use of common objects to visually editorialize is a substantive nature of Pop Art.

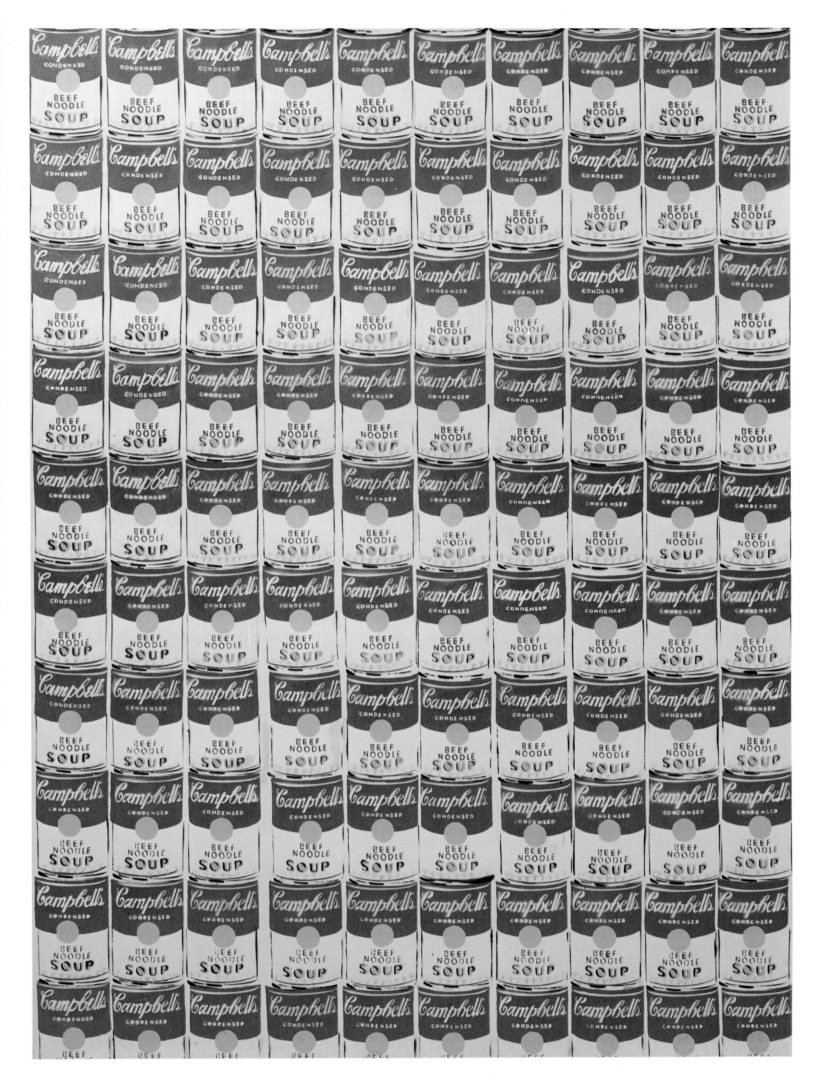

Par Transit 1966 (1966)
Kenneth Noland (1924–)

Norton Simon Museum of Art at Pasadena, California

There is nothing impulsive or spontaneous in the clean, clear precision of Kenneth Noland's Post Abstract Expressionist paintings. Noland has deliberately set out to deal with optical effects that relate to his lozenge and chevron shaped canvases. There is a hardness to the edge that contains and intensifies the geometry of color that Noland uses to structure an image that controls the viewer's eye rather than his pictorial reasoning.

Noland is North Carolina born and educated. His art education was both at Black Mountain College in North Carolina and in Paris. It was at Black Mountain that Noland came under the teaching influence of Josef Albers, whose color theories resulted in the hard edge austerity that marked his work. There were other influences at work on Noland—

technical influences—chiefly Morris Louis (1912–1962), whose method of staining unprimed canvases with acrylic pigment was adopted by Noland. The purity of design and the brilliance of color that typified the striped paintings of Louis found its polish and refinement and its viable creative extension in the stripes and chevrons of Kenneth Noland. While Noland moves beyond the Abstract Expressionists in terms of non-improvisation and non-spontaneity, he nevertheless is in the expressionist camp, so to speak, by sending out visual messages that are so highly defined as to control the subject response of the spectator. There is no drawing in a Noland canvas, no combination of values. There is only the optical sensation caused by the juxtaposition of color precisely designed to deliver a specific effect. *Par Transist 1966* is another milestone—one of color control abstraction—in the evolution of modern American painting.

Saskatoon I (1968) *Frank Stella (1936–)*
Leo Castelli Gallery, New York, New York

The vitality of abstract expressionism began to ebb by the late 1950s and early 1960s. The first generation abstract expressionists—De Kooning, Still, Pollock and others—seem to have withdrawn as activists among the avant garde of the New York art world. Solidly and historically established, they frequented less and less the New York arena of visibility that continued to make them and their work influential around the world. Pollock himself had died unexpectedly as the movement's speed and excitement was overtaken by second generation abstract expressionists—'followers,' as it were. Too many of these lacked the fire and inventiveness of their still omni-present predecessors. Into this esthetic breech stepped younger more intellectual painters seeking a more controlled relationship between themselves, their imagery and their audiences. Among those who moved onto this stage of sharply defined non-figurative abstraction was Frank Stella, Massachusetts born, Princeton educated.

Moving from one series of images to another—from colorless designs to very chromatic presentations, from shaped canvases to traditional rectangles, from flat impressions to implied space—Stella continuously challenged the viewer with the visual effects of geometry with originality and ingenuity. The patterns of his art weave in and out, resolving, dissolving and resolving again in a single piece. The works are overwhelming in size and scale. His *Saskatoon I* is 8′ × 16′. But more than its grand dimensions it represents a milestone in the onward mobility of non-figurative abstraction, and in its maturity it powerfully reestablishes the creative process in which the painter maintains measured control over his originality.

Andy Warhol (1970) *Alice Neel (1900–1984)*
The Whitney Museum of American Art, New York, New York

Born in Merion Square, Pennsylvania and trained at the Philadelphia School of Design for Women, Alice Neel has spent a lifetime developing a highly individual style of portraiture. An expressive realist whose figurative studies owe something to the abstract expressionists, Neel's work is decidedly in the representational camp. More importantly, the honesty of the portraits is so intense, the intuitive response to the sitter so genuine, that Alice Neel's faces and figures are personality probings beyond their surface appearances.

Perhaps not as humanly warm as Rembrandt Van Rijn (1606–1669) would have it, but Neel's portraits, nevertheless, are disarmingly direct and sympathetic reflections of her sitters. Bold and unflattering, they are alive and memorable. Moreover, the realism seems effortless and fluid, never detracting from the power of the image expressed with confident drawing and sensuous color.

Neel's portrait of Andy Warhol, who was victimized in a near tragic shooting, is a remarkable example of Neel's indifference to the expected. Here, Warhol is shown bare-chested exposing his wounds, sitting erect and stiffly uncomfortable as if any move would painfully undo the fragile body. The somewhat tense Warhol figure is a very unprivate likeness that removes the veil of romance that so often comes between the viewer and the painted personality. It is wholly in the modern idiom that holds little sacred and, in the modern vernacular, 'tells it like it is.'

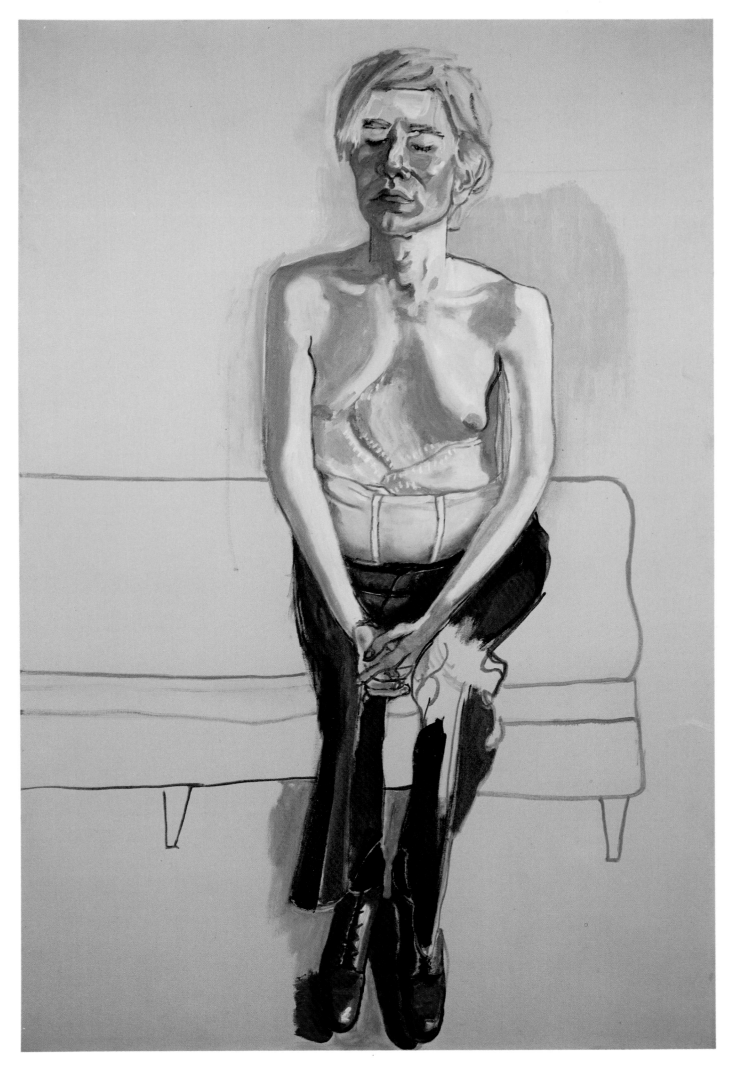

PICTURE CREDITS

1. *Paul Revere* (1770)
 John Singleton Copley (1738–1815)
 Museum of Fine Arts, Boston
 Oil on canvas, 35 × 28½ inches
 Gift of Joseph W, William B and
 Edward H R Revere
2. *Penn's Treaty with the Indians* (1771)
 Benjamin West (1738–1820)
 The Pennsylvania Academy of the Fine
 Arts
 Oil on canvas, 75½ × 107½ inches
 Gift of Joseph and Sarah Harrison
3. *Roger Sherman* (1775)
 Ralph Earl (1751–1801)
 Yale University Art Gallery
 Oil on canvas, 64⅝ × 49⅝ inches
 Gift of Roger Sherman White, BA 1859
4. *Capture of the Hessians at Trenton*
 (1787–1794)
 John Trumbull (1756–1843)
 Yale University Art Gallery
 Oil on canvas, 21¼ × 31⅛ inches
5. *Staircase Group* (1795)
 Charles Willson Peale (1741–1827)
 Philadelphia Museum of Art
 Oil on canvas, 89 × 39½ inches
 The George W Elkins Collection
6. *George Washington* (1796)
 Gilbert Stuart (1755–1828)
 The Pennsylvania Academy of the Fine
 Arts
 Oil on canvas laid on wood, 96¼ × 60¼
 inches
 Bequest of William Bingham
7. *Moonlit Landscape* (1819)
 Washington Allston (1779–1843)
 Museum of Fine Arts, Boston
 Oil on canvas, 24 × 35 inches
 Gift of William Sturgis Bigelow
8. *The Old House of Representatives* (1822)
 Samuel Finley Breese Morse (1791–
 1872)
 The Corcoran Gallery of Art,
 Washington, DC
 Oil on canvas, 86½ × 130¾ inches
 Museum Purchase
9. *After the Bath* (1823)
 Raphaelle Peale (1774–1825)
 The Nelson-Atkins Museum of Art,
 Kansas City, Missouri
 Oil on canvas, 29 × 24 inches
 Nelson Fund
10. *Bird's Eye View of the Mandan Village,
 1800 Miles Above St Louis* (1832)
 George Catlin (1796–1892)
 National Museum of American Art,
 Smithsonian Institution
 Oil on canvas, 24⅛ × 29 inches
 Gift of Mrs Joseph Harrison Jr
11. *The Oxbow* (1836)

Thomas Cole (1801–1848)
 The Metropolitan Museum of Art, New
 York
 Oil on canvas, 51½ × 76 inches
 Gift of Mrs Russell Sage, 1908
12. *Fur Traders Descending the Missouri*
 (1845)
 George Caleb Bingham (1808–1879)
 The Metropolitan Museum of Art, New
 York
 Oil on canvas, 29¼ × 36¼ inches
 Morris K Jessup Fund, 1933
13. *War News from Mexico* (1848)
 Richard Caton Woodville (1825–1856)
 National Academy of Design, New York
 Oil on canvas, 27 × 25 inches
14. *Kindred Spirits* (1849)
 Asher Brown Durand (1796–1886)
 The New York Public Library
 Oil on canvas, 46 × 36 inches
 Astor, Lenox and Tilden Foundations
15. *The Banjo Player* (c 1858)
 William Sydney Mount (1807–1868)
 The Detroit Institute of Arts
 Oil on canvas, 25 × 30 inches
 Accession Number 38.60
 Gift of Dexter M Ferry Jr
16. *Niagara* (1857)
 Frederick Edwin Church (1826–1900)
 The Corcoran Gallery of Art,
 Washington, DC
 Oil on canvas, 42¼ × 90½ inches
17. *Owl's Head, Penobscot Bay, Maine*
 (1862)
 Fitz High Lane (1804–1865)
 Museum of Fine Arts, Boston
 Oil on canvas, 16 × 26 inches
 M and M Karolik Collection
18. *Old Battersea Bridge (Nocturne in Blue
 and Gold)* (1865)
 James Abbott McNeill Whistler
 (1834–1903)
 The Tate Gallery, London
 Oil on canvas, 20⅛ × 27⅞ inches
19. *Prisoners From the Front* (1866)
 Winslow Homer (1836–1910)
 The Metropolitan Museum of Art, New
 York
 Oil on canvas, 24 × 38 inches
 Gift of Mrs Frank B Porter, 1922
20. *Thunderstorm Over Narragansett Bay*
 (1868)
 Martin Johnson Heade (1819–1904)
 Amon Carter Museum, Fort Worth
 Oil on canvas, 32⅛ × 54⅛ inches
21. *The Sierra Nevada in California* (1868)
 Albert Bierstadt (1830–1902)
 National Museum of American Art,
 Smithsonian Institution
 Oil on canvas, 72 × 120 inches

Bequest of Helen Huntington Hull
22. *Max Schmitt in a Single Scull* (1871)
 Thomas Eakins (1844–1916)
 The Metropolitan Museum of Art, New
 York
 Oil on canvas, 32¼ × 46¼ inches
 Alfred N Punnett Fund and Gift of
 George D Pratt, 1934
23. *Arrangement in Gray and Black: Portrait
 of the Artist's Mother* (1871)
 James Abbott McNeill Whistler (1834–
 1903)
 The Louvre, Paris
 Oil on canvas, 56 × 64 inches
24. *Flight and Pursuit* (1872)
 William Rimmer (1816–1879)
 Museum of Fine Arts, Boston
 Oil on canvas, 18 × 26¼ inches
 Bequest of Miss Edith Nichols
25. *The Gross Clinic* (1875)
 Thomas Eakins (1844–1916)
 The Jefferson Medical College of Thomas
 Jefferson University, Philadelphia
 Oil on canvas, 96 × 78 inches
26. *Historical Monument to the American
 Republic* (c 1876)
 Erastus Salisbury Field (1805–1900)
 Museum of Fine Arts, Springfield,
 Massachusetts
 Oil on canvas, 9 feet 6 × 13 feet 1 inch
 The Morgan Wesson Memorial
 Collection
27. *Reminiscences of 1865* (1879)
 John F Peto (1854–1907)
 Wadsworth Atheneum, Hartford
 Oil on canvas, 30 × 22 inches
 The Ella Gallup Sumner and Mary
 Catlin Sumner Collection
28. *The Cranberry Harvest* (1880)
 Eastman Johnson (1825–1906)
 Timken Art Gallery, San Diego,
 California
 Oil on canvas, 27½ × 54⅝ inches
 Putnam Foundation Collection
29. *The Monk* (1873)
 George Inness (1825–1894)
 Addison Gallery of American Art,
 Phillips Academy, Andover,
 Massachusetts
 Oil on canvas, 38 × 63 inches
30. *Madam X* (1884)
 John Singer Sargent (1856–1925)
 The Metropolitan Museum of Art,
 Oil on canvas, 82½ × 43¼ inches
 Arthur H Hearn Fund, 1916
31. *Eight Bells* (1886)
 Winslow Homer (1836–1910)
 Addison Gallery of American Art,
 Phillips Academy, Andover,
 Massachusetts

Oil on canvas, $25\frac{3}{16} \times 30\frac{1}{8}$ inches

32. *The Open Air Breakfast* (c 1888)
William Merritt Chase (1849–1916)
Toledo Museum of Art, Toledo, Ohio
Oil on canvas, $37\frac{7}{16} \times 56\frac{3}{4}$ inches
Gift of Florence Scott Libbey

33. *Moonlight* (c 1855–1889)
Ralph Albert Blakelock (1847–1919)
The Brooklyn Museum
Oil on canvas, $27\frac{1}{4} \times 32\frac{1}{4}$ inches
Dick S Ramsay Fund

34. *The Faithful Colt* (1890)
William Michael Harnett (1848–1892)
Wadsworth Atheneum, Hartford
Oil on canvas, $22\frac{1}{2} \times 18\frac{1}{2}$ inches
The Ella Gallup Sumner and Mary
Catlin Sumner Collection

35. *The Bachelor's Drawer* (1890–1894)
John Haberle (1856–1933)
The Metropolitan Museum of Art, New
York
Oil on canvas, 20×36 inches
Purchase 1970, Henry R Luce gift

36. *The Gulf Stream* (1899)
Winslow Homer (1836–1910)
The Metropolitan Museum of Art, New
York
Oil on canvas, $28\frac{1}{8} \times 49\frac{1}{8}$ inches
Wolfe Fund, 1906

37. *Afternoon Wind* (1899)
Louis Michel Eilshemius (1864–1941)
The Museum of Modern Art, New York
Oil on canvas, 20×36 inches
Given anonymously

38. *Geronimo* (c 1900)
Henry Cross (1837–1918)
The Thomas Gilcrease Institute of
American History and Art, Tulsa,
Oklahoma
Oil on canvas, $30\frac{1}{4} \times 25\frac{1}{8}$ inches

39. *The Spielers* (1905)
George B Luks (1867–1933)
Addison Gallery of American Art,
Phillips Academy, Andover,
Massachusetts
Oil on canvas, $36 \times 26\frac{3}{16}$ inches

40. *Park on the River* (c 1902)
William Glackens (1870–1938)
The Brooklyn Museum
Oil on canvas, $25\frac{7}{8} \times 32$ inches
Dick S Ramsay Fund

41. *Unicorns (Legend — Sea Calm)* (c 1906)
Arthur Bowen Davies (1862–1924)
The Metropolitan Museum of Art,
Oil on canvas, $18\frac{1}{4} \times 40\frac{1}{4}$ inches
Bequest of Lizzie P Bliss, 1931

42. *Wake of the Ferry* (1907)
John Sloan (1871–1952)

The Phillips Collection, Washington, DC
Oil on canvas, 26×32 inches

43. *Fight for the Waterhole* (1901)
Frederic Remington (1861–1909)
Museum of Fine Arts, Houston
Oil on canvas, 27×40 inches
The Hogg Brothers Collection

44. *Stag at Sharkey's* (1907)
George Wesley Bellows (1882–1925)
The Cleveland Museum of Art
Oil on canvas, $36\frac{1}{4} \times 48\frac{1}{4}$ inches
The Hinman B Hurlbut Collection

45. *The Race Track, or Death on a Pale Horse*
(c 1910)
Albert Pinkham Ryder (1847–1917)
The Cleveland Museum of Art
Oil on canvas, $27\frac{3}{4} \times 35\frac{3}{8}$ inches
Purchase from the J H Wade Fund

46. *The Rope Dancer Accompanies Herself*
with her Shadows (1916)
Man Ray (1890–1977)
The Museum of Modern Art, New York
Oil on canvas, 52 inches \times 6 feet
$1\frac{3}{4}$ inches
Gift of G David Thompson

47. *'Oriental.' Synchromy in Blue-Green*
(1918)
Stanton Macdonald-Wright (1890–
1973)
Whitney Museum of American Art,
New York
Oil on canvas, 36×50 inches
Purchase
Acq. Number 52.8

48. *The Bridge* (1922)
From the series of 5 paintings entitled
The Voice of the City of New York
Interpreted
Joseph Stella (1880–1946)
The Newark Museum, Newark, New
Jersey
Oil and Tempera on canvas, $88\frac{1}{2} \times 54$
inches

49. *The City from Greenwich Village* (1922)
John Sloan (1871–1951)
National Gallery of Art, Washington, DC
Oil on canvas, $26 \times 33\frac{3}{4}$ inches
Gift Helen Farr Sloan, 1970

50. *Ruby Green Singing* (1928)
James Chapin (1887–1975)
Norton Gallery and School of Art,
West Palm Beach, Florida
Oil on canvas, 36×40 inches

51. *I Saw the Figure 5 in Gold* (1928)
Charles Henry Demuth (1883–1935)
The Metropolitan Museum of Art, New
York
Oil on composition board, $36 \times 29\frac{3}{4}$
inches
The Alfred Stieglitz Collection, 1949

52. *Self Portrait* (1929)
John Kane (1860–1934)
The Museum of Modern Art, New York
Oil on canvas, over composition board,
$36\frac{1}{8} \times 27\frac{1}{8}$ inches
Abby Aldrich Rockefeller Fund

53. *Yellow Cactus Flower* (1929)
Georgia O'Keefe (1887–)
The Fort Worth Art Museum
Oil on canvas, $30\frac{3}{16} \times 42$ inches
Gift of William E Scott Foundation

54. *Early Sunday Morning* (1930)
Edward Hopper (1882–1937)
Whitney Museum of American Art,
New York
Oil on canvas, 35×60 inches
Acq. Number 31.426

55. *Why Not Use the 'L'?* (1930)
Reginald Marsh (1898–1954)
Whitney Museum of American Art,
New York
Egg Tempera on panel, 36×48 inches
Acq. Number 31.291

56. *American Gothic* (1930)
Grant Wood (1892–1942)
Art Institute of Chicago
Oil on beaver board, $29\frac{7}{8} \times 24\frac{7}{8}$ inches

57. *Engineer's Dream* (1931)
Thomas Hart Benton (1889–1975)
Memphis Brooks Museum of Art
Oil on panel, $29\frac{7}{8} \times 41\frac{1}{4}$ inches
Eugenia Buxton Whitnel Funds 75.1

58. *Midnight Ride of Paul Revere* (1931)
Grant Wood (1892–1942)
The Metropolitan Museum of Art, New
York
Oil on composition board, 30×40
inches
© Estate of Grant Wood/*Vaga*, New
York 1984

59. *The Passion of Sacco and Vanzetti*
(1931–32)
From the Sacco and Vanzetti Series of
23 paintings
Ben Shahn (1898–1969)
Whitney Museum of American Art,
New York
Tempera on canvas, $84\frac{1}{2} \times 48$ inches
Gift of Edith and Milton Lowenthal in
memory of Juliana Force
Acq. Number 49.22

60. *Six O'Clock* (1936)
Charles Burchfield (1893–1967)
Everson Museum of Art, Syracuse, New
York
Watercolor on paper, 24×30 inches
Museum Purchase, Jennie Dickinson
Buck Fund

61. *American Tragedy* (1937)
Philip Evergood (1901–1973)

221

Collection of Mrs Gerritt P Van de
Bovenkamp, New York City
Oil on canvas, 29½ × 39½ inches

62. *Trio* (1937)
Walt Kuhn (1880–1949)
The Taylor Museum, Colorado Springs
Fine Arts Center, Colorado Springs,
Colorado
Oil on canvas, 72 × 50 inches
Gift of the El Pomar Foundation

63. *Wisconsin Landscape* (1938–39)
John Steuart Curry (1897–1946)
The Metropolitan Museum of Art, New
York
Oil on canvas, 42 × 84 inches
George A Hearn Fund, 1942

64. *Rolling Power* (1939)
Charles Sheeler (1883–1965)
Smith College Museum of Art,
Northampton, Massachusetts
Oil on canvas, 15 × 30 inches
Purchased 1940

65. *The Wave* (1940)
Marsden Hartley (1887–1943)
Worcester Art Museum, Worcester,
Massachusetts
Oil on fiber board, 30¼ × 40⅛ inches

66. *Blind Bird* (1940)
Morris Graves (1910–)
The Museum of Modern Art, New York
Gouache on Japan paper, 30⅛ × 27
inches
Purchase

67. *Office at Night* (1940)
Edward Hopper (1882–1967)
Walker Art Center, Minneapolis
Oil on canvas, 22⅛ × 25 inches
Gift of T B Walker Foundation, Gilbert
M Walker Fund

68. *The Migration of the Negro: 'One of the
largest race riots occurred in East St
Louis.'* (1940–41)
Jacob Lawrence (1917–)
The Museum of Modern Art, New York
One of 30 temperas on composition
board, 12 × 18 inches
Gift of Mrs David M Levy

69. *San Francisco Street* (1941)
Mark Tobey (1890–1976)
The Detroit Institute of Arts
Gouache on paper, 27¼ × 13 inches
Accession Number 44.77
Founders Society Purchase,
Membership Fund

70. *Nighthawks* (1942)
Edward Hopper (1892–1967)
The Art Institute of Chicago
Oil on canvas, 33 × 60 inches

71. *John Brown Going to his Hanging* (1942)
Horace Pippin (1888–1946)
The Pennsylvania Academy of the Fine
Arts
Oil on canvas, 24 × 30 inches

72. *July Hay* (1943)
Thomas Hart Benton (1889–1975)
The Metropolitan Museum of Art, New
York
Oil and egg tempera on composition
board, 38 × 26¾ inches
George A Hearn Fund, 1943

73. *Sea, Fish and Constellation* (1944)
Morris Graves (1910–)
The Seattle Art Museum
Tempera on paper, 19 × 53½ inches
Gift of Mrs Thomas D Stimson

74. *Out for Christmas Trees* (1946)
Anna Mary Robertson (Grandma)
Moses (1860–1961)

Private Collection, © 1973, Grandma
Moses Properties Co, New York
Oil on pressed wood, 26 × 36 inches

75. *Hunger* (1946)
Ben Shahn (1898–1969)
Auburn University Permanent
Collections
Gouache on cardboard, 47½ × 33½
inches

76. *Spring* (1947)
Ben Shahn (1898–1969)
The Albright-Knox Gallery, Buffalo,
New York
Tempera on masonite, 17 × 30 inches
Room of Contemporary Art Fund, 1948

77. *Christina's World* (1948)
Andrew Wyeth (1917–)
The Museum of Modern Art, New York
Tempera on gesso panel, 32¼ × 47¾
inches
Purchase

78. *Number 1, 1950 (Lavender Mist)* (1950)
Jackson Pollock (1912–1956)
National Gallery of Art, Washington
Oil, enamel and aluminum on canvas,
87 × 118 inches
Ailsa Mellon Bruce Fund 1976

79. *Number 10* (1950)
Mark Rothko (1903–1970)
The Museum of Modern Art, New York
Oil on canvas, 7 feet 6⅜ × 57⅛ inches
Gift of Philip Johnson

80. *Spring No. 1* (1953)
John Marin (1870–1953)
The Phillips Collection, Washington, DC
Oil on canvas, 22 × 28 inches

81. *American Shrimp Girl* (1954)
Philip Evergood (1901–1973)
Oil on canvas mounted on wood,
46¼ × 32⅜ inches
Hirshhorn Museum and Sculpture
Garden, Smithsonian Institution,
Washington, DC

82. *Election Night* (1954)
Jack Levine (1915–)
The Museum of Modern Art, New York
Oil on canvas, 63⅛ × 6 feet ½ inches
Gift of Joseph H Hirshhorn

83. *Golden Gate* (1955)
Charles Sheeler (1883–1965)
The Metropolitan Museum of Art, New
York
Oil on canvas, 25 × 34 inches
George A Hearn Fund, 1955

84. *Gotham News* (1955)
William de Kooning (1904–)
Albright-Knox Art Gallery, Buffalo,
New York
Oil on canvas, 69 × 79 inches
Gift of Seymour H Knox, 1955

85. *1957-D No. 1* (1957)
Clyfford Still (1904–1980)
Albright-Knox Art Gallery, Buffalo,
New York
Oil on canvas, 113 × 159 inches
Gift of Seymour H Knox, 1959

86. *Flag* (1958)
Jasper Johns (1930–)
Leo Castelli Gallery
Encaustic on canvas, 41¼ × 60¾ inches
Collection of Mrs Leo Castelli

87. *Homage to a Square: Apparition* (1959)
Josef Albers (1888–1976)
Solomon R Guggenheim Museum, New
York
Oil on Masonite, 48 × 48 inches

88. *Beach Blankets* (1960)
Milton Avery (1893–1965)

Wichita Art Museum, Wichita, Kansas
Oil on canvas, 53⅝ × 71½ inches

89. *O Fearful Wonder of Man* (1961)
Henry Koerner (1915–)
Museum of Art, Carnegie Institute,
Pittsburgh
Oil on 16 canvases on panel,
88³⁄₁₆ × 102¾ inches
Henry L Hillman Fund, 1981

90. *100 Cans* (1962)
Andy Warhol (1929–)
Albright-Knox Art Gallery, Buffalo,
New York
Oil on canvas, 72 × 52 inches
Gift of Seymour H Knox, 1963

91. *Par Transit 1966* (1966)
Kenneth Noland (1924–)
Norton Simon Museum of Art at
Pasadena
Synthetic polymer on canvas,
114 × 241 inches
Gift of Mr and Mrs Robert A Rowan,
1969

92. *Saskatoon I* (1968)
Frank Stella (1936–)
Leo Castelli Gallery
Polymer and fluorescent polymer on
canvas, 96 × 192 inches
Private Collection

93. *Andy Warhol* (1970)
Alice Neel (1900–)
Whitney Museum of American Art,
New York
Oil on canvas, 60 × 40 inches
Gift of Timothy Collins
Acq. Number 80.52

94. *Shadow of a Ribbon* (1970)
Leonard Everett Fisher (1924–)
The New Britain Museum of Art
Acrylic, 49 × 49 inches
Friends Purchase Fund

95. *Watson and the Shark* (1778)
John Singleton Copley (1738–1815)
Museum of Fine Arts, Boston
Oil on canvas, 72 × 90¼ inches
Gift of Mrs George von Lengerke Meyer

INDEX